Digital Photography

David D. Busch

MIS:
PRESS

A Subsidiary of
Henry Holt and Co., Inc.

First Edition—1995

Printed in the United States of America.

Library of Congress Cataloging-in-Publication Data

Busch, David D.
 Digital photography / David D. Busch
 p. cm.
 ISBN 1-55828-448-6
 1. Photography—Digital techniques. I. Title.
 TR267.B87 1995
 778—dc20 95-33696
 CIP

10 9 8 7 6 5 4 3 2 1

MIS:Press books are available at special discounts for bulk purchases for sales promotions, premiums, fund-raising, or educational use. Special editions or book excerpts can also be created to specification.

For details contact: Special Sales Director
 MIS:Press
 a subsidiary of Henry Holt and Company, Inc.
 115 West 18th Street
 New York, New York 10011

Associate Publisher: *Paul Farrell* **Production Editor:** *Anne Incao*
Development Editor: *Cary Sullivan* **Technical Editor:** *Dan Margulis*
Copy Edit Manager: *Shari Chappell* **Copy Editor:** *Brian Oxman*

TABLE OF CONTENTS

CHAPTER 6 • SCANNERS 53

CHAPTER 7 • INSIDE OUTPUT TECHNOLOGY 67

CHAPTER 8 • DIGITAL HARDWARE 79

CHAPTER 9 • SOFTWARE FOR DIGITAL PHOTOGRAPHY 93

CHAPTER 10 • NEWS PHOTOGRAPHY 117

CHAPTER 11 • PHOTO ILLUSTRATION AND INDUSTRIAL PHOTOGRAPHY 123

CHAPTER 12 • PORTRAIT PHOTOGRAPHY 129

PREFACE

Over the past 20 years, I've watched many good photographers tentatively, reluctantly—and then enthusiastically embrace the stunning array of choices and creative techniques offered by computer technology. Their motivation is easy to understand—successful photographers have an unusual combination of an artistic eye, dedication to a demanding craft, a knack for self-promotion, good business sense, and an affinity for the mechanical and electronic gadgetry that make up cameras and darkroom equipment. Digital photography is, on one level, just another powerful kind of photography medium. If you like autofocus, can't live without automatic bracketing, and think databacks are cool, you'll love digital imaging.

As fun as digital photography can be, the capabilities it offers professional photographers also make good business sense. Photojournalists can view shots seconds after they were exposed and transmit them back to a picture editor in minutes. Catalog photographers working on high-volume, standardized setups can generate image after image ready for placement on the page. In many applications, digital photography offers a way of doing things faster, better, and with more flexibility.

Whether you're a working photographer who needs to know more about the advantages and disadvantages of this medium before taking the plunge, a computer graphics professional who wants to understand the needs and viewpoint of the photographer, or an art director looking for ideas, this book will introduce you to digital imaging.

INTRODUCTION

This is a book about digital photography, written with photographers in mind. I'm surprised that it's taken this long for a book of this sort to come to market. When I began working with a program called Digital Darkroom and later with Photoshop and other applications, I was struck by how closely digital image production and manipulation resembled traditional photography.

For anyone who's spent long hours in the darkroom breathing the fumes of Rapid Fix and stop bath, the cupped hand and paddle-like tool icon used to represent burning and dodging in Photoshop are instantly familiar. Radial blur filters in zoom mode remind me of my first 43-86mm Auto-Nikkor, used to produce psychedelic images of young rock star Joe Walsh as we both began our careers in northeast Ohio. Digital unsharp masking effects, mezzotints, airbrushing, solarization, friskets, and other tools all have their parallels—and origins—in conventional photographic and prepress techniques.

Even though the roots are in conventional photography, most of the books I've seen on digital photography, image editing, and desktop publishing have been written from the viewpoint of computer users. Certainly, there are many who become interested in digital imaging through their work with computers, but digital photography is now taught as a basic skill at photography schools, such as Douglas Ford Rea's program at the Rochester Institute of Technology.

Even though computers are becoming more prevalent in photography, there are still many photographers who find themselves needing to learn about digital imaging some time after they've already become photographers. Books that approach the topic strictly from a computer user's viewpoint miss a great opportunity to explain things to photographers in terms they'll easily understand. They also spend a great deal of time going over subject matter that is already intimately familiar to someone who works with a camera on a daily basis.

Photographers know about tonal range and the difficulty of holding detail in both highlights and shadows. We understand how halftones are made, and why those little dots tend to spread on the offset press. Masking—even relatively complex techniques like the in-camera masking often used in studio work—is something most photographers have to work with. Explain how digital cameras and software used to manipulate images do these things in the same terms used by photographers, and the explanations will go a great deal more smoothly. Yet most digital photography books concentrate more on bits and bytes than on ring-arounds and reticulation. I've long wanted to do a book that would turn this perspective upside down.

There is still plenty of computer technology discussed in this book. You can't work with digital images without absorbing quite a bit of technical background, and you probably need to know at least some of it before you read this, but everything discussed here will be written from the viewpoint of a photographer expecting to use digital imaging.

WHY ME?

I've been involved with computers for almost 20 years and with photography for even longer. In 1977, my first PC was furnished with a generous 48 kilobytes of RAM, a 64-character-wide screen, and no graphics. Since then, I've worked with nearly every personal computer on the market, from the initial IBM PCs and Macs to the latest power-packed systems. I've also made my living with these boxes as a contributing editor for eight different computer magazines and as columnist, writer, or reviewer for publications like *MacWorld* and *Windows Magazine*. Two of my 50 books have received top honors in the Computer Press Awards.

My original training and experience were heavily steeped in photography. I've operated a commercial photographic studio, worked as a photojournalist, served as photoposing instructor for a Barbizon-affiliated modeling agency, and written hundreds of articles for the major professional photo publications.

I undertook to write this book because I understand the technology, know photography, and have access to working digital photographers who can provide tips and examples even more thrilling and inspiring than those I might cook up on my own. During my research for this book, I spent time visiting with experts at Kodak in Rochester and speaking with photographers in the field.

DO YOU REALLY NEED TO KNOW ALL THIS STUFF?

I once attended a Nikon seminar at which two people rose from their seats during an intermission following the introductory session and walked purposefully to the speaker's lectern. Both wanted their money back. In an apologetic tone, the first explained that he had misunderstood the scope of the seminar when he signed up. It was clear from the introduction that he already understood quite thoroughly everything that was going to be covered. He felt that his time would be better spent elsewhere, and he politely asked for a refund.

The second man was abashed when he heard the first's request, but proceeded gamely anyway. "I didn't understand a word you said," he admitted. "I can see I'm not going to get anything from this seminar until I've done a little homework." He got his money back as well.

Books are not like seminars. You don't have to sit through explanations you don't need. Chapter titles and subheads help you skim through familiar material to find information that is of use to you. I've had very few readers complain about extraneous detail as long as there was enough solid, clearly presented information to satisfy them. In contrast, I have received letters from readers who enjoyed learning things they couldn't find elsewhere. After you finish reading this book, you may feel that you don't need to know everything that appears between these covers, but I think you'll find the journey was an interesting one.

CHAPTER 1

A NEW WORLD OF DIGITAL PHOTOGRAPHY

Humans instinctively rely on images to communicate. Our roadsides and towns are dotted with universally understood picture-symbols. Mathematicians, physicians and others who work almost entirely with numbers, nevertheless use visually-oriented terms such as *strings* and *black holes* to describe their discoveries.

Despite the importance of visual information and the multitude of technological advances in communications, technology was actually an inhibitor of graphic information for more than 500 years. Before the invention of movable type, pictures and text were equally easy (or equally difficult) to create, since both had to be created by hand. Whether a book was handwritten by its author, copied by a scribe, or engraved into a printing plate by an artisan, graphics and text were seamlessly blended in illuminated manuscripts, sketches, notebooks, and other forms of written communication. Graphics may even have been more efficient than words, since a skillfully drawn sketch might express an idea more quickly and clearly than an hour's worth of calligraphy.

While handwritten and hand-engraved texts encouraged visual information, only a few people had access to the knowledge these rare and expensive books contained. The invention of movable type made it possible to use the same characters repeatedly, so that large volumes could be typeset and mass-produced for distribution to a growing middle class, which became more literate as more books were produced. In contrast to type, this new ease of producing text made graphics more troublesome. Drawings still had to be created as laboriously carved woodcuts and, eventually, steel engravings.

Ironically, the printing press produced a powerful bias in favor of the printed word over the printed illustration. Newspapers, which could have benefited enormously from images, were almost 100% text, even after the invention of photography in 1839 (see Figure 1.1). Daily deadline pressures made it impractical to include anything but pre-existing artwork. Consequently, newspaper advertisements in the 1860s were better illustrated than news accounts of the Civil War because the illustrations could easily be prepared in advance.

FIGURE 1.1

Early newspapers were nearly devoid of news images, even after the invention of photography. Courtesy of the Bettmann Archive.

It wasn't until the early- to mid-20th century that technology reached the point where text and graphics could be freely intermingled. Photographic halftones, wirephotos, and the widespread replacement of the letterpress with the offset press in the 1960s restored images to their rightful importance in printed communications. Despite the revival of graphic images in print communications, color images didn't become common in daily newspapers until the 1980s, after newspapers like *The Boston Globe* and *USA Today* demonstrated how editorial color could increase circulation and attract advertisers.

As luck would have it, by the time images had regained importance, technology struck another blow. Computers became the most efficient way of collecting and distributing information—as long as the information was text. When the computer age started, around 1950,

graphical information was again forced to take a back seat, because computers didn't do a very good job of displaying or handling graphic information. Only in the last decade have computers powerful enough to work with images become widely available.

What is Digital Photography?

Digital photography is nothing more than the capturing and manipulation of images in a format that can be manipulated by binary computers. In many cases, a digital image will originate in an electronic camera and be transferred directly to a computer without the use of film. In other cases, a film image may be digitized with a scanner and then manipulated by a computer.

Beginning data processing books used to explain how computers work with binary numbers (1s and 0s). Today, few computer users, and even fewer photographers, need to understand binary systems. All you really need to know is that digital images consist of discrete "chunks" of picture information, all the same size and all containing whole number values within a particular range. An 8" x 10" black-and-white print that has been "digitized" is broken up into hundreds of thousands or even millions of regularly shaped picture elements, or *pixels*, each of which is assigned a value based on its relative brightness. Figure 1.2 shows one way to visualize this concept.

FIGURE 1.2

A photograph divided into pixels.

Typically, a grayscale pixel will be represented by a value between 0 (totally black) and 255 (totally white), as if the computer had to choose from a gray step wedge with 256 different gray tones on it. Because the values are digital and not analog, a particular pixel can be represented by a value of 128 or 129, but not 128.45. With only 256 tones available, some shades must be represented by tones that are close, but not exactly equivalent, to the actual value.

A conventional black-and-white photograph, by contrast, may contain thousands of different grayscale values. Although the images are actually composed of tiny clumps of black silver, these clumps are so small and varied in size that to the eye, a black-and-white photograph looks as if it contains a smooth continuum of black-gray-white, limited only by the whiteness of the paper and the pure blackness of fully exposed, fully developed dark areas.

Digital and conventional color images contain the same sort of density information, applied, instead, to the three primary colors of light. It's important to understand the "digital" nature of digital images, because photographers need to understand the limitations on resolution—the ability to capture tonal values—and output that are imposed by the computer.

These limitations are not as obvious in the world of conventional photography. A $250 point-and-shoot camera equipped with a good-quality lens has the potential to produce an image that is every bit as sharp and has the same tonal range as a $3,000 professional camera loaded with the same type of film. The more expensive camera may be used to produce better pictures because it has more advanced features for difficult shooting situations and is usually used by a more sophisticated photographer, but it has been proven time and time again that good photographers transcend their equipment. Pinhole camera projects, for example, are a time-honored way for college photojournalism students to prove their mettle, and recently David Meunch put together a series of stunning landscape photos taken with 35mm equipment instead of his trademark large-format gear.

Some years ago, I wrote an article for Petersen's *PhotoGraphic* in which I used a 110 pocket camera to produce portraits, sports action photos, and even architectural shots that were, by the time they went through the photomechanical reproduction process, virtually indistinguishable from control pictures I generated with more expensive cameras, 6 x 7 and larger. Of course, for my project, I intentionally selected situations that didn't call for faster shutter speeds, variable focus, sophisticated flash synch, or fine-grained films.

Digital technology imposes much more rigid restrictions on photography. If you purchase a low-end digital camera with a maximum of 640 x 480-pixel resolution, there's no way to upgrade by switching to a finer-grained film. If the computer system you use to manipulate digital images can only display 256 different colors, you'd better stick to grayscale images.

While digital photography does impose restrictions, it also frees us to do things with images that could only be accomplished by tedious work and experimentation using conventional tools. Most photographers have combined images with double exposures, sandwiched two slides together, cross-processed chromes in color-negative developing solutions, or pushed super-fast films to ridiculous exposure indexes to achieve a particular effect.

Where these techniques usually involve more error than trial when working with conventional films, the computer provides the freedom to tweak, re-tweak, and start over if the final results don't please us. Indeed, there is a wide array of tricks that could not be performed before the introduction of digital imaging.

Individual image components can be isolated, combined with other components, reversed, rebalanced, or removed entirely without a trace of what has been done. We can relocate the Great Pyramid of Egypt or show Elvis shaking hands with aliens from space. Figure 1.3 shows an example of a digitally manipulated image.

FIGURE 1.3

A digitally manipulated image can include objects that were not in the original scene.

More than anything else, digital photography is fun. Even though most photographers are capable of doing good work with simple equipment, they don't hesitate to take advantage of all the tools that are available, so it was only a matter of time before digital imaging seduced photographers who previously had no intention of using computers for their own sake. As cameras became more electronic and computerized, it was a logical next step to incorporate scanned images, electronic retouching, and eventually digitally originated images into the average photographer's repertoire.

Digital photography was actually developed when professionals in the imaging and graphics arts fields discovered that the power of the computer could effectively be applied to the use and manipulation of images. As far back as 1937, computer-like scanning techniques were used to extract color information from photographs to produce separations. In prepress operations, it was a relatively effortless (albeit expensive) step to move from scanners with conventional light sources and analog output to laser scanners that produced a digital signal before writing the color separations onto film. As you'll learn in the following chapters, once an image has been converted to digital format, a new world of manipulation, correction, and other options becomes available.

THANK THE DWEEBS AND SPOOKS

Digital imaging didn't really begin to burgeon until the U.S. space program and military got into the act. You can thank the big budgets of NASA and the Department of Defense for a lot more than just Teflon and velcro.

Much of the scientific information we have about our planet and other bodies in space comes from remote sensing platforms—a fancy name for cameras mounted on balloons, in airplanes, and, after 1957, on Earth satellites and spacecraft. Aerial images captured on black-and-white, color, or infrared film from balloons or airplanes can be returned to Earth and processed. The information the film contains can often be verified by "ground truth studies," if necessary.

That's not true of images of distant planets produced by unmanned spacecraft that never return to earth or fall into the atmosphere to burn up when their useful lives are over. Instead, images from these platforms are transmitted back as radio signals, which scientists and military personnel reconstruct into an approximation of the original image. Ordinary video equipment produces analog signals, which are subject to interference, degradation, and misinterpretation. Digital images, in contrast, can remain perfect even when transmitted over millions of miles. Figure 1.4 shows a digital image from a space platform.

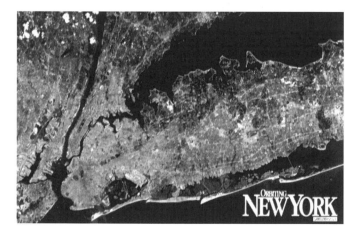

FIGURE 1.4
Digital imagery from space. Courtesy of Satellite Snaps Inc.

Digital information is more reliable because it is nothing more than a series of numbers. It's relatively simple to add a few digits to each number string as a *parity check*—a value that can be used to check the validity of the preceding set of numbers. A check digit might indicate whether the total of all the digits in the previous string was odd or even, for example. More sophisticated error detection and correction routines can include information that not only locates incorrect digits, but can reconstruct missing numbers.

The check digit process is similar to how photographers, in the days before digital darkroom thermometers, would keep two or more dial-type process thermometers and check them against each other. If the thermometers produced different readings, the photographer found out which one

was wrong instead of averaging the two readings, because color film processes were that critical. Similarly, digital error detection and correction provide the sort of cross-checks that give confidence to scientists (who want their images to be faultless for research reasons) and military intelligence specialists (who need accuracy for other purposes).

Once money was spent developing early digital imaging systems and the software used by installations like the Jet Propulsion Lab in Pasadena, California, the technology began to filter down to slightly less costly applications where the stakes were still very high. Soon, we had $100,000 systems that could be used for cartography (producing less costly, but highly accurate maps), oil exploration, color separation, and, eventually, 3-D rendering and animation systems. These are all very expensive applications in which it is fairly easy to save a million dollars here and there through the efficiency of digital technology.

The good news for photographers, of course, is that once economies of scale and a few technology breakthroughs come into play, $100,000 systems quickly become $10,000 or even $1,000 tools.

Although a few halting steps into lower-cost electronic imaging systems, like Sony's 1981 Mavica camera, were made, it wasn't until the first color Macintosh was introduced in 1987 that systems similar to those used today became practical. Between 1987 and 1990, photographers watched as the costs of desktop flatbed and slide scanners plummeted to less than $5,000; reasonably priced 24-bit color video boards became available; programs like Digital Darkroom and Adobe Photoshop provided image editing capabilities; and early continuous-tone color printers, although limited to snap-shot-size output and analog video input, could be connected to computers to at least preview digital files.

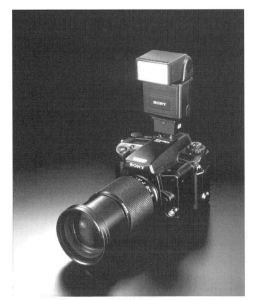

FIGURE 1.5

The original Sony Mavica, and models that followed it, like Sony's Mavica MVC-7000 (shown here) were among the very first electronic cameras on the market.

In the 1990s, digital photography has finally become practical for a broad range of professional applications. Sensors have grown from the megapixel range (1.4 million individual picture elements) to 6 million or more, with resolution rivaling that of 35mm film. Kodak, Canon, Nikon, and Fuji have worked together in various combinations to give us digital cameras with truly professional features. Storage systems have been developed that can handle the huge volumes of information that digital photography generates. We now have color management systems that help us calibrate and produce accurate repeatable color. Color output systems allow previewing, proofing, and generating hard copies of digital images for a variety of uses. Although you can expect even more improvements in the future, most of the pieces of the digital technology puzzle are already in place and in workable form.

Cameras priced at $5,000 to $30,000 and computer systems to work with the images they produce can be justified in a growing number of fields. Photojournalists can capture late-breaking news pictures, preview them on their laptops, and transmit images back to a picture editor from anywhere on the globe. Catalog photographers, medical illustrators, desktop publishers and others all find that digital photography provides significant advantages.

The Next Step

We'll look at more of the pros and cons of digital photography in Chapter 2. You'll learn why, if digital photography is so great, all photographers haven't switched to it. We'll discuss whether film is dead, what some of the important limitations are, and how these limitations can be bypassed.

CHAPTER 2

DIGITAL PROS AND CONS FOR PROFESSIONALS

Technology for its own sake can be justified only in the amateur or home environment, where talking cameras or computer pointing devices shaped like an airline pilot's control yoke add some fun to photography or computer hobbies. While no one would suggest that professional activities can't or shouldn't be enjoyable, the ever-present bottom line must be considered when choosing tools, as should artistic and ease-of-use concerns. Photographers looking to expand into the digital photography arena can't justify a $10,000 electronic camera simply because it's a cool tool, or even because it allows them to do some important things that aren't possible with conventional equipment. An important question must always be, "Will there be enough work to pay for this thing?" After all, you're shooting pictures to make a living, not feed an equipment habit.

Cost justification provides at least part of the answer to the question of why everyone hasn't switched to digital cameras. Even though digital cameras eliminate the need for film and film processing, expensive processing equipment, and, in some specific applications, the cost of conventional color separation, it can take a long, long time for a $30,000 camera to pay for itself. There are, of course, other considerations—digital cameras can't yet do everything that film cameras can do—and this chapter will look at some of those factors.

Cost

Low-end digital cameras are in the same price range as top-quality lenses or camera bodies—$800 to $3,000. Professionals who have specific applications suitable for these low-resolution devices won't have much trouble with cost justification. It can take only a few jobs to pay for

an inexpensive digital camera—not from the savings in film or processing but from client fees. If this is not the case, you may need to look at your overall pricing structure. Whether you use a day rate or some other fee arrangement, there should be enough left over after your overhead is paid to cover a cost like this fairly quickly.

A low-end camera usually won't require a heavy investment in ancillary equipment. Your current PC and software should handle the 900K image files with ease, a variety of printing options that will cost less than $1,000 can output acceptable rough proof images, and service bureaus can convert the manipulated images to prints or slides if that's what you need. Cost will not be a barrier to adding low-resolution digital capabilities to your repertoire.

The same is not true when it comes to true professional-level digital cameras. At the time of this writing, any digital camera with interchangeable lenses and other professional features will cost from $10,000 to $16,000, with the exception of a few $3,000 models intended for copystand or remote photography applications. At least one deluxe model, the Kodak DCS-460, is priced at $28,000. Digital camera backs for use with your existing view camera or rollfilm model are $16,000 to $30,000 and up. These prices will come down drastically as digital photographic technology matures. Within a year or two, we may see digital camera backs for $5,000, putting them well within the range of top-quality professional equipment. A Leica M6 or Nikon F4E body in the $2,000 price range or a Hasselblad 903 SWC for $3,500 may be expensive works of art, but a digital camera for the same money would seem like a bargain.

Unless fast turnaround is an overriding consideration, as it may be in photojournalism applications, you'll want to look long and hard at the cost advantages of digital photography before taking the plunge.

One factor that contributes to digital cameras saving money is that they don't require film. Whether you're paying $5 or $10 for a roll of film, or a dollar a sheet, one thing won't go away. Every time you take a new exposure, you need a new frame or piece of film. Silver recovery aside, film just can't be reused. Good exposures, bad exposures, outtakes, excess dupe frames—all of these use up one piece of film, forever. The amount of wasted film varies by the photographer and the application. At one end are studio photographers, who may be carefully composing a photo based on a layout submitted by an art director. An overlay on the groundglass may ensure that every component is exactly where it needs to be. Lighting can be examined visually, then fine-tuned using test Polaroids. The exact number of sheets of expensive film exposed can be relatively small.

At the other end of the scale are photojournalists, fashion photographers, and others who shoot in a candid mode or with rapidly changing poses and movements. These shooters created the original demand for motor drive cameras, and they may go through dozens of rolls of film in a short period of time. Amateurs may think that professionals use their machine-gun style to grab everything and anything in the hope that one frame will be good, but, in truth, we know that film-burning is sometimes necessary to provide the number of optional images and variations needed to get a perfect shot to suit the application. (A professional may shoot hundreds

of images that are all better than an amateur's best shots in the same time that a tyro may take to shoot dozens of photos that produce only one good picture.)

Digital cameras can provide the same freedom of taking many pictures from slightly different angles, at different bracketed exposures, or at different moments. You can, in fact, get many more than 36 exposures on one digital "roll" without the need for a large bulk film back like school photographers use. If a removable hard disk fills, slip it out and insert a new one. It takes only a second or two, and you can keep a couple of them in your shirt or vest pocket. You also don't have to open the camera back. Instead of rotating cameras while an assistant reloads, you can keep shooting with the same box as long as your PC card disks hold out.

PC card disks, such as the one shown in Figure 2.1, may cost $400 or more, but they can be reused hundreds of times. In effect, you can shoot tens of thousands of pictures for the cost of the media. A few thousand dollars' worth of PC card disks can replace untold rolls of film—that's a definite cost saving. Even adding in the cost of permanent storage for the images you choose to keep forever, those who shoot a lot of film—particularly newspapers and news magazines—can make up the cost of a digital camera in a year or less.

FIGURE 2.1

PC card storage device.

Digital cameras can save you money in other ways as well. With a studio digital camera connected to a monitor for previewing, it may be possible to eliminate Polaroid lighting checks, at a dollar or more per shot. After 20,000 shots (less than a year's worth of studio work), you've paid for a digital camera in instant film costs alone. As a bonus, if a digital photo—even a preliminary image—happens to be exactly right, the shoot is over. At some time in their careers, most photographers have had the experience of spending hours futilely trying to duplicate the look of a Polaroid image that the client is especially fond of. Unlike instant photos, which are for previews only, a digital test shot can be used if it's what you were looking for.

In some applications, digital cameras can pay for themselves in the form of reduced color separation costs. Specifically, catalogs that feature small items, notions, gadgets, and similar objects often have hundreds of individual color shots reproduced in a small size. Some companies have moved from conventional studio photography and color separation to a high-volume setup in which the photographer becomes image grabber, color separator, and desktop publisher all in one. The same person who sets up and shoots a product with a digital camera may preview and approve the image, import it into a page layout program, and produce color separations. For this relatively noncritical work, there's no art director, no client approval process, no film stripping, and no separate color separation, saving as much as $300 per image. A single catalog may produce savings that could pay for three digital cameras or camera backs.

Digital cameras also provide similar savings in more sophisticated catalog work, as demonstrated by the popularity of scan-back cameras for 4" x 5" view cameras, even though they may take several minutes to produce an exposure. In fixed, controllable situations with still-life subjects, these cameras—with resolutions up to 7000x5000 pixels, do very well and lead to enough savings in film, processing, and other costs to pay for themselves. One observer I respect noted that "nobody in their right mind is doing any kind of catalog work any other way at this point." Catalogs are one application that leverage all the advantages of digital photography, and this type of imaging is the bellwether application that is driving all aspects of the expansion of digital photography.

Don't forget the savings digital cameras can produce in personnel costs, if fewer people can handle the same job, or in transportation costs for the film. Instead of putting rolls of film in a courier bag and transporting them across the country to meet a deadline, news organizations can transmit pictures themselves over telephone lines at much lower cost. Low-resolution versions or thumbnails can be sent ahead, and only the selected high-resolution pictures need to be transmitted after the picture editor has narrowed down the choices.

Digital cameras don't require film processors, chemicals, or darkrooms. If your studio already has no need for these machines, you won't need to invest in them to go digital. If you already have processing gear, you'll find it used less and less as more of your shooting is done in the digital domain.

As you can see, there are many factors that go into cost-justifying digital cameras. If you're contemplating spending $10,000 to $30,000 or more, you'll want to think about them carefully.

Other Pros and Cons

Once you have cost out of the way, there are additional pros and cons to consider. Digital cameras still can't do everything that film cameras can do, but the reverse is also true. This section will look at some of the other factors.

STORAGE CAPACITY

Film has virtually unlimited storage capacity. You can always crack open another brick of film, and if you run out unexpectedly, professional film stocks or acceptable substitute amateur films are available virtually everywhere. Only photographers using sheet film cameras or, possibly, rollfilm models, will experience supply problems in remote locations.

Digital cameras, on the other hand, have fixed capacities in the field. You're limited to the storage of the media you happen to have brought with you. If you have a dozen PC card hard disks and they all are filled, you'd better have a portable computer with an alternate storage device, such as a tape drive, to offload images. It may be impractical—or very expensive—to purchase additional digital "film" when you need it most.

SHOOTING FLEXIBILITY

Film cameras offer the ultimate in shooting flexibility. You can equip them with films with speeds from ISO 25 to 6400 and super-wide to super-telephoto lenses. You can expose film at shutter speeds from 1/4000th of a second down to time exposures of a few minutes or longer or use a speedy motor drive to burn up a whole roll of film in seconds. Databacks that record date, time, or other information are available, along with dozens of other accessories.

Digital cameras, on the other hand, may offer a limited range of equivalent film speeds, magnify your image so that wide-angle photography becomes less wide, and limit the available shutter speeds that you can use with their less-sensitive ISO ratings. The need to save images to disk limits the number of "motor drive" shots you can fire at one clip, and unless your digital camera has a built-in data capability, forget about recording information on the image frame until after you've imported it into a computer.

Because professional-quality digital cameras are mated with the same camera bodies used with film, you'll find they have most of the shooting flexibility of regular cameras, but with the limitations I've outlined above.

IMAGE QUALITY

Outside the studio, only the Kodak DCS-460 offers image quality comparable to ISO 100 film. If you need 11" x 14" or larger prints and want to shoot out in the field, stick to conventional film cameras. Moreover, only with film is it possible to get the fine grain and even longer tonal range available with slower ISO 25–50 films like Kodachrome. Digital cameras just can't rival the very best films for quality, nor can they match them for speed, if you're planning on doing sports work at ISO 6400 ratings.

In the end, if the final destination for an image is the printed page, scanning is a great equalizer. When working with film that must be scanned, there will always be at least some quality loss, no matter how good the scanner operator is or how optimized the scanning process. Digital photographs taken at resolutions close to those required for printing, however, may actually produce quality better than you can get from film.

Applications for Digital Cameras

Unless you're reading this book just to spark ideas, you probably have a few applications for digital cameras in mind already. There may, however, be some closely related uses for digital photography that might apply to your work that you might not have thought of yet. This next section will list some of those uses.

APPLICATIONS FOR HIGH-END CAMERAS

Because they have more features, better resolution, and the greater flexibility that derives from the professional-style camera bodies they're built around, high-end digital cameras are suitable for many more applications than standard cameras, including:

- ❑ **Desktop publishing**. Photographers can use high-end digital cameras, which have good enough high-resolution and dynamic range to more rapidly produce free-standing product inserts and internal newsletters. Images from $10,000 digital cameras can usually be reproduced at sizes up to 5" x 7" with screen rulings of 150 lines per inch.

- ❑ **Catalogs**. Digital photography has revolutionized catalog production. It has blown conventional methods out of the water, and it's hard to find a studio that isn't at least considering switching to digital image capture for its work.

- ❑ **Monitoring**. Every digital camera from $3,000 and up can be controlled remotely in one way or another. This makes them a good choice for industrial remote monitoring applications, or, if properly shielded, for dangerous picture-taking situations. Digital cameras can even be used in situations where it's difficult or inconvenient to send a photographer, such as up in the air in a small tethered balloon or strapped to the rafters at a sports event or convention.

- ❑ **Portrait applications**. The features of some digital cameras, combined with the ability of the digital back to capture images very rapidly, make them a good choice for wedding and event photography, school portraits, and ID applications. Figure 2.2 shows a typical digital portrait.

FIGURE 2.2
A digital portrait.

- **Medical and scientific applications**. A high-resolution digital camera can replace video or instant photography as a means of providing real-time display of medical and scientific images. The fact that images are captured directly to a digital format allows scientists and lab technicians to begin computer-based analyses more quickly, without waiting for film processing and scanning. Typical applications include use in ophthalmology, dermatology, geology, and botany.

- **Law enforcement and military applications**. This includes surveillance, crime scene documentation, forensics, and mug shots—all of which are facilitated by the typical digital camera's rapid burst rate and expanded dynamic range.

- **Industrial, manufacturing, and general business applications**. Photographers can use a digital camera to produce user and service manuals, parts catalogs, and design documentation. These cameras can also be used for parts inspection and documentation, technical bulletins, and copystand archiving.

APPLICATIONS FOR LOW-END CAMERAS

Inexpensive digital and electronic cameras are likely to be used in professional applications such as the following:

- Quick image capture by professionals in nonphotographic fields who use images in their work, such as realtors who want to grab shots for uploading to on-line listing services. These so-called *applied imaging applications* range from visual inventory (e.g., at an antiques

shop) to picture catalogs. Even the smallest dealer in collectibles can capture images of current stock, print multiple copies, and distribute them to a mailing list. A typical application is shown in Figure 2.3.

FIGURE 2.3
Realtors can capture images quickly and easily with a low-cost digital camera.

❑ A surprising number of publications—particularly in-house magazines or corporate newsletters—often use these cameras for a quick head-shot to fill a column inch or two. In truth, though, for images that will be reproduced at a small size—such as 2" x 2"— virtually any subject matter is fair game for a low-end digital camera.

❑ When the final destination for an image is a desktop presentation that will be displayed on a monitor or enlarged with a video projector, the relatively low resolution of low-end cameras is more than sufficient. Since these devices are often furnished with a closeup or macro lens, they can do double-duty on a copystand, as shown in Figure 2.4.

FIGURE 2.4
Digital cameras can be used on a copy-stand to produce closeup pictures.

❑ Professionals looking for an easy way to scout shooting sites can tote one of these cameras around and snap quick pictures with point-and-shoot ease, then review low-cost (no-cost, if previewed on a display screen) previews before venturing back for an actual shoot.

❑ A digital camera may help an art director communicate with a photographer more easily. Assume that a creative director wants to dream up a dynamite shot of an automobile for an ad campaign. A quick way to do this would be to take a low-cost digital camera out and photograph the vehicle from every conceivable angle—perhaps several hundred shots. All those images can be reviewed on a computer, at negligible cost (this method may even save money since it can reduce the amount of creative time the art director has to spend visualizing the image). The selected shots can then be given to the photographer for guidance. The digital photos certainly beat a sketch that may not even be possible to duplicate, and they are much better than wasting a day's shooting because the photographer and art director weren't on the same wavelength.

❑ If a studio is equipped with a computer, a low-end electronic camera could conceivably replace Polaroids for previewing setups and lighting effects in real time. Several low-cost cameras can download directly to a computer or be triggered from the keyboard.

❑ Those tiny pictures on ID cards and badges or those stored in on-line databases for rapid retrieval at guard stations don't have to be of a very high resolution—but inexpensive cameras are good for such applications. Low-end digital cameras fit in well in this market, although specialized ID cameras are usually used where the volume is high enough to justify it. A company with 50 to 500 employees might want to use a digital camera, but organizations with thousands of workers are better off with an ID camera or using an outside firm that uses one.

The Next Step

This chapter has looked at some of the pros and cons of digital photography. You can use this information to see how these cameras may or may not fit in with your own work. In Chapter 3, we'll take a closer look at the technology behind the equipment, before moving on to a closer look at specific low-end and high-end cameras in Chapters 4 and 5.

CHAPTER 3

THE TECHNOLOGY OF DIGITAL PHOTOGRAPHY

This chapter will serve as an introduction to the technology behind digital cameras, scanners, and other capture devices. You'll learn what you need to know to understand the capabilities of digital devices and enough about their limitations to minimize the effect of those limits on your work. This chapter is an overview; individual types of digital cameras, scanners, and other devices will be covered in subsequent chapters.

Digital cameras and scanners have a lot in common. Both devices are equipped with a sensor that detects the amount of light reflected or transmitted by the subject. As you probably know, black objects absorb virtually all the colors of light that strike them and white objects equally reflect those same colors. The more light an object absorbs, the blacker it appears to our eyes. The more light that is reflected by an object, the whiter it appears.

In the real world, nothing this side of a black hole absorbs all the light that strikes it, and even mirrors don't reflect 100% of the light they receive. Things that look gray to us are somewhere in between: some of the light is absorbed, and some is reflected. If an object happens to absorb more of one of the three primary colors of light than the others, it will seem to have a hue. Any photographer who has worked with filters is familiar with these concepts.

How Digital Cameras and Scanners Work

Digital cameras and scanners, like our eyes, take advantage of the different ways in which objects reflect light. If the light received by the sensor does not exceed a predetermined threshold, that

picture element is recorded as dead black. Values higher than the threshold are either assigned a number representing white or, in the case of grayscale scanners, a number corresponding to some shade of gray. The digital nature of such images (e.g., values of 0 to 255 for grayscale images) were explained in Chapter 1.

Some devices allow the threshold to be adjusted either up or down. Making adjustments to a scanner can control whether artifacts like dirt or even the texture of the paper itself will be ignored or recorded as image information. Scanner software designed for grayscale imaging can also allow alteration of the values assigned to specific light levels, thus adjusting what is called the *gray map*. Color devices operate in exactly the same way, except that separate lightness and darkness values are recorded for each of the three primary colors.

SCANNING VERSUS FULL-FRAME IMAGING

One key difference between digital cameras and scanners is the way they capture images. Still cameras grab the entire image in a frame in one instant, while scanners gradually record an image until the entire image has been captured.

Scanning is any technique for surveying a surface, often by sweeping the scanning mechanism across the surface area. A light source of some sort illuminates the artwork, which can be opaque (reflective) artwork such as a photograph or magazine article clipping, or translucent—like a transparency. The amount of light reflected or transmitted by the artwork is detected by a sensor. The sensor can be a moving spot that travels pixel by pixel, line by line, over the entire area; a linear array that can read an entire line across the width of the artwork; or an area array that captures the full image at once. A linear array is shown in Figure 3.1.

FIGURE 3.1

This Kodak sensor is an example of a linear array.

High-end drum scanners ($20,000 to $200,000) use photomultiplier tubes as sensors. These scanners have very high sensitivity and ignore much of the noise that can degrade an image. With these devices, a flying spot of white light moves its field of view across the surface of the artwork, which is mounted on a rapidly rotating drum in much the same way the needle of an antique phonograph scans an Edison cylinder (see Figure 3.2). The reflected or transmitted illumination is focused on a series of dichroic mirrors, each of which reflects to one of a set of photomultiplier tubes designed to register red, green, and blue light. A fourth sensor in the set is used for a sharpening technique called *unsharp masking*. With this kind of scanner, all the information for a full-color image can be captured in a single pixel-by-pixel pass.

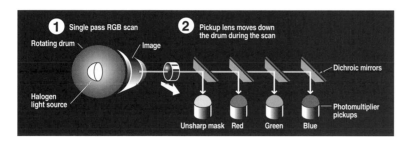

FIGURE 3.2

Drum scanners capture an entire image in one pass. Courtesy of Hewlett Packard.

Scanners built for the desktop market generally use *charge-coupled devices* (CCDs) to capture images. These silicon semiconductors, produced using technology similar to that which generates microprocessors and memory chips, have the advantage of being extremely efficient light gatherers. Some CCDs are capable of capturing at least 60% of light in the visible spectrum. They also have a wide dynamic range and are capable of recording faint signals without overloading on strong signals within the same image.

A linear array like that found in flatbed scanners consists of a strip of tiny CCDs. The area arrays used in digital cameras are square wafers with rows and columns of CCD sensors, as shown in Figure 3.3.

FIGURE 3.3

This Kodak area sensor has more than 6 million individual pixels.

Every silicon chip in a CCD has been treated with chemicals that make it sensitive to light. As photons strike the silicon surface of individual sensors, electrons are freed from the silicon atoms. The negatively charged electrons jump to positively charged regions on the sensor called *photosites*. Their presence is detected by a proportional increase in the electrical conductivity of the sensor. The increases and decreases as the scan progresses are amplified, converted to a digital value, and used to measure the lightness or darkness of a particular pixel.

Designers of CCDs must reconcile two simple physics principles. When each individual sensor is smaller, more of them can be packed into each linear inch, providing higher resolutions (measured in samples per inch but usually called "dots per inch"). However, a certain threshold of energy is required for an electron to break free. Larger sensors have less difficulty gathering enough light for an electron to break free and are therefore more sensitive to light. This means that CCD arrays need elements small enough to provide the resolution desired but large enough to capture sufficient light to register details in dark areas of the original.

It would be desirable to pack 300, 400, or 600 sensors per inch of scanned area to provide high resolutions, but not if it means the scanner or digital camera would require withering amounts of light in order to form an image. Anytime CCD designers find a way to make individual sensors smaller, they must also boost their sensitivity to light to keep pace.

Scanner designers can increase the brightness of the light source, but only within the limits of current technology. Other factors that affect how much light reaches the sensor of a digital camera, including the light-gathering ability of the camera system's lenses, the shutter's selected speed, and the amount of available or artificial light the photographer has to work with, are beyond the control of the sensor designer entirely.

Because there are significant differences in the way scanners and digital cameras capture images, the two will be treated separately in the following sections. If you'd rather not be immersed in so much detail, you'll find brief summaries in Chapters 5 and 6.

Scanners

Scanners consist of several components:

❑ *Artwork holder*—A glass platen, table, or copyboard is used on flatbed scanners to hold reflective art or transparencies. With transparency scanners, some sort of holder or transport mechanism supports the slide. Sheetfed scanners simply move the original past the sensor.

❑ *Scanner carriage*—This contains the moving, or scanning, portion of the device. It includes a light source and an optical system that gathers reflected or transmitted light and directs it to the sensor array.

CHAPTER 3 • The Technology of Digital Photography

❑ *Linear sensor array*—This captures each line across the width, or a shorter dimension, of the area being scanned.

❑ *Image processing circuitry*—A component that contains an analog/digital converter that transforms the continuous-tone light level information into digital bits. Scanner hardware usually also includes enough intelligence to adjust brightness/contrast, scale images, interpolate resolutions, and perform other tasks.

SCANNERS AND RESOLUTION

The actual width of the sensor strip may be less than the widest band it can capture, since a lens/mirror system is used to reflect and focus the light from the subject matter onto the array. Therefore, a scanner with a 400 dpi horizontal resolution over an 8.5" width may be less than 8.5" wide and therefore may actually have more than 400 individual sensors per inch of its length. While these more compact sensors are a challenge for CCD designers, their smaller size is actually an advantage when applying vertical resolution.

Since the same linear sensor is used to scan each line of an image, the vertical resolution is determined by the distance the array is moved between lines. That is, if the carriage is moved 1/400th of an inch between lines, the scanner has a vertical resolution of 400 dpi. Since the sensors in the linear array are smaller than .04" x .04", it may be possible to move the carriage 1/800th of an inch or some smaller increment, providing a higher vertical resolution than horizontal resolution. That's why you'll see scanners with specifications listing 300 x 600 or 400 x 800 optical resolution. In the past, more conservative scanner makers, like Hewlett Packard, did not advertise this capability and used the extra vertical resolution as a cushion to improve precision at announced resolutions.

As the scanner wars heated up, however, and buyers became wary of interpolated resolution, vendors began squeezing all they could out of the true optical capabilities of their machines, and true 400 x 800 dpi scanners became common.

SCALING AND INTERPOLATION

In scanning, *interpolation* is the process of creating estimated values for pixels based on known values acquired during a scan. A scanner may have to do some form of interpolation or scaling every time you request a scan at something other than the scanner's optical resolution and a 100% (1:1) scale.

Interpolation can be used either to reduce the amount of information in a scan or to increase it, converting a 600 x 600 dpi scanner's output to the equivalent of 300 x 300 dpi or estimating the values of in-between pixels to simulate a resolution of 1200 x 1200 dpi.

Interpolating up or down is relatively simple as long as an exact fraction or multiple of a scanner's optical resolution is used. Keep in mind that converting a 600 x 600 dpi scan to 300 x 300

dpi cannot be accomplished by discarding every other pixel. You'd end up with a 300 x 600 dpi image, because the original number of lines of vertical resolution would be preserved. Similarly, simulating a resolution of 1200 x 1200 dpi involves more than just duplicating each pixel.

To reduce resolution, clumps of four pixels are averaged to find the value of one that will replace them. To double resolution, the eight pixels that border a particular pixel are examined to get an accurate image of the four pixels needed to replace it. With even multiples of the original resolution, this is a fairly simple and accurate process. With any other resolution, the scanner also does not just discard or replicate pixels, but instead examines the available pixels and creates new ones based on the information found in the original samples.

Interpolation (or resampling) takes place any time you scan at something other than the resolution the scanner can supply with its array's fixed horizontal array or whatever increments of vertical carriage movement are provided and any time you choose a scale other than 100% (see Figure 3.4).

FIGURE 3.4

Interpolation is a way of simulating higher or lower resolutions by examining the values of surrounding pixels to create new ones.

Scaling is just a way of selecting a resolution that will produce a particular size on a given output device. An image scanned at 150 dpi and printed on a 300 dpi printer without specifying any scaling will appear half its original size. An image scanned at 600 dpi and output to a 300 dpi printer will end up twice its original size, unless you specify a scale. To insulate the user from having to bother with calculations, scanners offer scaling options, usually as slider controls in the scanning software's dialog box.

If a piece of line art measuring 2" x 2" is to be printed at twice its actual size on a 300 dpi laser printer, simply select a resolution of 300 dpi and a scale of 200%. Request a scale of 400%, and the same scanner will scan the image at 600 dpi and interpolate to the equivalent of 1200 dpi.

Scanners usually allow you to choose resolution settings in single dpi increments and specify scales in single percentages, so you can choose 175 dpi or 133% if you need them. The algorithms used to carry out interpolation—either in a scanner's hardware or in a PC's software—can have a dramatic effect on the appearance of a final image. A 600 dpi scanner with a clumsy interpolation scheme can produce worse results than a 400 dpi scanner with more elegant interpolation routines. Scanners may use algorithms like binary rate multiplication, nearest-neighbor interpolation, linear interpolation, or bicubic interpolation to optimize the guesses they make when creating new pixels or choosing which pixels to drop. Inadequate resolution causes images with prominent diagonal lines to have obvious stairstepping, or "jaggies"; good interpolation can disguise these artifacts, while bad interpolation can fail to compensate (see Figure 3.5).

FIGURE 3.5

Lack of sufficient resolution causes diagonal lines to display stairstepping.

SINGLE-PASS OR THREE-PASS?

The linear CCD arrays in scanners are sensitive only to white light. To capture color, the scanner needs three separate images of an original, each capturing the relative amounts of red, green, and blue for every pixel. This can be accomplished in two ways—by filtering the white light reflected or transmitted by the original through red, green, and blue filters or by using red, green, and blue light sources.

Three-pass scanners make three complete passes of the original image, each time using either a different red, green, or blue filter between the artwork and the optical system or three separate red, green, or blue light sources—fluorescent lamps, colored LEDs, cold-cathode tubes, or some other illumination.

Such scanners require a high degree of accuracy in positioning the carriage for the three consecutive scans. The original must also remain rigidly in place to allow the three individual scans to be registered without color fringing. The separate images must be buffered to a hard disk until the scans are completed, at which time they can be combined.

Theoretically, a three-pass scanner should be slower than a scanner that captures all three colors in a single pass. However, some well-designed three-pass units have speeds similar to less-optimized single-pass scanners and may be even faster in grayscale mode, which requires only one pass of the original. Figure 3.6 shows an example of a three-pass scanner.

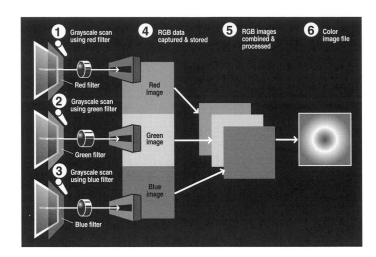

FIGURE 3.6

A three-pass scanner. Courtesy of Hewlett Packard.

One-pass scanners capture all three colored images with a single trip past the original art. The scan can be done using a single CCD array that has three different exposures per line of pixels, each with a different red, green, or blue light source. Alternatively, the scanner can include a trilinear array—most often three duplicate sets of CCDs, each with a colored filter directly on the chip which directs each of three white light exposures per line to a separate set of CCDs.

A third single-pass method uses a white light source and a trilinear array with a prism-like beam-splitter, which separates the full-spectrum white light into its red, green, and blue components. This is a more complex system, but it allows for capturing a color image with a single pass and a single exposure. An efficient beam-splitter is likely to produce better results than trilinear arrays with on-chip filters, and unlike the other systems, there's no need to buffer separate colored images. There are also fewer problems in registering separate images, since all are captured, converted to digital format, and passed along to the computer system simultaneously. This method also lets the scanner perform sharpening and other enhancements in real time.

White light sources—particularly those that duplicate the relative intensities of each color of light found in daylight—may be preferred over tricolor illumination if grayscale mode is used a lot because monochrome scans with a single red, green, or blue lamp will *drop out*, or eliminate any image information that is the same color as the selected lamp while darkening its complement. This can be considered either a bug or a feature, depending on whether you're trying to remove a coffee stain or produce a grayscale scan from a color original.

8 Bits versus 10 or 12 Bits per Channel

Until recently, desktop scanners always captured—at least on paper—8 bits of information per channel. Eight bits allowed 256 different tones for monochrome scans or 256 different colors

for each of the red, green, and blue channels—256 x 256 x 256 or 16.7 million colors overall. Eight bits per channel—24-bit color—should provide plenty of colors, but in practice color scanners always lose a little information because of the inherent noise in any analog electronics system, much like the sound on your car stereo suffers when you roll down the windows.

Noise affects a scan only from the time of capture until it is converted to digital format. Instead of 256 colors per channel, it is possible to end up with only 128 colors per channel as a result of noise. When a system is capable of reproducing 256 different colors, but only 128 are available, it is likely that one of the available colors will have to be substituted for actual colors in an image. This can happen when scanning transparencies, which have a wider dynamic range—detail of all areas from deep shadows to lightest highlights—and may easily contain 256 or more colors in a particular channel. CCD scanners are notorious for coming up with bogus values in shadow areas because of a lack of sensitivity in dark regions.

Desktop scanner vendors have borrowed a trick from designers of high-end drum scanners, and they now offer models with CCDs capable of extended dynamic ranges that require 10 bits or more per channel (30 or 36 bits overall) to capture images. With 1024 colors per channel (nearly 11 billion colors overall) with 30 bit scanners or 4096 hues (6.8 trillion colors overall) with 36-bit scanners, these systems can afford to lose a little information to noise and still have plenty of data to interpolate down to an optimized palette of 16.7 million colors. Even grayscale scans can benefit from the extended dynamic range of such units.

Digital Cameras

Most digital cameras today are simply conventional cameras in which the film transport mechanism has been replaced with a sensor mounted at the film plane. Some low-end models, such as the Logitech FotoMan and others that cost less than $1,000, are modeled after similarly priced point-and-shoot cameras. Professional-level digital 35mm-format cameras are the same Nikon and Canon models commonly used today, but they are equipped with a special back that includes the sensor and components needed to store images and export them to an external storage system or computer.

Digital camera technology is similar to that found in scanners, but there are some key differences. Nearly all digital cameras use a sensor array, rather than a linear sensor, to capture images. That is, instead of a single strip of CCDs, cameras will have a matrix consisting of rows and columns of individual sensors so that an image can be captured over the whole area being viewed simultaneously, rather than line by line.

Digital cameras generally offer a fixed resolution corresponding to the number of pixels in the array, although some consumer-oriented versions may offer the choice between low-resolution 640 x 480 and very-low-resolution 320 x 240 pictures as a way to increase the capacity of the built-in storage.

Professional-level cameras start at resolutions roughly 1500 x 1000 pixels. That's about 1.5 million pixels—three to five times as much resolution as low-end consumer-oriented cameras, which may have 280,000 to 410,000 pixels.

A typical camera in the professional range is Kodak's DCS-420. This camera offers 1525 (horizontal) x 1012 (vertical) pixels scanning 36 bits of information (12 bits per channel) with a sensor measuring about 13.8mm x 9.2mm. That's not large enough to cover an entire 35mm image frame, so these cameras provide a viewfinder mask within the full frame view that shows the area that will actually be captured. Figure 3.7 shows the typical image area you might expect.

FIGURE 3.7
Masked image area of a digital camera.

Since the view through the finder is not magnified to compensate for the reduced field of view, the photographer is peering at a relatively small image area—perhaps one-sixth or less of the overall finder—rather than the full-frame image. Composing an image may be more difficult for this reason, and if it weren't for the near-universal acceptance of autofocus, focusing would be more difficult as well.

Another effect is that lenses suddenly become longer. With the reduced field of view, a 50mm lens may image roughly the same area as a 135mm telephoto lens. With the Kodak DCS-420, a 50mm lens has the same field of view as the 130mm zoom setting on a conventional camera. To compensate, a 20 to 24mm wide-angle lens is needed to approximate a normal lens's view, and ultra-wide effects are entirely out of the question.

These adjustments are great for sports photographers because it's easier to follow the motions of fast-moving subjects outside the framing area, then snap a shot just as they are tightly composed. A 200mm F2.8 Canon telephoto lens is also immediately transformed into the

equivalent of a 560mm F2.8 optic that is either longer or faster than its 400mm f2.8 or 600 mm F4 stablemates.

Full-Frame Cameras

A full-frame field of view calls for a sensor with approximately 3000 (horizontal) x 2000 (vertical) pixels, a total of about 6 million pixels. At that resolution, a digital camera can image with about the same amount of detail as an ISO 100 35mm color negative film. (In fact, the electronic sensors in the Kodak cameras are also "rated" at ISO 100 to 400.) Conventional films have higher theoretical resolution (and fine-grained films like Kodachrome do even better), but when comparing a digital camera with the typical ISO 100 film, you can expect about the same visually relevant photosensitive data.

Scientists reached this conclusion by finding a point at which, visually, there is very little difference from what you see at a particular resolution than that available at a much higher resolution. That is, if a 200 dpi digital camera image is interpolated to 800 dpi and then compared with a conventional image scanned at that resolution, there is very little, if any, difference between the two. As Mr. Spock once remarked, "A difference that makes no difference is no difference."

How Digital Cameras Image Color

Like the CCDs found in scanners, the imager arrays in digital cameras only capture information in monochrome. To create a color image, it's necessary to capture separate images viewed through red, green, and blue filters. Digital cameras accomplish this in several ways.

Some models, such as the Kodak DCS-465, use a color filter wheel, which rotates between three consecutive exposures. The images are stored separately and combined when they are imported into the PC. This system is suitable only for studio work, in which the camera is mounted rigidly on a tripod and the subject does not move. While the camera takes about 10 seconds to produce each of the three exposures, the bottleneck in most studios is the time needed to recycle the strobes, which can take two or three times longer. A filter wheel version is also available to fit 120-format cameras such as the Hasselblad and view cameras.

Color filter wheel systems are used because each of the pixels in an array can be used to capture all the information in the frame for the red, green, and blue exposures. This is not the case for systems that grab a full-color image in one brief exposure, which, depending on lighting conditions and the capabilities of the camera body, can range from a second or longer to 1/2000th of a second or less, and of course flash exposures may be even faster.

One way to accomplish an "instantaneous" exposure is to use three separate CCD arrays and then split incoming light with a beam-splitter so that separate red, green, and blue information

is directed to different sensors. This system can be found in production video cameras. Still cameras use another system.

CCD manufacturers coat individual pixels with red, green, and blue filters, arranged in alternating fashion, although a strict red-green-blue pattern may not be used. One row of the array may be red-green-red-green-red-green, and so on, while the next row is green-blue-green-blue-green-blue. This "excess" of green-reading pixels is used to compensate for a CCD's varying sensitivity to different colors of light. The sensor itself is covered with an infrared-filter cover glass which allows only the visible spectrum to pass through. (Special infrared model cameras are also available.)

Since each CCD pixel can read only one color of light, firmware in the camera interpolates using data from the nearest pixels of the other two colors to create the missing information. Using this system, a 3000 x 2000-resolution camera doesn't offer that many actual samples for each color, but the wholesale interpolation produces images that are acceptable.

Image information is fed through a digital signal processor in the camera, then stored initially in the camera's dynamic RAM (DRAM). Some cameras have as much as 8Mb of DRAM, which allows the camera to clip off five-picture bursts as fast as the finger can press the shutter. Images are then transferred to the camera's Type III PC Card hard disk (105Mb to 170Mb or higher). Kodak uses a proprietary RGB format that allows up to 70 of the 4.5Mb images produced by its 1500 x 1000 pixel model on a single 105Mb disk.

Images can be transferred to a PC by either removing the hard disk and plugging it into a PC Card slot in the computer or by adding the camera to a system's SCSI bus using a cable. The files are read from the disk through a Photoshop-compatible *Acquire module*, which shows thumbnails of available images prior to importing them.

The Next Step

Now that the technology behind scanners and digital cameras has been discussed, we'll look at specific camera models on the market as of this writing. I'll start with the low-end, low-cost models—which have some surprising professional applications—and work through the intermediate-priced and expensive, high-resolution models. While you can expect new versions to be introduced during the life of this book, the following three chapters will give you a baseline of information with which to work.

CHAPTER 4

DIGITAL CAMERAS: THE LOW END

There is something about an inexpensive, low-end camera that professional photographers find irresistible. We snap up clunky cameras built from old sets of dies in what used to be East Germany and use them on suicide shoots involving inclement weather, explosions, or other punishing activities. Incredibly primitive Russian knock-offs find their way into the bags of photographers who are more concerned about finding a body to fit that old screw-mount lens than they are with the latest features. Low-end cameras have their own special place in photography, whether as a semidisposable extra body or the professional's version of a point-and-shoot vacation camera. Low-cost cameras with limited features can prove very useful. Some applications for these cameras are listed in Chapter 2.

Of course, low-end cameras encompass a broad range, from brand-new Chinese Seagulls to hard-to-find, exquisitely built Rollei 35s or Olympus Pen FTs from the 1960s. The same is true in the electronic realm. I'm arbitrarily defining the low end as every camera under $3,000, although most of the models described in this chapter list at $1,000 or less. These cameras have fewer features, lower resolution, and less flexibility than their more expensive counterparts, but they don't cost $10,000 and up, either.

Inexpensive Electronic Cameras: An Overview

I call them "electronic" cameras rather than digital cameras, because the low end includes so-called *analog video cameras*, which store a video image that can be converted to digital format.

The original Dycam models fall into this category. When used with still video printers, such devices offer a low-cost quick-print option without venturing into the digital world at all.

A digital camera that costs less than $1,000 might be the ticket if the limited resolution, capacity, and picture-taking flexibility of these models does not cancel out their speed and fast access to digital images. The top resolution you can expect from one of these cameras is the 640 x 480 pixel image provided by the Dycam Model 10-C and Apple's QuickTake 150. Kodak's DCS-40 mates a slightly wider lens (42mm versus 50mm) with the same one-pound Chinon-built camera body and charge-coupled device (CCD), which is unmasked to produce 756 x 504 pixel resolution. Any of these cameras will generate pictures that look good on the screen or in small 3" x 4" prints, particularly images that are not enlarged and are composed carefully to eliminate wasteful cropping.

The key to successfully using a low-end camera is, in fact, planning in advance to use as much of the original frame as possible. I've taken many digital photos at only 640 x 480 resolution and produced very good-looking prints, but I have found that enlarging such images even a small amount (to 5" x 7", or by cropping) made the pixels stand out dramatically. So, shoot tall one- and two-column pictures with a vertical orientation and those three- and four-column shots using a horizontal framing. Don't expect to change orientation with cropping or to pull details out of the background like you can with film.

In this price range, don't plan on capturing a large number of images at high resolution or on looking for removable media you can slip out of a camera and pop into your desktop or laptop PC. The Dycam Model 10-C does have an optional memory card that can hold 86 pictures at maximum resolution, but the card is more expensive than the whole camera.

Apple QuickTake

The Apple QuickTake uses a fixed 1Mb flash EPROM and data compression to store up to 16 640 x 480 pixel shots (double the capacity of the original QuickTake 100). Apple's internal RAM storage can also preserve images for up to a year, unlike some nondigital electronic cameras. The Dycam Model 4, for example, is an analog video device that uses power-hungry RAM that can contract image Alzheimer's in as little as a week, but it takes only a few minutes to move the 24-bit images from the camera to your PC using the PhotoNow Photoshop plug-in compatible TWAIN driver. Macintosh users get an even better product, PhotoFlash 2.0. Using either program is easy: just select the thumbnails you want to move, and click.

As is the case with most low-end cameras, the QuickTake cannot do sophisticated photo tricks. It operates much like a $100 snapshot camera equipped with ISO 100 film. It has autoexposure settings from 1/30th to 1/175th of a second and apertures from F2.8 to F16. The limited top shutter speed is better suited for reducing blur from a user's unsteady hand than for capturing action, and the slowest speed doesn't provide much in the way of indoor available light capabilities.

A built-in tripod socket is suitable for self- and group-portraits with the QuickTake's self-timer. The automatic flash provides illumination in low-light situations, but only in a range that extends from 4 to 10 feet.

Apple does include a snap-on closeup lens (which stretches the fixed-focus lens down to 10 to 14 inches) with parallax correction and an infrared filter. A diffuser softens the light to provide a less harsh, but bland, light for closeup work. You might like Kaidan's $135 Close-Take professional system, which includes a threaded lens adapter and three closeup lenses. There's a +2 diopter for focus from 18 to 48 inches, a +3 diopter for 9 to 18 inches, and a +4 diopter for focusing from 4 to 9 inches. If you don't mind a little lost sharpness, the lenses can be stacked to take you down to 2 inches. Figure 4.1 shows an Apple QuickTake 150.

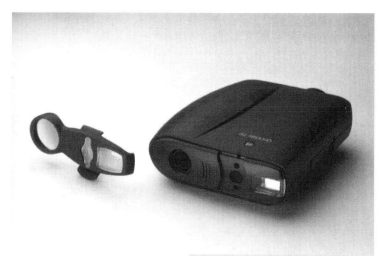

FIGURE 4.1

Apple QuickTake 150.

Kaidan also offers an $89.95 WideTake lens that expands the QuickTake's field of view by 75% and includes a 52mm screw-on filter mount that accepts filters (including Cokin special-effects glass) in that very common size, so you may already own a complete set of filters for your QuickTake. For more information on Kaidan, call (215) 364-1778.

Three AA lithium batteries (or optional NiCad rechargeables) power the camera and its built-in flash for 100 to 200 pictures, with enough juice left over to download the images to your PC through a serial port.

KODAK DCS-40

The Kodak DCS-40 is similar to the QuickTake 150, which uses the same Chinon-built camera body and CCD, but Kodak doesn't mask the sensor, using its full size to produce 756 x 504 pixel

resolution. Kodak also bumps up the flash RAM to 4Mb, good for 48 standard or 96 low-resolution images (378 x 256 pixel).

Slightly more expensive than the QuickTake 150, at $995, the DCS-40 also has a built-in automatic flash and can focus down to 48 inches. No closeup lens is included, but the camera accepts standard closeup lenses.

Professionals may like the DCS-40's less-obtrusive black finish and sturdier built-in handgrip, but the camera uses a larger LCD status screen and button controls that are not quite as easy to learn. It is also limited by the same 1/30th to 1/175th shutter speed range, and F2.8 to F16 apertures.

Although the DCS-40's images are only slightly larger than the Apple's, they take about a minute longer to download if you happen to be using a Macintosh. This is because the Kodak files are decompressed as they download, while those produced by the QuickTake are transferred to your computer in compressed form and expanded later. It just happens that serial transfers on a Mac take somewhat longer using the Kodak software, it's not an inherent failure of the platform or hardware.

Dycam Model 10-C

Dycam and Chinon have introduced a low-cost digital camera that goes beyond the point-and-shoot limitations of most of the cameras in this price range. Priced like the Kodak DCS-40, the Model 10-C has the same 640 x 480 resolution of the Apple QuickTake but includes a 3X power zoom and built-in closeup capability (no separate snap-on closeup lens is required). There's a parallax correction frame etched in the viewfinder to help minimize chopping off heads when the camera is focused down to its 19" minimum. At maximum zoom, you can fill a frame with a face at that setting. Normal focus range is infinity to 27 inches.

The other big addition of the Model 10-C is a Type II PC card slot for 2Mb, 4Mb, 8Mb, or 16Mb removable memory cards. These cards can hold from 10 to 86 pictures at maximum resolution, but their $199 to $1,150 cost puts them out of the range of amateurs. Professionals will need the capacity and realize that an 8Mb $599 "roll" of film that holds 43 images—but can be used over and over again—isn't entirely impractical.

The images need to be transferred over the included serial cable, which takes a few minutes even at the maximum 115K transfer speed. The proprietary format also means the expensive card can't do double-duty in your laptop by transferring programs and data files. Plan on dedicating this expensive device to your Dycam camera.

Since the Dycam has its own 1Mb of RAM, you can take up to five pictures at maximum resolution—or as many as 40 images at the quarter-size 320 x 240 resolution, even without a removable RAM card. Dycam calls the low-resolution mode "half-size," but since it produces images with one-quarter the pixels of the "superfine" mode, that terminology is misleading. For some types of images, you may be able to get away with the "fine" mode, which generates

640 x 480 pixel images like "superfine" but uses a compression scheme called *JPEG* to squeeze them into half as much space in the built-in memory or add-on RAM card.

Compression routines reduce the size of images by replacing information with shorter codes, which can represent the data replaced, or point to a place in the file where the same data is duplicated. Files are smaller, but when decompressed they exactly duplicate the original image with no lost information.

JPEG is what is known as a *lossy* compression scheme; it uses an additional squeezing technique in which groups of pixels are averaged together and represented by a single number. The software intelligently attempts to find data that is unimportant and discards it. When decompressed, the image is not exactly the same as it was originally, but if the compression scheme was done well, you may not notice. Most JPEG compression routines let you specify how much loss is acceptable, often with a Fair-to-Excellent slider or similar control. Some images, particularly those with large expanses (say, sky) that progress smoothly from one tone to another, can be squeezed down effectively with little information lost. Other types of images suffer from a blocky effect when they are restored. Your best bet is to experiment with the fine mode and see if the results are acceptable for your application.

When a RAM card is inserted, the Dycam automatically stores all subsequent images on the card. In fact, you can't capture images to the built-in RAM without removing the add-on card.

The software furnished with this camera makes downloading and manipulating images easy. It took me about 10 minutes to transfer 21 images to a Windows computer. They were stored in a 4Mb archive file that included thumbnail images for previewing. Dycam's **PICTURE** application shows the thumbnails, which can be viewed full-size with a double-click. You can save pictures in multiple file formats, including Tagged Image File Format (TIFF). There's a batch mode that can convert an entire set in one time-consuming step (about 20 minutes in my test). Since the final images used only 20 Mb of disk space (900K each), you can see that the Dycam archive format is an efficient and convenient way to store and back up your pictures.

After pictures have been downloaded, all the images in the camera can be erased by pressing a single button on the camera itself. You need to hold down the button for 2 seconds, and once the process has started, even turning the camera off won't bring it to a halt. The all-or-nothing step erases every picture; unfortunately, there isn't an option for removing one picture at a time.

This same camera is also available as the Chinon ES-3000 digital still camera.

DYCAM MODEL 4

Next to the Dycam Model 10-C, this older camera, a still video (not digital) model doesn't appear to be such a good deal at $795. It produces 496 x 365 pixel images, storing up to eight standard or twenty-four low-resolution images on its built-in RAM. Changing the resolution, flash, or shutter speed (1/2000th to 1/65th of a second) must be done when the camera is

linked to your computer—it doesn't have automatic exposure control. A neutral density filter can be used to cut down light when shooting outdoors if you don't have a computer handy to adjust this camera.

The built-in RAM can only store images for a week, and when battery power is low, the Model 4 refuses to shoot any more pictures, giving you about 3 hours to locate an electrical outlet and recharge before your images vanish. Now that newer and better models are available, you may see this camera, or its grayscale siblings—the Model 3 and 3XL—on sale for attractive prices (which I'd put at no more than $300).

Fujix DS-100

Jump up in price to about $2,400 and you can get true through-the-lens viewing, which comes in handy when you consider that the built-in power zoom lens focuses down to 1.6 inches.

While still limited to 640 x 480 resolution, this Fujix is loaded with professional features. For example, it outputs both composite and S-video so you can view the images on a television monitor—a great way to preview shots in the studio.

The Fujix DS-100 has autofocus and autoexposure for fast shooting, with white balance controls and override. The single-frame and continuous-record modes can be used with the self-timer. For ID or documentation applications, the camera can record the year, month, day, hour, minute, and second.

The power 8mm to 24mm zoom lens takes standard 52mm filters. You can download images directly from the camera over a serial port or use an optional RAM card that holds up to 21 images, and images can be read through a dedicated card reader that connects to your computer's SCSI interface.

Canon RC-360/RC-570 Still Video Cameras

Canon offers several still video cameras at prices up to $3,800. You might wonder why you'd pay that much for an analog camera that records 260,000 to 410,000 pixels, but as you'll see from the feature list that follows, these Canons can do some things that are not possible with less expensive digital cameras. Both use tiny 2" still video floppies, which can store from 25 to 50 images, depending on whether you record in field mode (every other line) or frame mode (both video fields, interlaced).

The RC-360, for example, is useful as a documentation, monitoring, or surveillance camera, since you can record one image at a time, use a self-timer to capture an image after a 10-second delay, shoot at selected preset intervals, or record images at speeds up to three per second.

It has a fixed 9.5mm lens, which provides a field of view equivalent to a 50mm lens on a 35mm SLR. It focuses from 3 feet to infinity, or as close as 10 inches in macro mode. The

built-in flash automatically fires in low light levels. Images can be deleted one at a time, or an entire still video disk can be erased in a single step. An optional film adapter is available for quickly recording images from 35mm slides or negatives.

The RC-570 adds a 3:1, 8mm to 25mm power zoom lens, which provides a view equivalent to a 43mm to 130mm lens on a 35mm SLR. If you need something wider, a 28mm-equivalent add-on lens is available.

If you work with still video images a lot, this model has great flexibility. You can record images from any still video source (including camcorders, VCRs, or televisions) in addition to capturing images with the RC-570's lens. The video images can be exported to your computer, manipulated, and imported back as analog video images. That means you can edit still video images with your computer and convert them back to a format suitable for printing by a still video printer. (That is, the still video printer doesn't have to be attached to, or even compatible with, your computer.)

Continuous shooting of up to 2.5 images per second or at intervals from 1 to 99 seconds, makes time-lapse photography easy with the RC-570. The camera also serves as a playback device and can show the images stored on the video floppy disk one at a time, continuously, or at 3.5-second intervals, in both forward and reverse.

Sony MVC-C1

This descendant of the original Mavica of 15 years ago is, along with some other offerings like Logitech's FotoMan, the cheapest way to get into electronic photography. At about $250, the MVC-C1 has a fixed-focus 15mm F2.8 lens and records only 280,000 pixels, but its high-speed electronic shutter gives you exposures from 1/60th to 1/500th of a second. The fast shutter speed lends itself to (low-resolution) quasi-sports photography of a sort, since the MVC-C1 can snap off 4 to 9 pictures per second, which can eat up the 50-picture capacity of the 2" floppy rather quickly. There's also a self-timer to snap one picture after a delay of 10 seconds and a built-in flash.

This is strictly a snapshot camera, but one that can still be useful in specialized monitoring applications or where still video images are needed for presentations.

The Next Step

Now that we've looked at the low-end electronic and digital camera models, Chapter 5 will review the pricier offerings from Kodak, Canon, and Nikon. You won't have to stretch your imagination quite as much to visualize applications for these cameras, although justifying their $10,000 and up price tags may take a little more work.

CHAPTER 5

DIGITAL CAMERAS: THE HIGH END

My collection of vintage Nikon F and F2 camera bodies from the 1960s and 1970s look like Model Ts next to today's streamlined, autofocus, motor-transport 35mm single-lens reflex cameras (SLRs). Yet, even though the guts of new models are nearly all electronic and high-impact and lightweight polymers have replaced castings and titanium in many places, the outer shape of modern cameras has retained a certain familiarity. The time-honored 35mm shape still reigns supreme, and if W. Eugene Smith returned from the grave after nearly 20 years to resume his career, he'd have no trouble mounting bayonet lenses or finding the shutter release or viewfinder. It might take him a few minutes to figure out how to turn the thing on, but after that he'd be outgunning the best of us.

This chapter will discuss the leading digital cameras now available. You'll learn about their capabilities and limitations, since there are some very different features scattered among even the few different models on the market.

Since digital camera image quality can be provided by conventional cameras in the $300 to $1,000 price range, to justify even the least expensive model, you must have a serious need to bypass the film processing step, a time-sensitive computer application for direct-to-digital image files, or a desire to transmit image files by modem with a minimum of delays.

A Familiar Face

Digital cameras are generally based on existing film cameras, for three good reasons—familiarity, the cost of re-outfitting the photographer with all new lenses and accessories that fit the digital camera body, and the cost of the equipment itself.

Familiarity is important because photographers don't want to be distracted by an unfamiliar tool as they work. You'd never catch Danny Sullivan slipping into an Indy car that had all the controls mounted in strange places. More importantly, however, using a familiar tool allows a photographer to keep costs down by choosing a model that is compatible with his or her current stash of lenses and accessories. Not all components from the same camera family can be used with all digital cameras. Some components, such as lenses, don't provide optimum coverage or results with a given digital camera; others, like databacks, simply are irrelevant.

Finally, while the cost of potentially duplicating accessories is nothing to sniff at, the most important reason digital cameras are built on existing models is to reduce the cost of the final product. A $28,000 digital camera might consist of standard off-the-shelf components that you can purchase anywhere: a $750 camera body, a $500 zoom lens, and a $400 PC card hard disk or memory card. The other $26,000 goes for electronics to interface with the sensor and your computer, a rugged housing for those electronics, and one exotic expensive-to-produce sensor. Unlike memory chips, which can include "spare" sites to serve as replacements, digital image sensors must be as close to perfect as possible, since bad pixels mean image information that is forever lost. Sensors can boost the cost significantly because many slightly imperfect sensors must be discarded for each one that can be used.

Oddly enough, only the sensors at the very top and bottom of a manufacturer's line may actually be perfect. The simple arrays used in 640 x 480 pixel cameras are easy to manufacture using techniques that produce high yields, so vendors can afford to use only the perfect output in their products. High-end products such as Kodak's 6 million pixel DCS-460 and 465 command their premium price, in part, because they are flawless. Journeyman products in the middle, the 1.3 million to 1.5 million pixel models, may have sensors with a few flaws that are identified during manufacture. Compensating routines are created and downloaded to the camera's firmware, so that missing pixels are automatically calculated by interpolation.

Imagine that digital camera vendors also had to design the shutter, through-the-lens viewfinder and rapid-return mirror, autofocus mechanism, and all the programming that goes into something like a matrix metering system. Given the lack of economies of scale ($30,000 digital cameras don't sell in the tens of thousands), you'd end up paying twice as much for one—if you were still interested.

Luckily, professional cameras have removable backs that provide access to the film plane where the image sensor should go, so most digital models consist of little more than a camera back, storage unit, power supply, and interfacing electronics. Once mounted, there is little reason to remove the back except, perhaps, to clean the sensor, which is, after all, exposed for a brief moment each time the shutter curtain passes in front of it.

The exceptions, of course, are digital cameras that are used in the studio with view cameras or 120 rollfilm models. A single digital back may be used with a variety of cameras or left in place and used with one camera for thousands of exposures.

Camera Overview

This section will examine some of the leading cameras on the market. I won't claim to tell you everything you need to know to select one for your own applications, because it would be silly to suggest that anyone would put down $10,000 or more without doing more research than reading this book. I do hope to give you a sufficient overview to help you focus your research on the models most likely to meet your needs.

At the professional level, all the digital cameras are based on Canon or Nikon SLR camera bodies, since anyone paying $10,000 or more for a digital camera probably already has a lot of money tied up in lenses and other interchangeable accessories. While Canons are favored by photojournalists because of the broader array of faster and longer lenses, Nikons are still entrenched in industrial, scientific, and medical applications.

Professional cameras have aperture or shutter priority modes, manual shutter speeds and f-stops, fully interchangeable lenses, and the ability to annotate each frame verbally with built-in microphones. They also have burst modes of up to 3 frames per second, spot or matrix metering, various lighting settings, and precise exposure compensation control. All use PC cards, hard disks, or flash memory and are two to three times as heavy as a conventional 35mm camera. Professional cameras are suited for photojournalism, sports, annual reports, some portrait work, industrial use, manufacturing photography, specialized work requiring immediate viewing, short deadlines, or rapid electronic transmission.

WHAT TO LOOK FOR IN A DIGITAL CAMERA

In choosing among the available digital cameras, you'll want to take the following factors into consideration and see how each of them matches your applications:

❑ **Resolution**. Is the roughly 1500 x 1000 pixel resolution available from most digital cameras sufficient for your application? Remember, interpolation is used to produce color images with these cameras, so actual resolution is a little lower. For photojournalism, digital publications (including CD-ROMs), and similar work, the resulting 1.3 million to 1.4 million pixels of information may be enough. This relatively low resolution may actually be an advantage if you need to transmit an image over telephone lines to meet a tight deadline. Many types of studio work and photo illustration, on the other hand, require the 3000 x 2000 pixel resolution of the top-of-the-line digital cameras. Some of these cameras take three separate exposures through a color filter wheel and merge them, so you actually get the full resolution of the sensor, but these models are too slow to take pictures of living, moving subjects. They are instead suitable only for still lifes, product shots, and similar work.

❑ **Field of view**. Can you live with a small viewfinder image, cropped from the full area of a 35mm frame, or do you want a full-size view? Some digital cameras have sensors that are smaller than 24mm x 36mm; others use sensors that are closer to full size or have optical systems that enlarge the area photographed in the viewfinder.

❑ **Camera features**. Capabilities of digital cameras vary depending on the features of the camera on which they are based. You might want a Canon model to take advantage of the longer, faster lenses available for that line. You may need a Nikon for compatibility with an existing photomicroscopy setup. You'll also find differences in top shutter speed, metering methods, and available accessories that could be important to you.

❑ **Capacity**. Not all high-end digital cameras use internal hard disks. Those using RAM cards have more limited capacity. RAM cards may cost as much as hard disks but hold fewer pictures because they have less storage space (e.g., 8Mb versus 170Mb at the same price). Studio cameras may be tethered to a computer and therefore have effectively unlimited capacity.

❑ **Portability**. Digital cameras that use a color wheel or have a linear array scanning system must be used on tripods. You may also have to link the camera to a computer. Either requirement can seriously impact the portability of the system. You may also have to work in a studio, and packing up and moving the whole system to another location may be tedious and time-consuming.

❑ **Subject limitations**. Cameras that use color wheels or scanning to capture images cannot grab pictures of moving objects, which eliminates people-oriented photographic applications, such as fashion work or portraiture. Cameras that increase the focal length of your lens make wide-angle photography, including architectural work, difficult. Even with a perspective control lens, you'll find it has been transformed from a 28mm or 35mm PC lens into a 72mm or 91mm swinging tilting telephoto through the magic of cropping.

KODAK DCS-420

Kodak's professional DCS-420 digital camera is based on the popular Nikon N90 camera body and uses a 1524 x 1012 pixel sensor array to capture 36-bit 4.5Mb images. It's the successor to the Kodak DCS-200, which fit the body of a Nikon 8008s camera. This new model accepts all F-mount lenses offered for the N90, and it offers nearly all of the Nikon's standard SLR features, including automatic exposure, flash, and self-timer.

The camera captures 12 bits per RGB color (36-bit color), which offers better capture of highlights and shadows than the DCS 200. Software upgrades will allow for full 36-bit transfer to your applications. The DCS-420 also offers equivalent ISO ranges of 50 to 400 in color and 100 to 800 in black and white.

Rather than incorporating a built-in nonremovable hard drive (which was the case with some earlier digital cameras), the DCS-420 supports removable storage media that conform to

the PCMCIA ATA standard. This allows users to plug in a variety of compatible hard disk cards and flash memory cards. The camera is furnished with a 170Mb hard disk.

A single rechargeable nickel-hydride battery pack powers both the Nikon N90 camera and the electronic camera back. This battery pack provides 10 times the power of the batteries in the DCS-200, delivering at least 1000 exposures per charge. An AC adapter, which can also be used to power the camera, will recharge a dead battery pack in about an hour. The DCS-420 can be used with the portable Quantum Battery 5 in applications that require more power capacity.

The $11,000 DCS-420 also offers a built-in microphone that can record telephone-quality audio clips onto the same PCMCIA ATA cards used to store images.

The time required to warm up to the first shot is only 1/4th of a second. The camera can fire up to a five-image burst in just 2.25 seconds. The images can then be loaded to the disc at 2 to 3 seconds per image, at which time another burst can be shot.

A standard SCSI cable connects the camera either directly to a Macintosh computer or to an IBM PC or compatible using a host adapter. The camera requires a computer with a minimum of 8Mb of RAM and Adobe Photoshop software. It is 6.4" wide by 3.5" deep by 7.1" high. It weighs 3.6 pounds without a lens or storage card. The Kodak DCS-420 is shown in Figure 5.1.

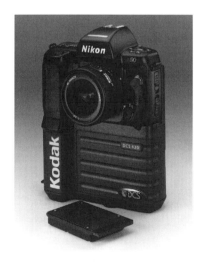

FIGURE 5.1
Kodak DCS-420 camera.

KODAK EOS DCS-5

Priced a little higher than the DCS-420, at $12,000, the EOS DCS-5 has similar features but is based on a Canon EOS 1-N camera body, which is popular with sports photographers. It uses the same full-frame CCD imager measuring 1524 x 1012 pixels, with a total resolution of 1.5 million pixels.

The camera also captures 12 bits per RGB color, for 36-bit color, but interpolates to 24-bit files before the images are downloaded to a host computer. The EOS DCS-5 offers equivalent ISO ranges of 100 to 400 in color and 200 to 800 in black and white.

You can use the same removable storage media supplied for the DCS-420, including a broad range of compatible hard disk and flash memory cards, with capacities as high as 260Mb. A single rechargeable nickel-hydride battery pack powers both the Canon EOS-1N camera body and the electronic back. This battery pack is capable of delivering up to 1000 exposures per charge. There's also an AC adapter, which recharges the battery in an hour, and a Quantum Battery 5 option.

The camera has the same built-in microphone to record audio clips as the DCS-420. These sound files can be intermingled with image files and do not have to be linked with a specific image.

Once the camera is powered up, the time to the first shot is less than 1/4th of a second. By holding down the shutter button, a user can fire off a 10-image burst in just over 4 seconds. Succeeding exposures require 3 seconds per frame.

A standard SCSI cable connects the camera directly to a Macintosh computer or to an IBM PC or compatible using a host adapter, with the same minimum equipment requirements as the DCS-420.

The camera, available in color, black-and-white, and special-order infrared models, is 6.3" wide by 3.5" deep by 7.5" high. It weighs 3.8 pounds without a lens or storage card.

The new camera combines the features of Canon's highly advanced EOS-1N SLR camera—such as multipoint autofocus and an extensive range of metering modes and ultra-fast shooting speeds (up 10 images in just 4 seconds). The EOS DCS-5 accepts all EF lenses and offers multi-point autofocus and Canon's exclusive Advanced Integrated Multipoint (AIM) control system, which links focus and exposure for better camera performance. The Kodak EOS DCS-5 camera is shown in Figure 5.2.

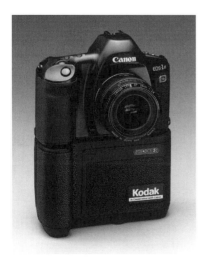

FIGURE 5.2
Kodak EOS DCS-5 camera.

KODAK PROFESSIONAL DCS-460 DIGITAL CAMERA

The new Kodak professional DCS-460 digital camera is, as of this writing, the world's highest-resolution single-shot color device designed for use both inside and outside the studio. It consists of a special electronic back fixed to the body of a Nikon N90 camera. It accepts all F-mount lenses offered for the N90, and it takes advantage of nearly all of the Nikon's standard SLR features, including autofocus, automatic exposure, flash, and self-timing.

The DCS-460 is the first camera to bring multimegapixel image quality to a state-of-the-art 35mm SLR. The result is a truly portable device capable of delivering fast, high-resolution digital images in a variety of applications, from catalog and portrait photography to microscopy and telepathology.

The DCS-460 uses a full-frame CCD imager measuring 3060 x 2036 pixels. Total resolution is 6 million pixels, and it captures 12 bits per RGB color, for the same 36-bit extended dynamic range color of the other models in the Kodak stable. Its "film" speed is the equivalent of ISO 100.

Other specifications are similar to those of the other Kodak cameras, including support for PC card removable storage media and a rechargeable nickel-hydride battery pack that powers both the Nikon N90 camera and the electronic camera back for at least 300 exposures per charge. Recharging takes an hour, and the portable Quantum Battery 5 can be used with this camera.

While first-shot time is only 1/4th of a second, like the other Kodak cameras, the time needed to store the much larger images to disk limits subsequent exposures to one every 12 seconds.

Color, black-and-white, and infrared models of this camera are available. It has the microphone and sound annotation capabilities of the other cameras, and it is 6.7" wide by 4.5" deep by 8.2" high. It weighs 3.75 pounds without a lens or storage card.

KODAK PROFESSIONAL DCS-465 DIGITAL CAMERA BACK

Professionals using medium-format cameras can capture high-resolution digital images with Kodak's full-featured digital back for several popular 120 and 4" x 5" devices. The Kodak professional DCS-465 digital camera back offers photographers a unique combination of image quality and convenience.

These include image resolution of 3060 x 2036 pixels, for a total resolution of 6 million pixels. The DCS-465 has single-shot 36-bit color exposure, with resulting portability that will enable the camera-back system to be used almost anywhere, inside or outside the studio. The camera has an ISO equivalent of 100.

The DCS-465 uses PCMCIA ATA Type III cards (both flash memory and hard disk cards) and has a battery pack good for at least 100 images per charge, with a one-hour recharge.

Based on the same technology as the Kodak DCS-400-series digital cameras, which feature a digital back fixed to the body of the Nikon N90 35mm SLR, the camera back has target applications for the DCS-465 back, including catalog and studio imaging, scientific and industrial uses, and copystand applications. The back can also be used in a variety of military, law enforcement, and government applications.

Kodak has been working with leading camera manufacturers, such as Hasselblad and Sinar, to adapt DCS-465 technology to their equipment. The discussions will also help ensure the compatibility of future Kodak film products with leading cameras. The Kodak DCS-465 camera is shown in Figure 5.3.

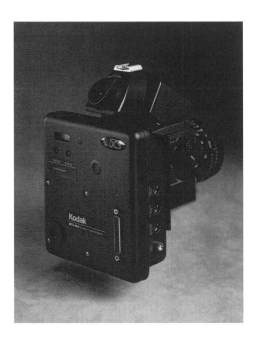

FIGURE 5.3
Kodak DCS-465 camera.

Canon EOS DCS-3

The Canon EOS DCS-3 is similar to the Kodak and is exactly the same as the AP Kodak NC 2000, which is sold through the associated press. A slightly smaller CCD, 1280 x 1024 pixels, can generate 2.7 images per second in burst mode.

This camera shares some features with the Kodak, such as sound annotation, PC card storage, and 36-bit color, but offers a wider range of exposure equivalents, providing more flexibility under varying lighting conditions. The DCS-3 can be used with ISO ratings of 200 to 1600 for the color model and 400 to 6400 for black-and-white and infrared exposures.

Fujix DS-505/DS-515

The Fujix DS-515 and Nikon E2s digital camera systems share the same squat, boxy body that looks like a little like a Mamiya 645 rollfilm camera. A bit more complicated to operate than the Kodak models, the Fujix has its own endearing features.

Some of these features include an optical condenser system that fills the entire viewfinder area with the image actually being captured and supposedly eliminates the lens-lengthening effect produced by the two Kodak professional DCS models. Despite Fuji's claims, however, the Fujix still reduces the field of view of lenses, although not as much as the Kodak. In tests using the same Nikon zoom lens set at 50mm at a fixed arbitrary distance (about 3 feet), the Kodak DCS-420 provided a 6" field of view, the Fuji a 12" field of view, and a conventional film-wielding Nikon a full 15".

Because of its condenser system, the Fuji doesn't use the Nikon lens aperture to adjust the amount of light using the sensor, instead it uses an aperture built into the image reduction optics. If you're accustomed to stopping down the lens to preview depth of field, you're out of luck, especially if you'd planned to put selective focus to work as a creative element. Expect to lose some light-gathering power as well—the Fuji's effective aperture range turns a fast F1.2 lens into an F6.5 model (but with increased depth of field to match), and lenses with F5.6 or smaller maximum apertures to F8 or worse. However, the Fuji offers a choice of ISO 800 and ISO 1600 sensitivity ranges, so available-light photography is still an option.

The camera offers shutter speeds from 1/8th to 1/2000th of a second and 700 x 650 line resolution. The Fujix has a flip-out PC card slot in the back that looks a little like the cavities used to load quick-load amateur cameras, but it holds a 15Mb ATA memory card instead of a hard disk. At full resolution, only five images fit on the card in noncompressed format. JPEG compression is available, however, to boost capacity to 43 images (at 8X compression) or up to 84 images using 16X compression. Remember that JPEG is a lossy compression scheme, so some blockiness may be apparent at maximum squeeze setting.

The limited RAM card capacity doesn't make the Fujix a replacement for a film camera equipped with a motor drive, but you can squeeze out seven shots at 3 frames per second in a pinch. Professionals will like the ability to synchronize the Fujix to a film camera to make simultaneous exposures—low-resolution digital images for previewing and proofing and high-resolution film images for printing.

The video terminal output lets you download images to an inexpensive analog video printer for quick previews or look at your shots directly on an available television monitor.

Specialized Studio Camera Backs

Most of the specialized studio camera backs are priced from $15,000 to $30,000 and up, and all except the Kodak DCS-465, require tethering to a computer, which limits their portability

and forces you to operate from the computer itself at least some of the time. Studio cameras offer the highest resolution but need long exposures.

The KanImage GA scanning camera, for example, takes from 0.5 to 16 seconds for each exposure, while Screen USA's Fotex F10 captures images in 15 seconds. Others can take up to 12 minutes, which limits their utility to brightly lit still lifes. Since separate exposures are made for red, green, and blue channels, even slight movement between or during exposures can cause a rainbow effect or color fringing.

If fast exposures are required, look into the Leaf digital camera back, which can capture images in 30 seconds. It's compatible with Sinar, Hasselblad, and Mamiya cameras.

Other digital camera backs include one from Dicomed, which offers a $23,000 4" x 5" back with 6000 x 7520 pixel resolution at ISO 25, 100, or 200. An internal 1Gb hard disk can nevertheless store only a dozen of the 129Mb image files.

Phase One has a similar 4" x 6" scanning back with a fixed ISO 400 speed and 5000 x 7142 pixel resolution. Priced in the same range as the Dicomed, it has no internal data storage and must be linked to a Macintosh at all times.

The Next Step

Not all digital image capture devices are cameras. In Chapter 6, we'll examine another option for creating digital images—scanners. These handy devices let you convert images that originated from film into a digital format that can be manipulated and enhanced with your computer.

CHAPTER 6

SCANNERS

Scanners provide an excellent alternative to digital cameras for capturing some kinds of image information. In many cases, you'll want to start with drawings, photographic prints, negatives, or transparencies, and convert them to digital form for retouching, manipulation, or compositing with other digital images. Digital cameras can be used to capture such images, and, indeed, are frequently put to work on copy stands in police or forensic photography labs.

However, most of the time you're better off using a scanner specifically designed for grabbing images from flat reflective art or transparencies/negatives. This chapter will serve as an introduction to scanner technology and will help you choose the right scanner for the kind of work you do. We'll look at everything this side of color separation scanners, which are sophisticated (and expensive) prepress tools that are beyond the scope of this book.

Where Did Scanners Come from?

Scanning was first proposed in 1850 as a method of transmitting photographs over telegraph lines. In 1863, a Catholic priest named Caselli achieved the first facsimile transmission when an image was sent between Paris and Le Havre, France. In one sense, you could almost say that the telephone was invented 13 years later so we'd have a way to call somebody and see if our fax arrived okay.

Another image scanning system was developed in 1884 as a precursor to early television systems. Then, work by a German physicist in the early part of the 20th century led to wire photos, which were introduced to the United States in 1925. The first scanner used to produce color separations for graphic arts applications was developed in 1937.

For many years, image scanners were available only as part of very expensive ($100,000-plus) color prepress systems that earned their keep by automating the tedious process of producing color separations and/or halftones. If you ever worked in a prepress department in the days when calculating things like flash or bump exposures was a black art, you'll agree that color separation scanners are a key reason why magazines and daily newspapers are able to publish so many high-quality color pages on tight deadlines. Since color attracts advertisers with deep pockets, it's easy to see how megabuck scanners were able to pay their way.

Scanners became available for desktop computers by the mid-1980s, although in a primitive form. The first affordable devices could capture only black-and-white images or, if you were lucky, grayscale images with a whopping 16 different gray tones. The HP ScanJet, introduced in 1987 at a price of $2,495, fired the first really effective shots of the digital imaging revolution. The ScanJet Plus, unveiled in 1989 as a 256-tone grayscale scanner, when coupled with software tools like Adobe Photoshop, gave photographers the ability to manipulate monochrome photographs in some amazing ways.

The basic layout of the flatbed scanner, shown in Figure 6.1, has remained unchanged for nearly 10 years.

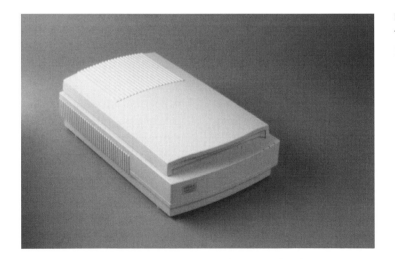

FIGURE 6.1

The basic flatbed scanner layout has remained unchanged since the mid-1980s. Courtesy of UMAX.

Today, you can purchase a full-color scanner for less than $1,000, like the Hewlett-Packard ScanJet 3c, which operates at a speed and resolution that matches your digital camera.

Transparency scanners that produce images suitable for comps or FPO (*for position only*) artwork in layouts—or even for reproduction, in some cases—add from $700 to $3,000 or more to your outlay. Scanners are particularly useful when you need a particular image or image-bit to enhance a digital image. You can grab the piece, import it into your image editor, and smoothly blend it with other components. Scanners are definitely a cool tool, and one that more photographers are adding to their digital darkrooms.

What Can You Do with a Scanner?

There are eight key applications for scanners. The first four listed below are of particular interest to photographers. You may or may not have any use for the second four, depending on the type and amount of nonphotographic functions performed in your studio.

- ❑ **Capture photographs for image manipulation, halftoning, and color separation.** A flatbed scanner can digitize images from virtually any artwork that will fit on its glass platen and convert them into a format that can be fine-tuned and modified by image editing software such as Adobe Photoshop. You can perform traditional retouching, color balancing, dodging, and burning with image editing software. The finished image can then be sent to an electronic prepress system for halftoning or color separation, or it can be separated right at your PC or Macintosh.

- ❑ **Capture line art.** Photographers who are heavily involved with photoillustration often need line art as elements of their compositions. Even if you have a CD-ROM drive and discs with megabytes of clip art, you'll still want to capture logos, drawings, and other artwork.

- ❑ **Imaging 3D objects.** If you have small items such as nuts and bolts, coins, product packaging, or small mechanical components that you'd like to use as a background texture, you could put them on a copystand, set up a few lights, and capture an image using your favorite macro lens. That would be the route to go if you needed the ultimate in image quality or had to apply subtle lighting to model the objects, reduce glare, or achieve another effect. Unless you used a digital camera, you'd have to get the film processed and then scanned. If the background is intended for a desktop presentation or will be blurred or otherwise manipulated so resolution isn't critical, you can scan the items directly from the platen glass of a flatbed. This technique will give you greater resolution than you might get from a digital camera, with the same capture speed. Where a digital camera might produce a 3000 x 2000 pixel image of a 12" x 8" subject area, you can easily achieve true resolutions of 7200 x 4800 pixels for the same area by using a direct scan on a flatbed scanner.

❑ **Acquiring low-resolution images**. Desktop scanners are great for capturing low-resolution images quickly from your existing photos. Low-resolution scans at 72 dpi are quick to make and look great as FPO artwork in layouts or as final images in desktop presentations. Low-resolution scans can also be used for a digital catalog of your conventional images. Put proof prints or contact sheets on the scanner, capture the whole image area with one gang scan, and then deposit the preview images into a cataloging or image browser program.

OTHER USES FOR SCANNERS

When you take off your photographer's hat, you might have applications for the following capabilities of desktop scanners:

❑ **Capture images for autotracing**. Vector-oriented (outline) drawing software such as Adobe Illustrator, Deneba Canvas, Macromedia FreeHand, or CorelDraw and computer-assisted drawing (CAD) applications can't do much with bitmapped images. Their meat-and-potatoes are scalable outlines, which can be incorporated into illustrations, CAD, designs, custom-tailored fonts, and so on. Scanned images, particularly those of line art (such as architectural drawings), can be converted to editable outlines using autotracing programs, such as CorelTrace or Adobe Streamline. If you do architectural or industrial photography, you might have to convert a picture into an outline format, using your scanner and an autotracing tool.

❑ **Optical character recognition (OCR)**. Although the paperless office still seems as likely as the paperless bathroom, there's a huge demand for converting the flood of paper that inundates most businesses each year into text that can be searched and/or edited. Documents ranging from legal briefs to business correspondence become a lot more manageable when captured with a scanner, indexed, and stored on a computer for rapid retrieval. OCR makes a great data compression tool, too: a picture of a single-page document (for example, a fax file stored on your hard disk) can easily consume 50 to 150K of space. Converted through OCR to an ASCII or word processing file, that same page will be compressed down 50 to 100 times.

❑ **Translating hard copy material to a faxable format**. If you have a fax/modem and a scanner, you don't need a dedicated fax machine. Images of any document you want to fax can be captured and pasted, or imported, into your fax software. In a pinch, a scanner can act as a photocopier, too: the "faxes" you create can be printed out same size or in a reduced or enlarged format.

❑ **Forms input**. Converting information entered on forms is such a huge business that many companies have shipped work overseas for low-cost manual processing. However, it's practical to replace error-prone key entry with a scanner and specialized forms

reader OCR software (some can recognize ordinary or constrained [carefully written] handwriting) that can translate piles of forms into orders, claims, or databases.

What's a Scanner?

In many ways, scanners and digital cameras capture images in much the same way. However, instead of a complex (and costly) sensor array, scanners use a capture device made up of a single row of sensors. The image is scanned one line at a time.

Modern scanners generally use a *charge-coupled device* (CCD) sensor to capture images one line at a time. In flatbed scanners, a moving light bar passes under (or over) the original, and reflected (or transmitted, in the case of slides) light is directed to the sensor array, which consists of one tiny light-sensitive element for each pixel across the maximum width of the scan. Figure 6.2 shows how the light bar(s) and sensor array are arranged in an average flatbed scanner.

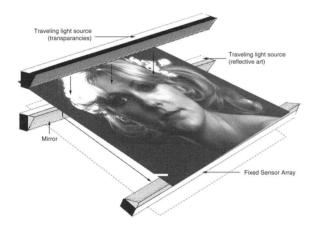

Traveling light source
(transparancies)

Traveling light source
(reflective art)

Mirror

Fixed Sensor Array

FIGURE 6.2

In the typical flatbed scanner, a moving light bar passes over (or under) the artwork, and light is reflected back to a sensor array.

The more sensors packed into the array, the higher the horizontal resolution. The vertical resolution of the scan is determined by the size of the sensor and the distance traveled between each scan line. A scanner with a 600-sensor array that moves 1/1200th inch between lines is said to have an optical resolution of 600 x 1200 dpi.

Sheetfed scanners operate in a similar way, except, like a dedicated fax machine, the sensor and/or light bar remain stationary and the original is drawn past by rollers. This type of scanner is less useful to photographers because it can scan only flat, flexible sheets of a limited width. That may be fine for photographs that happen to fit through the slot, but it presents a problem if you want to scan a paste-up, a mounted image, or anything bound into a book. At the very bottom end of the scanner scale are handheld scanners, which substitute the movement of your arm for the traveling light bar. Handheld scanners are good for capturing bits and

pieces of images on the run, especially if you have a laptop computer and one of the new hand scanners that need no external power source.

Color scanners capture the individual red, green, and blue components of a full-color image either by three separate passes (each with a different colored filter) or by a single pass. One-pass scanners—which are sometimes faster than three-pass models—may have individual sensor arrays for each color or may use a single set of sensors and a light source that alternates among the three primary colors during the scan. The analog information captured optically is converted to digital format, merged to form a single image, and sent on to your image editing software, through either a proprietary card that fits in your computer or a faster port, like the SCSI (small computer systems interface) connection found in all modern Macintoshes and many IBM PC compatibles.

There are too many different flatbed scanners available to list them all here, but you'll find a variety of models available from Agfa, Howtek, HP, UMAX, Sharp, Canon, Microtek, Relisys, and others for around $500 (grayscale scanners), $500 to $1,000 (24-bit, 300–400 dpi scanners), $1,000 to $3,500 (30- to 36-bit, 400–800 dpi scanners), and up (scanners that capture larger than 8.5" x 11" image areas). These include models like the PixelCraft A3/Plus, an 11.7" x 17" 2400 dpi scanner for reflective artwork. It's actually the entry-level model of the PixelCraft large-format line. Scanner prices have been wildly unstable in the past few months as the competition heats up, so all the figures I provide in this chapter should be taken only as a guideline.

Scanners have widely varying capabilities. Some can handle prints only, others can work with just film, and still others are equally facile with both types of media. A few require expensive option packages to work with film and prints. Of those that can handle film, some can scan negatives as well as chromes, while others cannot. Film scanners may be limited to 35mm film, or be able to scan 120-format (2.25" wide) to 4" x 5" and larger transparencies or negatives. Maximum scanning area can vary, along with maximum resolution—and sometimes these are tied together. That is, there are a few film scanners that narrow their field of view as you increase the resolution. Obviously, before you buy you'll need to look at a scanner in more detail than I'll be able to provide in this chapter.

I'll explain the important specifications and other factors that go into choosing a scanner later in this chapter.

Transparency Scanners

Transparency scanning—once the exclusive province of high-end graphic arts drum scanners—is becoming an important tool for desktop publishers and individual graphic artists. Virtually all the leading color scanners can be fitted with a slide scanning attachment. This is important

because slides may be your lowest-cost (after digital cameras, of course) and most faithful medium for originating color images.

A roll of color slide film and processing is generally less expensive than the equivalent number of exposures and high-quality, custom printing of color negative film. As a bonus, your images aren't subject to the vagaries of automated or manual printing. A transparency is the closest thing to "what you see is what you get" available in conventional photography. However, if you're in a hurry you may not always be able to wait for a chrome to be processed; in that case, if you have the capability to scan negatives directly, this may be your only option.

Dedicated slide scanners, such as the Nikon CoolScan (available to fit an internal drive bay or as a stand-alone external unit), simplify slide scanning—you just insert a slide into a carrier and pop in the slide scanner's slot. Many flatbed scanners also have slide attachments. Some, like the Sharp JX-325, include a second set of sensors specifically for slide scanning. Others, such as the UMAX PowerLook or HP ScanJet 3c, incorporate an additional light source into the slide attachment to back-light the transparencies for capture by the flatbed's original sensor array.

Of the stand-alone slide scanners, the Nikon CoolScan was an early leader at the low end, because it has the cachet of the Nikon name, and it is fast, producing single-pass 24-bit scans at up to 2700 dpi, using a patented red-green-blue LED illumination system. The LEDs, of course, produce much less heat than traditional light sources, hence the CoolScan name. Nikon also offers the $6,000 LS-3510 36-bit slide scanner with a 40 x 40mm scanning area, 3185 dpi resolution, and an optional 300-slide feeder for high-volume work. At the higher end of the scale, the company has its $10,000 LS-4500.

Microtek was one of the first to market a low-cost slide scanner, and its ScanMaker 35t can still be purchased for less than $1,000. This compact, five-pound external scanner can capture 24-bit images at up to 1828 dpi, which is enough for many applications. If you need higher resolutions, it can calculate, or interpolate, extra pixels from the values of the pixels it does capture, producing simulated resolutions of up to 3600 dpi on the Mac or 7200 dpi on the IBM PC.

Moving up the scale, you'll find the Polaroid SprintScan 35, which uses 10 bits per color to capture up to one billion different colors. The scanner automatically color-corrects your image and interpolates the information down to an optimized 24-bit image. It boasts a dynamic range of 0 to 3.0 (see the discussion on dynamic range in the next section), and it has automatic calibration.

Kodak's $9,000 RFS 3570 is a 36-bit scanner with 800 to 2000 dpi resolution. As you might guess from its name, this device can handle both 35mm and 70mm film, and it takes about one minute to capture an image. Its speed, autofocus, and auto color balancing make it a good choice for high-volume users, such as service bureaus, photojournalism organizations, or wedding/portrait photographers.

From the folks who brought you the Leaf Picture Desk, you'll find the $5,000 Lumina flat art, 3D, and film scanner a versatile machine, because it looks and works more like a digital camera than a traditional scanner. In fact, it accepts standard Nikon bayonet mount lenses, so you can use your favorite macro lens and mount this device on a copystand, or use it with a motorized film strip attachment. The Lumina is the modern-day equivalent of the bellows-mounted slide copying attachment. It can be fitted with a Kodak Ektagraphic slide projector attachment for automated slide scanning.

The Lumina features 12-bit color depth per channel (36 bits overall) for better shadow definition and a wider dynamic range, and it can capture at up to 2700 dpi. Despite its camera-like appearance, the Lumina uses a trilinear array (three rows of sensors—one each for red, green, and blue). As a result, the subject must remain still for the entire scan (no point-and-click captures like you get with a true digital camera). It takes less than three minutes to acquire an image at maximum resolution.

Drum scanners have come down in price so much that some studios should be able to justify purchasing one, such as the ScanMate Magic (roughly $11,000), which has a 10" x 12.5" drum and uses a photo diode to scan at up to 2000 dpi in 36-bit color. ScanMate offers two other scanners—the Plus II and 3000—for less than $20,000, with resolutions of up to 3000 dpi.

In selecting a slide scanner or attachment, key considerations are resolution, color fidelity, and scanning area—probably in that order. Since 35mm slides measure only 24 x 36mm, you'll want relatively high, true (optical) resolutions to capture all the detail they can contain. You'll find 600 to 800 dpi will be sufficient for images used in desktop presentations. Higher resolutions don't give you as much detail as you can use, and they generate humongous image files. We'll look at resolution issues in more detail later in this chapter.

If you have a strong stomach and a stout heart and you intend to scan transparencies for reproduction, you'll want a generous dynamic range to pull information out of inky shadows and luminous highlights. We'll look at dynamic range later, too. Couple that with accurate color, calibration tools, and proofing tools so you can match what you see with what you're going to get on the press.

Don't forget that some transparency attachments for flatbed scanners narrow their scanning area as resolution increases. An 8.5" x 14" scanner may not be able to handle 120-format rollfilm transparencies, 4" x 5", or larger sheet film transparencies at the highest resolutions.

Choosing a Scanner

Resolution may not be your best benchmark for a flatbed or slide scanner. Speed may not be your overriding concern, unless you plan to grab a great many images in a short period of time on a regular basis. So, how do you choose which scanner is best for you? This section looks at some of the key factors involved in choosing a good scanner.

However, if you want only the bottom line, I like the HP ScanJet 3c for applications when 600 dpi is good enough. It's fast, accurate, provides 30-bit color, and can be equipped with a film/transparency adapter that works well for noncritical capture of slides or negatives. If you need higher resolution, look into one of the UMAX or Sharp scanners in the $3,000 price range. I like the Sharp models because their transparency adapter has its own high-resolution sensor—and slide scanning is where you need extra sharpness.

ONE-PASS OR THREE-PASS

Neither three-pass nor one-pass systems have a decisive edge in speed or image quality. So many other factors are involved—such as resolution and how quickly or accurately the device can capture and process an image—that a well-designed three-pass unit can easily be faster and provide better scans than a low-end single-pass scanner. I wouldn't give any weight to this feature at all in choosing a scanner.

COLOR SCANNING CAPABILITIES

Although desktop publishers can get by with a grayscale scanner, photographers must have a color model to get the most from their images. However, color scanners can devour hard disk space with massive multimegabyte image files. An 8" x 10" photograph scanned at 300 dpi in full color can balloon to nearly 22Mb before compression. The lesson? Scan in full color only when you must, and use 256-color, grayscale, or black-and-white scans when they're appropriate. Scan only the portion of an image you need, at a resolution adequate for the intended application.

HIGHER RESOLUTIONS

Today, 400 to 600 dpi scanners are becoming common, with built-in features that simulate—through a process called interpolation—resolutions up to 2400 x 2400 dpi or 4800 x 4800 dpi.

In many cases, the hoopla over higher resolutions is essentially a marketing ploy. In practice, resolution makes a poor criterion for choosing a scanner. There are other factors, such as the *dynamic range*—the range of light to dark tones the scanner can capture—that can make a much more important contribution to final image quality.

If you're scanning continuous-tone originals—black-and-white or color photographs—for output to a low-resolution device such as a 300 to 720 dpi inkjet or laser printer, you'll rarely need resolutions greater than 150 dpi, provided you don't plan to use the image at greater than original size. That is, if you're scanning an 8" x 10" print and it is targeted for a 4" x 5" slot in a layout, 150 dpi will do just fine. But, if the original is a 5" x 7" print and it will be reproduced as a full-page image, higher resolutions can be useful. However, in desktop publishing with low-resolution output devices, the former example is true more often than the latter.

In such cases, with the typical 300 to 720 dpi printer, the effective final resolution used to reproduce grayscale or color images is only 53 to roughly 100 dots (or lines) per inch, so the extra information is largely wasted.

The picture changes drastically if you're scanning for professional reproduction. Reflective art intended for 1200+ lpi imagesetters can look crisper and retain more detail when scanned at higher resolutions. Even so, resolutions much beyond even 250 to 300 dpi (600 dpi is definitely overkill) aren't needed for scanning photographic prints, because the grain of black-and-white images or the dye clumps in color photographs break down the image more quickly than the lack of optical resolution. While you'll often find that photos—with their limited tonal range and image detail—can be scanned and used in many different applications, for the best image quality using relatively low-end desktop scanners, you'll want to scan transparencies, or, if your setup allows it, negatives. When you get into the world of drum scanners, good 8" x 10" C prints can be scanned with the same final quality as film.

All resolution bets are off when it comes to color transparencies or negatives, since they have a lot more information than the typical color print packed into a tiny area. A 24 x 36mm color slide (assuming it's in a glass mount or carrier that exposes the full image area) would generate only a 600 x 900 pixel image when scanned at 600 dpi. Even a 6 x 7 cm original would be scanned to just 1350 x 1650 pixels at 600 dpi. While I've had good luck scanning such images with my ScanJet 3c at 600 dpi, the results are best suited for desktop presentations and other noncritical applications. If you insist on the best quality, you'll want a professional-quality slide scanner with 2000 dpi resolution or better, such as one of the models discussed in the previous section.

HIGHER DYNAMIC RANGE

As a photographer, you'll readily appreciate the importance of dynamic range in a scanner. Desktop publishers and other types of graphics workers tend to focus on resolution and understand less about tonal range.

Photographers, however, are acutely aware of the problems involved in capturing and reproducing a wide range of tones. Until digital photography became so widespread, every photographer cut his or her teeth on variable-contrast enlarging papers and working regimens like Ansel Adams' Zone System. Even today, manipulating lighting ratios, using fill light, and other techniques that take into account the medium's ability to capture detail in highlight, shadow, and midtone areas are part of the photographic art.

Photographers, then, understand the important differences between a photographic print and a slide. A print, which uses reflective light to present an image to our eyes, can handle only tones between the whitest white of the unadorned (or optically brightened) paper and the darkest black of a fully exposed and developed image area. Transparencies (and negatives), on the other hand, use transmitted light and can retain detail in very thin areas of the film as well as image information in fairly dense shadow areas.

In photography, dynamic range—the number of different tones from the purest whites to the deepest blacks that still hold detail—is often measured using a densitometer that determines the point of no density and that of maximum density (called *DMin* and *DMax* for short), on a scale that may run from 0 to 4.0. Conventional scanners do a good job of capturing run-of-the-mill black-and-white or color photographs, which have a limited dynamic range from 0 to about 2 or perhaps 2.3. Color transparencies, on the other hand, can include a much broader range of tones and call for a higher Dmax in the range of at least 3.0 to 3.4.

If you've done much darkroom work, you're probably aware of one other factor that can affect tonal range: the characteristics of the light source itself. An enlarger equipped with a point-source illumination system delivers a high-contrast type of light that tends to make images look sharper, while reducing the apparent tonal range. You might use a lower-contrast paper or lower variable contrast filter to compensate for that. Enlargers equipped with diffused light sources deliver softer illumination to the film, which tends to mask dust spots and defects and reduces contrast of the image.

The most common desktop scanners for transparencies and negatives tend to use a rather diffused light source. You don't get a choice between types of illumination, so you won't have to take this into account.

How do scanners boost their dynamic range? The easiest way to do this is to increase the number of bits used to capture information for each color of the image. A 30-bit scanner, like the HP ScanJet 3c, allocates 10 bits each for red, green, and blue information. The UMAX PowerLook captures 12 bits per channel and is counted, therefore, as a 36-bit scanner.

As you know, a 24-bit scanner (8 bits per channel) captures 256 different colors each for the red, green, and blue information in your image, producing a theoretical 256 x 256 x 256 (16.7 million) different hues. In practice, things like signal-to-noise ratio cause some of the information to be lost before the final 24-bit image can be calculated, so you may get 128 x 128 x 128 (2 million) colors or even fewer. That may not be enough to reproduce a really snappy color transparency.

A 30-bit scanner, on the other hand (10 bits per channel), starts with 1024 x 1024 x 1024 colors (1 billion!), while a 36-bit scanner gives you 4096 x 4096 x 4096 hues (nearly 69 billion!). Even if some information is lost during the scan, these image grabbers have enough colors to work with that they can always internally choose a palette of 16.7 million that best represents your scanned image. High-end color scanners, such as those used in prepress operations, use this oversampling technique to get the best color, too.

Using a Scanner

Early scanners for the Macintosh used connector boxes, while those for the PC required proprietary interface boards and special, memory-hungry drivers to access them. Today, you

can often connect a scanner to your Mac or PC using the same SCSI port you use to drive a hard disk or a CD-ROM drive. Just plug the scanner into your SCSI daisy chain, install some simple software, and start scanning. On my Macintosh, a ScanJet 3c cohabits peacefully with the obligatory SyQuest drive, a Bernoulli cartridge drive that lets me swap image files with my PC, a CD-ROM drive, and an external 2 gigabyte hard disk. My PC has six (count 'em) devices daisy-chained on a single SCSI bus—a CD-ROM changer, an HP ScanJet 3c, and four Bernoulli drives.

Not only has peace been declared between hardware components, but scanning and imaging software have also been more tightly integrated. Scanners for the Macintosh are usually furnished with a Photoshop-compatible plug-in (which means it will also work with ColorIt, Fractal Design Painter, PixelPaint Pro, and other programs) that appears either in your File:Acquire menu, or in the Filters menu itself.

Some scanners for the Mac are furnished with *TWAIN* (Technology Without An Interesting Name) drivers, which have become the most com-mon scanner interface on the PC. TWAIN serves as a common set of driver protocols that can interface Mac or Windows software with a broader range of applications.

Only a few years ago, software developers had to write their own routines to access a scanner's features. A given image editing package might be able to use only a few of the most popular scanners, and support was sure to lag behind new scanner introductions. Scanner vendors were forced to provide dedicated scanning applications or to bundle special "lite" editions of third-party image editors with their hardware.

TWAIN provides a common (although evolving) interface that can couple any TWAIN-compliant software with any scanner that offers a TWAIN driver. There's a downside, however: individual application developers often provide better, more powerful scanner interfaces than those available from the hardware manufacturer. If your scanner's TWAIN driver makes it difficult to adjust resolution, crop a prescan, or select an output format, you're stuck—unless an alternative, such as Corel's TWAIN Source, is available. Some TWAIN drivers, like the MagicScan for Windows, provided with the UMAX PowerLook, are sensational. Others are less than stellar. TWAIN simultaneously expands your software choices and limits your interface options.

On the whole, however, connecting a scanner to your computer has become easier and more troublefree.

Are Hand Scanners Practical?

Although I've written six full books on scanners (three each for the Macintosh and IBM PC), most of the questions I get from readers involve hand scanners. A vast number of people find the low cost and ease of use of hand scanners rather seductive. A typical hand scanner is shown in Figure 6.3.

FIGURE 6.3

A hand scanner. Courtesy of Logitech.

Photographers, who may spend a couple of thousand dollars on a camera body or lens without blinking an eye, probably shouldn't be overly concerned about pinching pennies when it comes to purchasing an essential tool like an image scanner. Yet, the hand scanner's compact size may make you wonder if there isn't a place for such a device in your Domke bag.

After all, hand scanners are the mountain bikes of the scanner world. Fast, compact (like a slightly overgrown mouse), and flexible, they can do virtually anything you'd normally use a flatbed scanner for—and then some. Hand scanners are priced at $150 to $250 for grayscale models, and about $100 to $150 more for color units. Some can be attached to a laptop computer through a parallel port, so portable scanning—say, for reference works in a research library—is now practical.

And, while their swathe is generally limited to 4" to 5", the accompanying software can easily "stitch" together several scans to meld them into a seamless image from larger original artwork. You may find it actually easier to scan an 11" x 17" original with a hand scanner than with a flatbed with an 8.5" x 11" platen.

Indeed, many of the "limitations" of hand scanners can be easily overcome if you know a few tricks like these:

❑ **Watch alignment.** While some scanning software has a "de-skewing" feature to straighten out errant scans, you're better off hand scanning on a straight and narrow path with one of the tray-like devices available, or even with a homemade tool that can be assembled from a few wood blocks glued to a clipboard.

- **Scan "with the grain" of larger images that have strong vertical or horizontal lines.** You'll get better combined images if the "seams" fall on or between one of these lines when multiple passes are stitched together.

- **If you have a grayscale scanner that uses a color LED (usually red or yellow-green), keep the hue of the light source in mind when you scan originals that contain colors.** Red LEDs can't "see" red, so skin tones (particularly ruddy cheeks and rosy lips) are portrayed much lighter in grayscale scans. Greens are portrayed correspondingly darker. You can use this effect to your benefit to drop out stains and unwanted colors or to accentuate other tones.

- **Some hand scanners have a "halftone" setting that produces a dithered image.** Use this only if you scan an image at the same size it will be reproduced in your publication and don't plan (or need) to retouch the image with an editor like Photoshop or PhotoStyler. Once an image has been halftoned, you can't enlarge or reduce it readily or make any other corrections.

- **Concentrate on the strengths of your hand scanner, rather than its limitations.** Explore portable scanning with a laptop computer and hand scanner with a parallel port interface. Take advantage of the hand scanner's zero footprint and instant setup time by keeping one connected and readily available for spur-of-the-moment scanning of articles, pictures, or other material. TWAIN-compatible drivers let your hand scanner become an integral part of desktop publishing, word processing, or image editing applications. A hand scanner can capture books or flat surfaces of objects that are too large or bulky to fit on the platen of a flatbed scanner.

The Next Step

I've tried to provide everything you need to know to decide if a scanner is in the works for you. Unless you work exclusively with images captured by digital cameras, scanners provide a simple way to merge conventional images and digital originals, for editing and manipulation and, eventually, for output. In the next chapter, we'll look at your choices for output devices, including the latest printer and film recorder options.

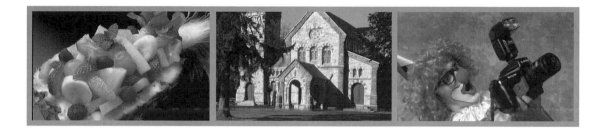

CHAPTER 7

INSIDE OUTPUT TECHNOLOGY

One of the first things a photographer learns is how to look at a negative and decide whether it's too thin to print or if the highlights are blocked up. Any professional can eyeball a set of 35mm slides through a loupe on a light table and pick the good shots from the bad, so why do digital images need to be output as hard copies for proofing or written back to film with a film recorder, when there are big beautiful images that can be viewed at multiple zoom levels on a computer display? Can't we go "all digital" from lens to printing plate?

In practice, there are certain disadvantages to "soft" proofing or previewing images on a monitor, which uses phosphors with an entirely different range of reproducible hues from the dyes used in films or photographic papers. It's one thing to follow a portrait sitting with a quick previewing session with a customer, when the inclination to order an upscale package and multiple prints is highest. It's another to convince an art director that the colors of a garment shown on the display screen will closely match the original when a catalog is printed.

Modern monitor calibration routines notwithstanding, prints and hard copies of digitally processed images will still be required for a long time to come. The process of working with images involves a great deal more than just a single person creating an image, choosing the best version, manipulating it, and sending it on for distribution or reproduction. In many professional environments, it is common for several people to participate in the creative effort, including an art director and other representatives of the client.

Although it's common to find digital image editing workstations in many advertising agencies, photo studios, prepress shops, and other locations, we're still a long way from working in a 100% digital environment. Prints of digital image files have hundreds of uses today, from composites and approval copies to product packaging mock-ups and archival file copies.

Digital files that are output as transparencies can be used in stock photo libraries, and, while someday, photographers may rely on Photo CDs as a flexible, updatable type of portfolio, there is still something to be said for showing off a big gorgeous print.

Because the phosphors used in monitors don't match the inks used on the press, digital printers—which do use cyan, magenta, yellow, and black as their base colors—can produce hard copies that are much closer to what the final product will look like on the press. However, be aware that not all of the devices discussed in this chapter can produce a MatchPrint or other output that would qualify as a contract proof—something a print shop will accept as color guidance for the press run. Just as the invention of densitometers didn't eliminate the test strip, computerized color correction devices haven't made the ring-around obsolete. So, don't expect to dispense with hard copy output of your digital efforts any time soon.

This chapter provides a technology overview of currently popular output technologies. The goal is to help you understand the available options as they apply to photographers. The following devices are a sampling of what products are available. The information supplied, however, can be applied to the full range of output hardware.

How Output Devices Handle Bitmaps

Digital photographs are just another type of *bit map*—an array of rows and columns of picture elements that the computer stores as a file. Information about each pixel, including which of 256 levels of red, green, and blue light should be used to display that pixel (for 24-bit RGB images) or what amounts of cyan, yellow, magenta, or black pigment will go into printed output (for CYMK images) is stored in the file.

Because these images are bitmapped, it would follow that printing them should be simple. Just place a dot in the proper position, using the correct color, and the bitmap is reproduced. Unfortunately, even though most hard copy devices use bitmaps (also known as *raster images*) they don't function the same way with digital images.

Most hard copy output devices—thermal dye sublimation printers being the notable exception—can't print a dot with 256 different levels of tone, whether full color or monochrome is used. Instead, black-and-white printers can either image a black dot or leave the space empty, allowing the white paper to show. These printers simulate gray by slightly varying the size of the dot (using something called *resolution enhancement technology*) or by combining groups of dots to produce a larger selection of spot sizes and generate more gray tones.

If this is starting to sound like the halftone process to you, jump to the front of the class. Computerized *grayscale* images are printed by breaking down the image into a halftone-like black-and-white version. Many of the same techniques, such as the use of elliptical, round, or square dots, found in conventional halftoning, can be found in grayscale images. Some typical computer "halftone" effects are shown in Figure 7.1.

F I G U R E 7 . 1
Digitally generated halftones.

Color printing with a digital printer is done much the same way as color printing on an offset press—using a set of three or four halftone screens. Each screen is set at a different angle to reduce moiré effects and to separately print cyan, magenta, yellow, and black. (Some low-cost color printers don't use black, but instead rely on a rather muddy composite black produced by combining all three primary pigment colors.)

When multiple printer dots are used to create halftone dots of various sizes, apparent resolution will suffer. A 300 dpi printer has sharp .03" x .03" dots. But, if only 16 different tones are going to be reproduced, a cell measuring four of those dots on each side needs to be created. That gives you the option of either filling or not filling each of the dots in the cell with color. Although the cell is larger (so your effective resolution has dropped from 300 dpi to just 75 dpi), the human eye will still blur all the dots within it, combining their tones.

If 4 of the 16 dots have a black spot in them, you'll have what is called a 25% gray. Filling 8 of the 16 dots generates a 50% gray, or what you would think of as a 50% dot. Since there are 16 different combinations of black/white dots in the cell, 16 different gray tones can be produced. Collect enough of these coarser cells into an image and you end up with a halftoned or *dithered* picture, looking much like the photographs printed in newspapers or magazines. The 16 different combinations of dots available with such a cell are shown in Figure 7.2.

FIGURE 7.2

The 16 "dot" sizes available with a 4 x 4 cell.

While an effective resolution of 75 cells per inch (using our 4 x 4 printer cells) provides resolution that is comparable to what you see in a daily newspaper (e.g. A 65- to 85-line screen), in truth it will generate only 16 gray tones, while a newspaper picture at the same resolution can reproduce many more grays. This is because even at 85 lpi, a conventional halftone can include many more dot sizes than can be achieved with digital output at the same resolution.

Sixteen gray tones are not enough to reproduce a black-and-white photograph. The human eye needs at least 64 grays to see a realistic image.

An 8 x 8-dot printer cell cuts the effective resolution of a 300 dpi printer down to 37.5 lpi, providing enough gray tones but not enough resolution—hardly a solution. For this reason, higher-resolution monochrome printers have made serious inroads during the past few years and 600 dpi devices have effectively become the acceptable minimum.

A 600 dpi printer offers at least 64 grays and 75 lines per inch. Most of them use resolution enhancement to vary the size and position of the laser spot that images a dot, providing higher resolutions and up to 256 grays.

Ink-jet and thermal wax color printers use this same dithering technique, only with the ability to lay down multiple dots in the same place and create additional colors. The dots of each particular color are rotated slightly so they are not directly on top of each other, mimicking the screen angles originally used for camera—and now scanner—color separations. Because resolution enhancement techniques aren't yet widely available for ink-jet and thermal wax printers, those may only provide 256 different colors.

Recently, ink-jet printers with up to 720 dpi resolution have offered a low-cost color output alternative with enough colors to offer photo-realistic output.

Thermal dye sublimation printers produce black-and-white and color a little differently. They are able to transfer exacting amounts of each color to a special printing surface, generating 256 grays or 16.7 million colors at the printer's full resolution. This produces near-photographic quality. At the very low end, the Epson Stylus Color printer (which costs less than $600) has output that printers of a few years ago that were ten times more expensive could not match. A compact printer, the Epson is typical of most desktop devices today (see Figure 7.3).

FIGURE 7.3

The Epson Stylus Color printer.

In the next section, I'll explain how each of the main printing technologies works, beginning with black-and-white printers.

How Page Printers Work

The most commonly used output device for the kind of images we've been working with is one of several types of page printers. Not all printers of this type use lasers to write an image. The laser device found in color laser printers is nothing more than a very precise light beam that is used to expose a pixel from the bit map of your page onto a photosensitive conductor, which may be a belt or a drum. Other equally precise light sources can also be used. For example, some printers use *LEDs* (light bar arrays of up to 600 dpi) to make the exposure, while others put a liquid crystal shutter to work to modulate the light that prints pixels onto the photoconductor.

Beyond the light source, the imaging process is fairly standard in common page printers and involves several different components.

CONTROLLER

To print a page containing a scanned image, a page printer must have a bit map. The bit map can either be downloaded directly to the printer from your computer or the computer can send instructions for building the bit map using the *QuickDraw* or *QuickDraw* GX programs in the Macintosh or the *PostScript* program for both PCs and Macs. *Hewlett-Packard Printer Control Language* (PCL), can also be used in a PC.

The controller, which converts instructions to a bit map, is sometimes called a *raster-image processor* (RIP) because a bit map is a type of raster image. RIPs are found in desktop and personal workgroup printers and in high-resolution printers called *imagesetters*. The RIP is most commonly considered an integral part of your desktop printer, but it is a separate component in an imagesetter because in the prepress environment they are frequently upgraded or replaced without necessarily making changes to the rest of the output device.

The controller has access to the full complement of memory in the printer, some of which can be dedicated to storing bit-mapped images of various fonts, called *soft fonts*, which are created by software rather than hardware. To create a soft font, the application sends a code to the printer, activating a particular font. Then, when an ASCII code corresponding to an alphanumeric character is received, that letter, number, or symbol is printed in the selected font.

IMAGE WRITING

Writing can be done in one of two ways. Either the printer can expose the image area (the black lines of your scanned image or text), which is called a *write black* printing engine, or it can expose the white areas on the page (skipping over those pixels that are to be printed black, which is called a *write white* engine.

Since the laser, LED, or liquid crystal shutter must scan each line on the page, it doesn't take any longer to write the white areas than to write black. However, each of these systems has advantages and disadvantages.

With write black systems, toner is attracted to those areas of the drum that have been illuminated by the writing light source. Such systems are better at defining very fine details, since only the pixels of the image are written to the photoconductor. All other areas of the drum or belt are left untouched, reducing the chance of spurious pixels that can produce artifacts that reduce resolution.

In write white systems, toner is attracted to those areas not illuminated by the writing light source. Because of the toning systems used, this usually results in much denser black areas.

Write black printers are often preferred by those who use laser-printed pages as masters for offset printing, because ink used in lithography tends to soak into a page and spread. (The degree to which ink spreads depends on the type of paper stock.) Photographers frequently notice this spreading in a halftoning phenomenon called *dot gain*, which must be allowed for when preparing photographs for press.

TONING ENGINE

Like the rotating photoconductor belt or drum and the paper, which are supplied with an electrical charge from a set of charging coronas, the toner itself is also electrically charged, either through the addition of charging agents or because of natural electrical characteristics.

Toner contains pigment (black , in a monochrome printer and one of the four primary colors in a color printer), and the somewhat larger carrier particles to which the pigment clings. The image areas on the drum are given one charge (positive or negative) while the surrounding areas have the opposite charge. Toner particles also have the opposite charge and are, therefore, attracted to the image areas and repelled by the nonimage areas. The toner is picked up by the drum and is transferred to the paper, which is charged to attract the toner. The paper then passes through a set of heated fuser rollers, permanently fusing the toner to the paper.

Color page, or laser printers, work much the same as their black-and-white cousins, except that each image is run through the exposure, image writing, and toning steps four times (once each for cyan, magenta, yellow, and black portions of the image) rather than once. Obviously, separate toning stations must be provided in the printer for each color. Once all four colors of toner are transferred to the electrically charged drum or belt, they are transferred to the paper and permanently fused with heat. Because of their complexity, color page printers are often considerably more expensive than many of the alternatives.

Laser-type color printers typically don't provide quality that is as good as that of dye sublimation printers for photographic output, but they are much better with fine lines and text. These printers were long thought of as best suited for spot color—images with specific elements that must be represented in cyan, magenta, yellow, red, green, or blue rather than continuous tone output.

Laser Printers Today

There's something of a price war among vendors of color laser printers, which is good news for photographers who need this type of output. While there are some models priced less than $6,000, the best in terms of price and performance start at around $7,000. One of these is Apple's Color LaserWriter 12/600 PS. Unlike other color lasers in this price range, the 600 dpi Apple does a good job of mimicking continuous tone output, and it includes Color Sync 2.0 to allow more accurate calibrating and color matching between input sources (such as scanners or digital cameras), displays, and output.

Another printer in this price range is the QMS Magicolor, which comes standard with 24Mb of RAM—twice that of Apple's basic configuration. Upgrade to 28Mb, however, and you can image photographs as large as 8" x 14". Also 600 dpi, the Magicolor does an excellent job in outputting photographs, and it can print on transparency film, glossy paper, and thick card stocks (up to 43 pounds.) It also costs less than Hewlett-Packard's Color LaserJet, which is a 300 dpi device.

At the higher end of the price scale, you'll find devices that can perform double or triple duty as color printers, color copiers, and proofing devices. Ricoh's NC5006, for example, can output six pages per minute at 400 dpi on tabloid-size or smaller paper. To connect this $30,000 copier to a PostScript device, the widely used *Electronics for Imaging* (EFI) Fiery controller is required. This can cost about as much as the copier itself. Expenditures this large start to encroach on digital color proofing systems and may be out of range for most photographers.

Ink-Jet Printers

Ink-jet printers, which spray a jet of ink onto paper under precision computer control, offer good resolution—360 to 720 dpi—and the ability to produce color at reasonable prices ($600 to $3,000).

Ink-jet images are formed one dot at a time using a fine stream of ink, either water-based or solid (which is melted just before application), in disposable or refillable ink cartridges. Piezoelectric crystals in the ink containers vibrate as electric current flows through them, issuing carefully timed streams of ink from a tiny nozzle, generating a precisely positioned dot.

Liquid inks tend to soak into paper and enlarge the size of the dots, so a 360 dpi printer may produce output that looks no better than 300 dpi when the page dries. A special paper stock may also be required for optimal results with this kind of printer because liquid inks can smear when they are wet.

Printers that use solid inks, used in called *phase change* printers, are less finicky about paper quality, since any tendency to absorb ink can be ignored. On the other hand, solid inks produce washed-out overheads when used on transparent material, and they tend to cost more than liquid ink.

The first ink-jet color printers used just three ink cartridges—cyan, magenta, and yellow—and simulated black by combining equal quantities of all three colors. There are a couple of problems with this approach. For example, composite blacks tend to be brown and muddy rather than true black. Black ink is also less expensive than colored ink, so it makes little sense to use three times as much expensive ink to create black tones, especially when generating black-and-white-only pages, such as pages of text. Because of these problems, most color ink-jet printers today use four cartridges—cyan, magenta, yellow, and black.

If you can afford an expensive color printer, high-end models like the Iris or Stork (priced in the tens of thousands of dollars) are two of the only printers mentioned in this chapter that are accurate enough to be accepted as contract proof.

Thermal Wax Transfer Printers

Thermal wax printers are more expensive than some ink-jet models, but at $1,500 to $4,000, they can produce better quality at higher speeds. In the past, these printers required special ultrasmooth paper, but many can now use ordinary cut-sheet paper.

Unlike ink-jet printers, thermal wax models don't complete each line in all three (or four) colors before moving on to the next. Instead, each page is printed three or four times, depending on whether a three-color or four-color process is being used. As you might guess, such printers must maintain rigid registration standards to ensure that the dots of each color are positioned properly in relation to those of the other colors.

The *printhead* of the printer is a component with thousands of tiny heating elements that turn on and off to melt dots of wax coated on a wide roll of plastic film. The roll contains alternating panels of cyan, magenta, yellow, and often black. Each panel is the size of the full page. The printhead applies all the dots for one color at a time as the page moves past. Then the roll advances to the next color (each panel is used only once) and those dots are printed. After three or four passes, the full-color page is finished.

Because a thermal wax printer always uses all three (or four) panels in a set, some capacity is wasted if the image only requires one or two of those colors or if color is applied in only a small area of a page. On the other hand, there is no additional cost to produce pages that have heavy color demands (such as overhead transparencies), so you may come out ahead of ink-jet printers in cost (and image quality) if you do much work of that type. Additionally, the capacity of each roll is highly predictable: a roll capable of 100 images will produce 100 images—no more, no less.

Both ink-jet and thermal wax printers take an all-or-nothing approach when it comes to laying down dots of color, so they suffer from the same tonal range constraints as monochrome page printers. However, the extra information offered by color images can make output from these devices look significantly sharper than those produced by a laser printer of the same resolution.

Interestingly, there are a number of printers, such as Fargo's low-cost Primera Pro (see Figure 7.4) or Seiko's Professional ColorPoint 2, that can use either thermal-wax transfer or thermal dye sublimation, giving you the option of saving money or having high image quality. We'll look at dye-sublimation printers in the next section.

FIGURE 7.4
The Fargo Primera Pro printer.

Thermal Sublimation Printers

A thermal sublimation printer uses a thermal process to transfer dye to the printed page. The advantage of thermal dye sublimation is that the heat used to transfer the dye can be varied continuously over a range of 0 to 255, allowing different shades of a given color to be printed. Resolution lost through dithering is not a factor, therefore these devices can reproduce photographic-quality images. For the price, if you want the absolute best-quality reproduction of images, a dye-sublimation printer is the only way to go. (High-end Iris or Stork ink-jet printers, and even the new Apple Color LaserWriter 12/600 PS produce superior output.)

Like thermal wax printers, dye-sublimation models use a continuous ribbon with alternating bands of color and a printhead equipped with tiny heaters. However, these heaters are not just switched on and off: their temperature can be precisely controlled to transfer as much or as little dye as required to produce a particular color. The dye in these printers *sublimates*—turns from a solid into a gas, without becoming liquid—and is absorbed by the polyester substrate of the receiver sheet.

A special receiver paper with a substrate and coating that accepts the dye transfer is required for this type of printer. Media costs can run several dollars per page (the 11" x 17" full bleed output of the Radius ProofPositive runs about $6.50 a page), compared to roughly 50 cents a page with ink-jet or thermal wax printers.

Because they don't require dithering to reproduce colors, dye-sublimation printers can offer photographic quality without using a linear resolution as high as other printers. The dots diffuse evenly onto the receiver sheet, producing a smooth blend of colors. While you'd

never notice that a dye-sublimation printer may use as few as 163 to 200 dpi to generate dazzling full-color images, text that is printed in small sizes and finely detailed line art at that resolution will suffer from this diffusion. These printers are great for 24-bit images, but less stunning when your bit maps are combined with text or lines. To alleviate this problem, some models provide antialiasing, and most newer models go to 300 dpi output.

Thermal sublimation printers are useful for preparing special reports and other photo-intensive material in small quantitsies, but keep in mind that they are expensive to operate, and they are slower than other options (about three minutes per page).

On the plus side, some of these color printers can accept PostScript output, either directly or through a software interface. Starting at $5,000, they can be justified by any photographer who does a lot of color printing and wants to proof work and by those who need short-run color documents.

Since these printers are entirely practical for use as rough color proofing devices (but not for contract proofs), make sure you get and use a color matching system to calibrate your printer to the final output device. Most come with some sort of proof-to-press color matching software.

The double-duty wax/dye-sublimation printers are the most economical to operate, since you can choose between rough-proof quality and near-photographic quality. Fargo's Primera Pro delivers up to 300 x 600-dpi images on paper as large as 8.5" x 13". If you need a tabloid-sized digital printer, Fargo's Picture 310 handles paper 12" x 18". Kodak, which introduced one of the very first dye-sublimation printers in its XL7700 back in the late 1980s, has a very fast offering in its XLS-8600PS (see Figure 7.5), which can produce an 8" x 10" print in 70 seconds or less. It has a black-only "XtraLife" ribbon that is ideal for photographers who work with a lot of grayscale images.

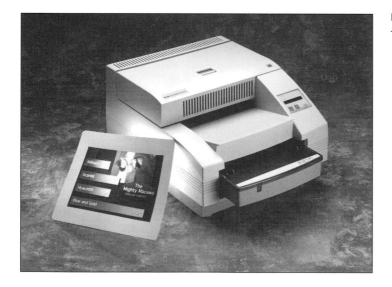

FIGURE 7.5

The Kodak XLS-8600PS printer.

Film Recorders

It's one thing to capture a color negative or transparency in digital format, and it's quite another to go in the other direction. The most significant factor to consider when writing a digital file to film is that nearly any piece of original camera film has quite a bit more information in it than most digital systems use. A 35mm Kodachrome slide scanned at 2000 dpi probably has at least twice that much picture information. Our ability to build high-resolution scanners and computer systems to process 30 to 120Mb image files in a reasonable amount of time is the real limiting factor—not the film.

So, what happens when you write a digital image back to film? Unless you're using a very high-resolution film recorder, the results are apt to be less than satisfactory. When a low-resolution film is viewed in a projector or under a loupe or scanned for reproduction, the pixels stand out like the proverbial sore thumb.

As a result, good film recorders are not cheap. Mirus offers its FilmPrinter Turbo II ($7,000/4000 dpi) and Galleria ($10,000/5000 dpi) 36-bit printers that can output 35mm color slides in 70 seconds or less, with no color processor required.

Many other recorders use conventional film and require an additional processor, with a comparable hit on the pocketbook. Lasergraphics' 4000-line LFT Mark II and 8000-line LFR Mark III start at around $18,000 (the company does offer a 4000-line Personal LFR Plus for $6,000 that produces 35mm slides only). Most other processors with 120/220, 70mm, 4" x 5", and 35mm formats are priced at $30,000 and up. Symbolic Sciences' Fire 450, for example, costs $79,000, but is fast enough to produce a 4" x 5" image in nine minutes.

Film recorders use high-resolution monitors or plotting-type imaging to expose digital images onto conventional photographic films. Working with these devices is part science and part art form, so most photographers are better off relying on service bureaus, which are set up to produce film in large quantities and can provide their expertise at economical prices.

The Next Step

Output devices are something a digital photographer just can't do without. Using output devices, prints and slides can be routed for approval, marked up for cropping or editing, and archived in stock libraries and files. Digital files output to film can even be rescanned and reproduced.

In the next chapter, we'll look at other hardware needed for digital photography. The realistic minimum configurations you should consider will be explained, and we'll even tackle the old PC-versus-Macintosh debate in a way that I think you'll find honest—and surprising.

CHAPTER 8

DIGITAL HARDWARE

In Chapters 6 and 7, we discussed two key peripherals used by digital photographers. In this chapter, we'll explore the other hardware components of the computer system, beginning with the Big Question.

Mac or PC... or Something Else?

For some time the choice for many photographers has been the Apple Macintosh. For those photographers, the decision was similar to selecting a 35mm Canon SLR for photo journalism, or a Sinar view camera for studio work—a no brainer. While I don't have hard figures, my gut feeling is that Macs significantly outnumber PCs in imaging environments while the opposite is true in the rest of the business world.

There are higher-end imaging workstations that aren't Macs—such as Intergraph's dual-Pentium TD workstation and some pricey all-in-one editing, retouching, and previewing systems intended for studios—and some photographers even use expensive workstations that are fully capable of doing top-shelf video animation and 3D rendering work.

By and large, though, the latest Power Macintoshes and their clones provide enough muscle for still image work, particularly when equipped with Photoshop accelerator boards and 128Mb or more of RAM. Keep in mind, these are not bargain basement systems since it's not much of a stretch to spend several thousand dollars on RAM alone.

While a Mac may be your first choice because of its compatibility with the rest of the graphics world, there are some solid reasons why you might want to consider a Windows-based system. I am, after all, *not* one of those Macintosh snobs who think that "Wintel" computers are just Mac wannabes. I've always done at least 60% of my imaging work on IBM PCs, and I upgraded to a Pentium-133 system before I got my first Power Macintosh. My only bias is in favor of the fastest, most capable and flexible imaging computer I can afford.

PROS AND CONS

The Mac's head start in the digital imaging race can be traced to its early compatibility with PostScript and its wonderful graphics-oriented interface. Microsoft Windows has been working to catch up to the Macintosh for the past decade, and only with Windows 95 has it achieved anything close to parity in terms of ease of use. As a result, the Macintosh has enjoyed a great many firsts in the digital imaging field, including the following:

❑ The Thunderscan unit replaced the ribbon cartridge on an ImageWriter and laboriously scanned in dithered black-and-white images of any original that would fit through the printer's rollers.

❑ Early image editing programs such as Digital Darkroom and the ground-breaking Photoshop were available on the Macintosh years before anything with similar power was offered for the PC.

❑ Most software breakthroughs become available for the Macintosh months—or even years—before similar capabilities come to the PC.

❑ Digital cameras, scanners, and output devices have typically interfaced with Macintoshes first because of demand and the Mac's inherent plug-and-play nature.

Macs have often been easier than PCs to upgrade in terms of memory, hard disks, and other peripherals (although frequently at higher prices). While the adage "the customer is always right" may be true in some fields, service bureaus and prepress houses are often highly prejudiced against non-Mac users.

PCs, on the other hand, are more numerous because they are used more often in non-imaging business environments and by home users who want to remain compatible with their office systems and who see the PC as a way to get more power for their money.

Macs have traditionally been considered more expensive when compared feature-for-feature, although so much is built into the Mac that absolute comparisons can be misleading. Power Macs definitely seem competitive with equivalent "Wintel" machines.

Even though the Power Macs appear to be competitive, anyone who needs to get double duty from his or her computer, while remaining compatible with what everyone else is using, may find that PCs are the more cost-effective way to go. Today, just about anything that can be

done on a Macintosh can also be done on a PC. Photoshop 3.0 was released in a Windows version only a few months after the Mac version came out, and other tools—from Kai's Power Tools and Convolver to Fauve's xRes—are available on both platforms.

Dropping Prices, Rising Capabilities

The prices for photographic equipment have remained fairly stable in comparison to the inflation curve over the past decade or two. A top-of-the-line Nikon or Canon body can be purchased today for roughly the same price as the equivalent model a decade ago. If you adjust for inflation, a Hasselbad 50K with 80mm F2.8 normal lens costs about the same as the venerable 500C of 25 years ago. The Pentax 6x7 I bought in 1970 remains on the market for close to the price I originally paid—making a current model cheaper, and with TTL pentaprism it is also more capable than the one I still own. Compared to the price drops and capability increases of computer equipment in the past decade, you should be able to purchase a Linhof Master Teknika for $500 or a new Leica M6 for about $200.

I paid $3,495 for my first IBM PC in 1982. It had 64K of RAM, no hard disk, and a monochrome monitor incapable of displaying graphics in any form. My first 128K Macintosh arrived in March 1984 with a $2,495 price tag and a single floppy disk drive that could store only 400K worth of data. A decade later, I purchased a 133MHz Pentium with 24Mb of RAM, a 1.2Gb hard disk drive, and a 17" SVGA monitor for approximately the same price as my original PC. By the time this book is finished, I'll be buying one of the new PCI Power Macintoshes with 32Mb of RAM and a lot more than 64 times the speed of my first Mac— for virtually the same price.

Because of this competitive pricing, you can build yourself an image-capable PC or Mac for $6,000 to $10,000 today that makes a $40,000 workstation of a few years ago look outdated. Put another way, for a lot less than you'd spend on even the most conventional professional camera outfit (a camera body or two and a couple lenses) you can get a fairly powerful computer to manipulate your images.

What do You Need?

Image editing is among the most demanding types of work you can put on a computer, so before you start, it's important to know about the minefields along the way.

The following is my top ten most important things you'll need to consider when building a system:

1. RAM
2. RAM

3. RAM

4. Adequate local storage (fast, big hard disk)

5. Microprocessor

6. Expandable/archival storage

7. Video capabilities

8. Other peripherals

9. RAM

10. RAM

I've listed RAM five times on my top ten list, because even though a fast, big hard disk is important (both to give you room to work with your current project's files and as a substitute for RAM when you do run out), *nothing* can replace memory when decent performance is your goal.

When working with images, you must have at least twice as much RAM as the largest image file you plan to work with on a regular basis. Without that, all the money spent on a super-speedy microprocessor or Photoshop accelerator board is completely wasted. Other heavy-duty hardware will come to a screeching halt every time you scroll, apply a filter, or perform any of a number of simple functions. Without enough RAM to keep the entire image—and your image editor's "undo" file (a copy of the image in its most recently saved state)—in memory at once, your computer will be forced to write some or all of the image to your hard disk to make room for the next portion with which it needs to work.

Using a hard disk to simulate RAM is called *virtual memory*. Macs get virtual memory through either the Memory Control Panel or add-on utilities such as RAM Doubler. Some programs, such as Photoshop, use their own virtual memory schemes. Windows 3.1 PCs achieve virtual memory through the Enhanced Control Panel, using either a permanent swap file of a fixed maximum size that has been specified or a slower temporary swap file, which can consume as much as half of the hard disk drive it uses. Windows 95 lets nearly all of the hard disk space go to virtual memory. No matter which substitute is used, virtual memory is slow.

A simple analogy should make this clear. Hard disk drive speed characteristics are expressed in milliseconds (thousandths of a second), while memory response is described using nanoseconds (billionths of a second). Think of it as the difference between a one-second time exposure and one that lasts almost 32 years! While RAM operations aren't really a million times faster than those involving your hard disk, it may seem like it if you try to work without enough memory.

Memory is the least expensive performance enhancement you can put into a graphics system. All image processing applications run faster when an entire multimegabyte image and the duplicate used to undo aborted operations can be kept in RAM, rather than on your hard disk. With the cost of memory roughly $25 a megabyte, it is not unreasonable to equip a graphics workstation with at least 32Mb of RAM.

Images created with digital cameras using 1000 x 1500-pixel sensors average 6Mb each; those generated by high-end 2000 x 3000-pixel imagers run closer to 18Mb. They may use less room than that on your hard disk, but remember that images load into your RAM in uncompressed form, so 32Mb of RAM will allow you to work with either two or three lower-resolution RGB images or an equal number of high-resolution grayscale images.

The same amount of memory is barely enough to work with even a single high-resolution, 18Mb image, so if you need to composite several such photos or manipulate even larger image files, plan to install at least 48 to 64Mb of RAM. Macs, and more recently PCs, equipped with 128 to 256Mb of RAM are also fairly common these days.

PC RAM Tips

Windows 3.1 users should allocate 2 to 4Mb to SmartDrive or another disk cache (unless you're using Windows for Workgroups 3.11, which uses its own 32-bit Fastdisk access scheme instead). Leave the rest of the RAM as extended memory. Windows always uses available RAM before it touches a temporary or permanent swap file, so upgrading with an extra 32Mb of RAM will be the best $800 to $1,000 you've ever spent.

With Windows 95, the operating system should handle memory effectively—as long as there is enough of it.

Macintosh RAM Tips

Allocate 256K to 512K to a disk cache (through the Memory Control Panel), and possibly another megabyte or two to a RAM disk if you're working with an older graphics program that insists on creating temporary files even if RAM is still available. Direct those temporary scratch files to the RAM disk. That will not only speed up the application, but you won't have to hunt and erase scratch files if your system crashes. Reboot, and you have a clean RAM disk. Ordinarily, it's unnecessary to use a RAM disk for temporary files, because in most cases a program won't need to create such a file until all RAM is used up, and that will happen sooner if you work with a RAM disk. Some software won't let you avoid temporary files, however, no matter how much RAM you have. The Mac's Memory Control Panel is shown in Figure 8.1.

FIGURE 8.1
Macintosh OS Memory Control Panel.

The rest of the RAM can be devoted to running applications—either as one huge program or as a number of smaller programs. Software like Photoshop can require 4 to 5Mb just to load, and when you're working with one or more 24-bit images, it's easy to eat up another 8 to 10Mb or more for each image. Don't forget that for Photoshop to effectively use extra RAM, you'll need to open up the Get Info box and enter a higher figure in the Preferred RAM box. Otherwise, Photoshop defaults to using only 8Mb of RAM. The Get Info box is shown in Figure 8.2.

FIGURE 8.2
Don't forget to tell Photoshop to use additional RAM.

What you want to avoid, when possible, is the use of virtual memory to substitute for RAM while working within a single application. As mentioned earlier, using the hard disk to simulate memory is much slower than electronic memory.

Virtual memory is fine if you have three or more nongraphics applications loaded simultaneously. When you switch from Microsoft Word to Excel, there may be a slight pause as your Mac dumps Word from memory onto the hard disk and pulls up Excel in its place, but the delay may not even be noticeable.

If all that is running is Photoshop, however, and your system must continually bring pieces of the current image off the disk, saving other pieces to make room, you can easily spend more time exercising the hard disk than doing actual work. In the worst case, the system may *never* have everything it must have in memory all at once, and it will suffer from a syndrome known as *thrashing*.

Other memory-stretching options have come on the market recently, which may or may not provide benefits to Photoshop users, since the Adobe application uses its own memory routines and doesn't gain anything from either of the new options. Regardless of the relationship to Photoshop, OptiMem from Jump Development Group, and RAM Doubler from Connectix Corporation are the best-selling Mac utilities.

Each of these new options takes a different approach to using memory more efficiently. Normally, applications will grab as much memory as they can, up to the amount specified in the program's Get Info box, even if it's more RAM than they really need. OptiMem, however, places all RAM in a common pool and allocates only enough to each application to get it up and running. More is provided, but only if actually required by the application. In most cases, Photoshop and other image editing programs use quite a bit more than the minimum, so OptiMem won't help much unless you're fooling around with one or two very small images.

RAM Doubler works differently—grabbing all available RAM when the Mac boots, telling the system that it has twice as much memory as it really has, and then allocating it to applications as they request it. To make memory go farther, RAM Doubler compresses the information in memory that has been least recently used and turns into a virtual memory manager when it finally runs out of RAM, paging portions to the hard disk, if necessary, using virtual memory.

Neither OptiMem nor RAM Doubler help if you want to run a single program like Photoshop, which requires a lot of memory, but they can make your available RAM go farther by keeping inactive applications from tying up more memory than they really need.

When you do buy RAM, I urge you to purchase modules with higher capacities in order to preserve your upgrade options for the future, if your particular Mac allows it. Older Macs force you to upgrade with *banks* of four identical single in-line memory modules (SIMMs), so your only choice may be between four 1Mb, 4Mb, 16Mb, or 32Mb modules.

Newer Macs, which use 72-pin SIMMs or double in-line memory modules (DIMMs), allow you to add a single module (68040-based machines) or pairs (Power Macs). When you do have the option, don't buy four 8Mb SIMMs for a Mac with only four memory slots, even if you feel that you will never need to upgrade the system beyond that. Instead, get two 16 Mb SIMMs or DIMMs or one 32Mb module and leave two or three RAM slots open, just in case.

CACHE CROP

A memory cache is a special kind of RAM used to keep your microprocessor constantly supplied with data and instructions with a minimum amount of waiting time. All true (Intel) 486, Pentium, and P6 microprocessors have an 8K to 32K on-board instruction cache. Most systems in this performance range have an external secondary (or Level 2) cache of 64K to 512K. The 133MHz Pentium can manage even more external cache, although the system was designed for multiprocessor setups.

Macs and Power Macs also have separate on-board instruction and data caches and can be accelerated by plugging a card like DayStar's PowerCache into the Processor Direct Slot (PDS), with 32K to 256K or more of additional high-speed RAM.

Graphics software often includes instructions that are carried out on successive portions of an image through many iterations, so it's a plus to have instructions ready and waiting in the cache.

While the difference between a medium-size external cache and a huge one might be a hit rate (the information needed is already in RAM) of 97% bumped up to 99%, the added cost is not a lot ($300 or less), and even a single percentage point can translate into a lot of wasted CPU cycles. This is especially true with PowerPC-equipped Macintoshes: because they process simpler sets of instructions rapidly, RISC (reduced instruction set computer) systems like the Power Mac benefit even more from cache than do CISC (complex instruction set computer) chips like the 680x0 series. Extra cache on this type of machine can theoretically improve microprocessor performance by 20 to 30%.

SLIP YOUR DISK

The graphics powerhouse is only as fast as its narrowest bottleneck, so pay special attention to the biggest potential roadblock: the mass storage subsystems.

Some of the mass storage problem can be solved by getting the fastest, most expandable hard disk possible. Today that means a Fast (or Wide) SCSI-II or SCSI-III hard disk linked to a bus-mastering adapter.

You can daisy-chain up to seven hard drives, scanners, CD-ROM drives, and removable cartridge devices on a single SCSI bus.

It's important to note that the SCSI bus can fill up rather quickly, and if you're not careful, you might not be able to add a key SCSI peripheral—such as a digital camera—without dis-

connecting another device. It's usually better to connect a single, larger hard drive than several smaller ones with the same total capacity, to prevent using all the available SCSI ID numbers.

Settling on a reasonable capacity for the hard disk drive is not easy to do. Whatever you have will ultimately not be enough, so plan on using some sort of removable storage, which is discussed in the next section.

The good news is that hard disks are reasonably priced. I just paid $449 for a 2Gb SCSI-II drive, and I expect that prices will go even lower during the life of this book. I added this new drive to a varied collection of drives, adding up to nearly 6Gb on my main machine. My problems and storage needs may be fairly common, so you may be interested in my reasoning for setting up my system the way I did:

❑ Twin 1.4Gb drives, which store my system software, main programs, and important data in exact duplicate form on each drive. That is, I work with one of the 1.4Gb drives, and everything is automatically copied to the second at intervals, giving me a constantly updated backup. If you have $4,000 to $10,000 or more to spend on a hard disk subsystem, you can purchase a RAID (redundant array of inexpensive disks) setup that will automatically mirror the data to two or more hard drives. I have to type a command to back up my twin disks, but the cost was the $259 I paid for each of the 1.4Gb drives.

❑ One 1Gb drive set aside as a scratch disk. This drive is used for nothing but currently active projects. It can fill up quickly, but I try to remove older files every couple of weeks.

❑ One 2Gb drive that stores files for recent projects that I want to hold onto longer. I probably would have been happier with a 4 to 9Gb drive—and you should consider one—but these four drives cost less than $1,400, and splitting up files among them is not inconvenient. Everything important is backed up regularly to other media.

AVOIDING NO-BRAINERS

A speedy hard disk can actually have more impact on performance than a system's CPU. A Mac II or a 486 computer with an empty 2Gb hard drive may actually seem faster than a Power Mac or Pentium computer with a crowded 540Mb disk that has only a few scattered sectors available for storage.

If you're buying a new machine, however, there's no reason not to buy one with the fastest microprocessor available—within reason. The CPU chip processes many of the program instructions—everything that isn't handled by a separate digital signal processing chip—so the faster it runs, the faster your image editing software will work.

Each individual pixel of an image involves at least one byte of information (an RGB image requires three bytes, a CMYK image needs four bytes, and additional alpha channels

take up one byte each). Even a relatively small 640 x 480-pixel 24-bit image can involve nearly a megabyte of data.

If the image editor is asked to apply an image processing filter to an entire image, the microprocessor must calculate the effects of that filter on each and every one of those million bytes. This request can take a second or two with a fast system, or as long as a minute or more with a slow one. Although there are other constraints (such as memory or hard disk speed), nearly everything done on a system is affected by the speed of the microprocessor, making a fast CPU a major consideration when assembling a graphics workstation.

PC owners should consider a 100 to 133MHz Pentium machine, because the price to performance ratio is attractive. These models operate a bit faster in image editing applications than 60, 66, 75, or 90MHz versions and are not noticeably slower than Pentium-150 or P6 models. On the Mac side, any PowerPC microprocessor operating at 80 to 110MHz or faster will do the job. Be aware that IBM is scheduled to introduce PowerPC systems at about the time this book is published.

Fast microprocessors should be coupled with a PCI bus. Since Apple adopted this bus for its latest Power Macs, peripheral card vendors are eager to begin production on video cards, Photoshop accelerators, and other add-ons that can be used in either Mac or PC platforms with a minimal amount of driver support. The PCI bus, which allows cards to "talk" directly to the microprocessor, is not only fast, but it will be the rallying point for a peripheral price war in the coming months, so be ready.

There are other considerations beyond the CPU chip and PCI bus. Newer Macs may include AT&T DSP3210 digital signal processor (DSP) chips. Older Macs can add a DSP through an add-in board. A DSP is a coprocessor designed to apply large amounts of numerical calculations to data rapidly. They are particularly useful for real-time operations such as digital audio and video. While it may be acceptable to wait while a Photoshop filter is applied to an image, there shouldn't be any waiting time between frames of video images.

If you don't plan to work with multimedia you may not need the built-in DSP capabilities of some Macs. But keep in mind that specialized add-in boards intended to speed up programs like Photoshop are available for $1,500 to $5,000. (That's a lot of money, but professionals who work with Photoshop all day can make up the price in a few months.)

Secondary Considerations

Even the largest hard disk drive can fill faster than Yankee Stadium on Bat Day. Because of this, your graphics powerhouse needs open-ended storage that is relatively cheap, reliable, and provides near-on-line access speeds—SyQuest and Bernoulli drives have long been popular in such applications for those reasons.

These drives don't eliminate tape backup as a secondary storage medium. While you may not want to search a serial medium like tape from end to end when you need a crucial file

right away, it's actually more common to reload an entire project—all 200Mb of it—from a single tape. In such cases an inexpensive, easily accessed DAT (digital audio tape) can be faster and just as convenient.

Removable Bernoulli cartridges or SyQuest hard disk cartridges are the traditional choice for offline storage when files need to be sent to clients or service bureaus. Both media seem to have reached something of a dead end in terms of capacity and cost efficiency, however, and they are likely to be replaced by newer options like Iomega's Zip and Jaz drives or SyQuest's EZ series. It is also possible that something, such as a rewritable optical disk, may become the new standard.

Bernoulli media, available in 5 1/4-inch cartridges with up to 230Mb in capacity, provide nearly crash-proof storage, since the type of events that cause hard disk crashes tend to force the giant floppy disk inside a Bernoulli cartridge *away* from the head. SyQuest cartridges are true hard disks, but they are robust enough to allow transport to service bureaus. Nearly all service bureaus can accept graphic files for output on SyQuest cartridges, while a smaller number can work with Bernoulli media. That alone might be enough to sway your decision. At roughly 50 cents a megabyte, neither Bernoulli nor SyQuest cartridges are inexpensive, but at the same time, they are not outrageously expensive. An Iomega JAZ drive is shown in Figure 8.3.

FIGURE 8.3

JAZ drives are safe, widely available removable storage subsystems. Courtesy of Iomega.

SyQuest systems come in 3.5" and 5.25" versions, which are not compatible with each other. The larger cartridges are the most common and may be the best choice if you need to exchange images with clients or service bureaus who don't have a 3.5" drive available. The smaller drives have more capacity and are, of course, more compact.

Iomega's 100Mb Zip drives are gaining popularity because the floppy-sized cartridges cost less than $15 when purchased in large quantities. The company has already announced a larger,

1Gb version of this technology—called Jaz—with a medium that will cost less than $100 and could prove to be even more popular than the Zip drive.

While the media for Iomega's new products are potentially cheap enough for permanent archiving, tape is still the least expensive choice on a cost-per-megabyte basis. A $10 digital audio tape (DAT) cartridge can store gigabytes of information. Some service bureaus and CD-ROM pressing houses are set up to work with 4mm or 8mm tapes, and a good DAT tape drive starts at approximately $1,000. There are less expensive models, such as the 3M/HP Colorado Travan systems, but these don't have the multigigabyte capacity that photographers need.

OPTICAL MEDIA

In the future, look for more graphics workstations to incorporate some sort of writable CD-ROM (CD-R), Photo CD, or optical disk media. These are excellent for archiving files, and the write-once, read many (WORM) type (CD-R, and Photo CD) are tamper-proof. All optical media are resistant to damage and can hold from 128Mb (low-end optical disks) to 680Mb (the current version of CD-R and Photo CD), or even as much as 10Gb of information (for 14" optical disks).

CD-ROM writers should cost less than $1,000 by the time this book is published. Even as I write this, Pinnacle Micro's RCD-1000, which has a 1Mb buffer that helps even a fairly slow hard disk keep up with the drive's double-speed writing is available for approximately $1,200.

The big advantage of CD-R over most other forms of optical disk is that no special hardware is required to read a disk. If 230Mb optical disks are used, anyone who wants to access that data must have a compatible drive. CD-ROM drives, on the other hand, are standard equipment these days, leaving little reason to fear that a client or service bureau won't have a system equipped to read CD-ROMs. A few types of CD-ROM drives have trouble with a few special kinds of discs, but in general these discs are a universal medium of exchange.

PHOTO CD

Photo CD, developed by Eastman Kodak Company, is a form of write-once CD-ROM with some special advantages for photographers. Photo CDs store each image in five compressed versions called *Image Pacs*, each with a different resolution. The basic, or base resolution is a 512 x 768, 1Mb file. Smaller Base/4, 256 x 384 (300K) and Base/16 128 x 192 thumbnails (74K) are available, along with 1024 x 1536 Base X 4 (5Mb) and full-resolution 2048 x 3072 Base X 16 (18Mb) images. The Pro CD version adds a sixth 4096 x 6144 Base X 64 (74Mb) version.

The following is a list of some of the features Photo CD offers:

❑ Compatible image-editing software can choose which resolution to work with. You can preview the tiny Base/16 images, use the Base version for comps, edit and release

the Base X 4 image for noncritical work, or unleash the full-resolution Base X 16 or Base X 64 images for full-page layouts, posters, and so on.

❑ A high-resolution scanner is not required to produce Photo CDs. Photofinishers and professional labs can convert your negatives or slides to Photo CD format using their own Kodak Photo CD Imaging Workstations (PIWs).

❑ There is a choice of Photo CD Master Discs, which are designed for 35mm photography and hold up to 100 images at the five basic resolutions, or Pro Photo CD Master Discs, which can store images in 35mm, 120, 70mm or 4" x 5" format. Up to 25 images can be included with the sixth Base X 64 resolution added.

❑ The Photo CD Portfolio disc, which is one you can create yourself, is also available using Kodak Built-It software. It can include photos, stereo audio, graphics, text, and other material. With a Photo CD writer ($3,000 and up), business presentations, trade show displays, or educational programs can be created.

❑ Photo CD Catalog discs are a potential money-maker for photographers. These can store up to 4400 images at the base resolution. While they can't be used to make photo-quality prints, these discs make good catalogs for mail-order retailers, art galleries, and other similar organizations.

❑ Print Photo CD discs store images using CMYK color space rather than Kodak's proprietary YCC color encoding scheme, making them practical for color electronic prepress systems.

❑ Images can be encrypted on Photo CDs, so a disk can be used by photographers as a portfolio and a stock photo distribution tool. Sample discs can be sent to clients who can then retrieve the unencrypted base version to see what your work looks like on their own computer screens, but they don't have access to the high-resolution versions needed for reproduction until a password is supplied.

Photo CD technology is still in its infancy, and I recommend that photographers keep a close watch on the events as they unfold. There is a lot of potential in these disks.

I CAN SEE CLEARLY NOW

A really fast CPU and hard disk can make conventional video seem slow. At resolutions from 1024 x 768 (the minimum for graphics applications) up to 1600 x 1200 and 16.7 million colors, the system has a lot of data to supply to the video screen. Nothing is more frustrating than moving a graphic from one part of the workspace to another and then sitting for 30 seconds while the screen redraws.

A common element in a graphics workstation should be a 24-bit color card that includes a graphics accelerator. Instead of forcing the CPU to do all the graphics work, which is what

happens with simple frame-buffer video cards, the accelerator draws lines and circles, fills rectangles, and moves graphics internally, using its own intelligence.

The new Power Macintoshes offer dual monitor support as a standard feature, and with the right video card they can add 24-bit color to a 21" monitor! Even $100 video cards for PCs can provide 16 million colors at 640 x 480 resolution or 65K colors at 800 x 600 resolution, so 24-bit color at 1024 x 768 resolution is neither expensive nor unusual. It is possible to get by with 15-bit or 16-bit color, but 24-bit color video is a realistic minimum. At 256 colors, the screen image will have more dithers than a Sunday morning Blondie comic strip. With 15-bit or 16-bit color, there will be some banding in what should be smooth color gradients, but this is enough to preview work. The best choice is to go for full 24-bit color.

With 24-bit color, you'll need a monitor to view all those colors. While a 17" monitor at 1024 x 768 resolution is enough for some types of work, serious graphics applications call for at least a 20" monitor that supports 1280 x 1024 resolution and a high enough vertical refresh rate (70Hz or higher) to eliminate flickering. Monitors are one component you can choose without getting swamped in technical data; if the screen image looks good to you, it will likely do the job.

POINTING DEVICE

Most people find it more comfortable doing graphics work with a pen-based graphics tablet rather than a mouse. Pressure-sensitive tablets with cordless pens are fairly common. Used with applications that support pressure-sensitive pads, such as Fractal Design Painter and Macromedia FreeHand, these tablets enable users to draw thicker lines just by pressing harder. Tablets and pens are a very natural way of working with graphics; if you can draw, you can use one faster and more accurately than you can sketch with a mouse, but trackballs and alternatives to the standard mouse are also available options.

The Next Step

Up to this point, all the bases in terms of hardware you need to work with digital images have been covered. Now we'll wind up this technology section with a look at software requirements, including important tools such as Adobe Photoshop and HSC's Live Picture.

CHAPTER 9

SOFTWARE FOR DIGITAL PHOTOGRAPHY

Since the invention of photography in 1839, the actual taking of a picture has always been just one small step in the long, complicated process of making an image. Indeed, the first photographers had to manufacture and sensitize their own plates or, perhaps, build their own cameras. Through the years, photographers have remained intimately involved with as much of photo production as humanly possible. Indeed, craftsmen like Ansel Adams and Brett Weston are known as much for the care and skill they put into making a print as they are for their photographic art. Weston, for example, wanted all his negatives destroyed when he died, because he felt that only he was capable of carrying his vision from camera to print.

So, it should come as no surprise that today's digital photographers are similarly drawn to the electronic darkroom. Certainly, the fluid pixels of digital images can be manipulated and transformed, but they may also need to be color balanced, sharpened, given slight gamma tweaks, or cropped judiciously. Today's sophisticated software, when coupled with the hardware described in Chapter 8, gives you the digital darkroom required to move electronic images out of the camera and to a form ready for publication or distribution.

This chapter will outline some of the key software tools available, explain their capabilities, and help you choose what to use in your own work.

Categories of Software

There are eight key categories of software that can be used for manipulating images. I'll outline all of them briefly in the next section, then provide expanded discussions of the most important types of software in the sections that follow. Some types of software, such as type manipulation, vector drawing, 3-D rendering, and animation packages, are specialized tools that may either see relatively little use by most photographers or turn into favorite "gadgets."

Image Editors

Serious digital photography requires a fully featured image-editing program. In one of these basic tools, you'll want a package with flexible selection capabilities so you can choose precisely what portion of an image to work with. Necessary elements of a package include a full range of filters for sharpening, blurring, and modifying selections and tools for working with individual color layers using RGB or CMYK color models. If you're doing color separating, it's nice to have that capability built right into the image editor.

We'll look at the undisputed leader in the field, Adobe Photoshop, in some detail later as well as at its rivals, old and new. For additional information on Photoshop, I recommend two books that will speed you on the road to image-editing proficiency. Absolute beginners who use a Mac can ease themselves into Photoshop using *teach yourself... Photoshop 3.0 for the Macintosh,* written by Karen Winter and myself and published by MIS:Press. That book is strictly an introduction to commands and features. For true proficiency with Photoshop, get *Professional Photoshop* by Dan Margulis, published by John Wiley & Sons. It's the only book on Photoshop that I've seen that was written from the viewpoint of the professional. You'll find all the information a working photographer must have on color correction, retouching, and image manipulation.

Add-On Filters

Filters can perform some magic on either a specific selected area of an image or on the image as a whole. Images can be sharpened, blurred, or distorted, or textures can be added or manipulated in other ways with filters. While most image editors have a good complement of filters built in, few photographers with a creative eye will be satisfied with the stock effects for very long. Add-on filters such as Kai's Power Tools or Adobe Gallery Effects offer many more new image processing functions from which to choose and will work with any image editor that can use Photoshop-compatible plug-ins. Some of these image editors include Fractal Design Painter, Corel Photo Paint, Pixel Paint Professional, Canvas, and Picture Publisher. Filters will be discussed in greater detail later in this chapter.

The following specialized categories are a general overview. For color separation and calibration topics, check out *Professional Photoshop* for a definitive discussion of options and techniques.

Color Separation and Calibration Software

Depending on what image editor you use, you may also require stand-alone color separating software to create the individual images for cyan, magenta, yellow, and black films and perhaps to create traps and other effects. Specialized packages like Second Glance's LaserSeps or a suite of high-priced applications from Alaras can help photographers get good separations quickly. You'll find that desktop publishing software like QuarkXPress may also have separation capabilities built into the application.

Calibration software (and, possibly, hardware to "read" your monitor or output) is certainly a good idea to make sure your monitor, scanner, and color printer proofing device are all in sync with the press used to produce your finished piece. More scanners and editing packages are being bundled with calibration utilities such as Kodak's Color Management System.

VECTOR-ORIENTED SOFTWARE

Some photographers may need to add line art or type to their images or layouts. If you want to work with both bitmaps and line art, you may need a stand-alone package that can handle so-called *outline* or *vector-oriented* files. These include CorelDRAW, Adobe Illustrator, and Macromind FreeHand. Some PC and Macintosh programs, such as Deneba Canvas, can handle both types of files. Tools such as Adobe Streamline or CorelTrace can convert bitmaps into editable sets of lines by automatically tracing around the edges of your raster images.

You may never need one of these packages, and since they are all rather complex and have steep learning curves, you may want to avoid them unless it's impossible to make the modifications to your images any other way. CorelDRAW, a vector software package, is shown in Figure 9.1.

FIGURE 9.1

CorelDRAW, a vector-oriented software package.

RENDERING SOFTWARE

Software such as RayDream Designer, available for both the Mac and PC and now provided as part of the Windows 95 version of CorelDRAW, take outlines and convert them into realistically modeled 3-D images by coloring, shading, and texturing the surfaces. These applications are

good tools for adding new objects to digital images. Figure 9.2 shows a medieval castle that was modeled in RayDream Designer and dropped into a photograph.

FIGURE 9.2
This castle was created using a 3-D modeling package and a little digital magic.

TYPE MANIPULATION SOFTWARE

Special packages, such as Pixar Typestry, available for both the PC and Macintosh, are available to create stunning 3-D type effects that may be saved as full-color PICT or TIFF files. These may be used alone or dropped into images with an image editor. Some packages can also create animations from a series of progressive frames.

ANIMATION SOFTWARE

Full-fledged animation packages are complex, high-ticket items that can suck users into time-consuming (but rewarding) careers of their own. Most of the emphasis in this book is on still photography, but it's important to mention this category, since low-end digital cameras produce images at a resolution that can easily be used in animation projects.

MORPHING SOFTWARE

Programs such as Elastic Reality, Morph, and PhotoMorph are a combination of animation tools and especially dynamic still photo filters. Like the scenes in Michael Jackson's "Black or White" video, these packages can create smooth transitions from one image to another, transforming a person into a cat or a man into a woman. It is possible to choose one of the intermediate images to work with or to animate the entire series. I've successfully used morphing software to manipulate still images in interesting ways, as shown in Figure 9.3.

FIGURE 9.3
A morphed still image.

A Look at Some Key Packages

This section will provide a quick look at some key packages that you will want to consider. It will describe Adobe Photoshop in some detail, because it is both the most popular image-editing software for the Macintosh and PC and many of its features are shared by other software that can be used. Once you understand why a broad range of selection tools (like those in Photoshop) is good to have, you'll know why Live Picture or Fractal Design Painter is also good to have.

ADOBE PHOTOSHOP

I'm going to go out on a limb here, but I think I'm in fairly safe territory, by saying that Adobe Photoshop is the most important graphics application ever put on the market. What other program on the market prompted uncounted thousands of non-computer-using professional photographers, newspaper and magazine prepress departments, and other graphics professionals to rush out and purchase a Macintosh simply so they could use Photoshop to enhance and manipulate images in exciting new ways? What other program migrated from the Macintosh world to the Windows environment, where there were already several well-established products in the same category, and immediately became the market leader?

No other program has become such an integral, essential part of so many other products, ranging from digital electronic cameras to sophisticated image processing add-ons. Since its introduction, Photoshop has been the proverbial *killer app*—the application that by itself

justifies the purchase of a computer and that becomes the standard by which all competing programs are judged.

The original Photoshop was probably the best reason to pay a premium price for a Macintosh, and it is one of the key reasons why Macs have dominated graphics for such a long time. Now, with Photoshop 3, we have an even more powerful program that has layers and better control of color.

The following list includes some of the key features of Photoshop. Other image editors may have some or all of these features, but, to date, nobody does all of this as well or as easily.

❑ **Color correction of 24-bit (16.7 million color) images**. You can bring off-color or dull originals to blazing life, and ready for use in presentations, output to a color digital printer, or transfer to an electronic color prepress system. Photoshop offers a visually oriented Variations mode (see Figure 9.4) that lets you choose the best color balance, rather than dial it in manually. It's the equivalent of the photographer's ring-around, and it works great.

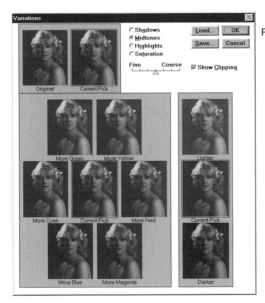

FIGURE 9.4

Photoshop Variations mode.

❑ **Color separation**. You can split a color image into CMYK (cyan, magenta, yellow, and black) channels, and direct them individually to high-resolution output devices as color separations. Photoshop includes essential routines to calibrate the program with the monitor, printing stocks, and inks you'll be using. You can compensate for *dot gain* (spreading) on the press and remove equal quantities of color, which produces a neutral gray, replacing them with cheaper black ink.

❏ **Image manipulation**. Photoshop offers a dazzling array of selection and painting tools, as well as a full complement of filters and special effects. You can retouch images, extract and drop in components, and transform portions to create new or composite images. Up to 16 channels, or layers, per image can be used for masks (see Figure 9.5) or as holding areas for components merged with the main image.

FIGURE 9.5

Masking in Photoshop.

❏ **Image creation**. Both object-based and pixel-oriented drawing tools can be used to create objects, which you may extrude, fill with gradients, use to cast shadows, or combine with editable text. Photoshop has some unusual filters, including Wind, which produces trailing streaks, and Lens Flare, which brings to the PC the image defects that lens designers hoped multicoating would eliminate.

Photoshop, or any other sophisticated 24-bit image editor, has a lot more power than the neophyte needs or can handle, but photographers will soon learn to use these tools, because they are closely related to many conventional imaging techniques. If you know what gray component replacement or undercolor removal are, these programs can provide them. Unless you're a seasoned graphics veteran, you'll probably have to grow into Photoshop's full feature set.

All the high-end editors have these tools, so what does Photoshop bring to the party? Photoshop shines in the depth of its options and the ease with which you can apply them. Adobe's long experience in this arena seems to have taught the company that image editing power involves a lot more than assembling a huge collection of nested menus and populating a few hundred dialog boxes with slider controls. A couple of quick examples will illustrate what I mean.

COLOR CORRECTION

Any image editor can correct a badly balanced or poorly exposed color photo. All you need to do is learn the ins and outs of correction, the intricacies of at least one or two different methods for modeling color space, and such photographic basics as adding cyan when you want to remove some red from an image.

Most photographers have already built up enough expertise to use such tools effectively, so color correction in Photoshop is more than a mere trial-and-error exercise; we can do a lot more than just jiggle sliders until the Preview looks better than the Original view.

Adobe figures that even if you think a histogram is a cold remedy, you'll know what you like when you see it, and Photoshop gives you the option of picking the color balance and density you want from a lineup. Photoshop's Variations mode, mentioned earlier, caters to your needs like a commercial photo lab caters to a Madison Avenue art director.

In Variations mode, the program arrays a selection of thumbnail versions of your original image, each skewed in one color direction or another: More Yellow, More Red, More Magenta, and so on. You can compare the 12 miniature views simultaneously and decide one which looks best. If you like, you can start with a "coarser" setting so that each variation is drastically different from the others. Then you can select finer increments and stir lighter or darker versions into the pot.

You'll be surprised at how dramatically an image can be improved without more fine-tuning than a Pink Floyd sound check. If you still need even more color correction precision, Photoshop doesn't dump you back in the pool with the techno-sharks. Instead, it provides the equivalent of an automated densitometer to tune the image to the aimpoints determined during installation and calibration of the monitor and output device.

All of this is a lot easier than it sounds. When Photoshop is installed, you're invited to load a few sample files and make some adjustments that tell the program how your particular equipment renders color. Later, when you need to precisely correct a color image, the Adjust Levels dialog box can be used to specify white and black points (to adjust the brightness values of the midtones without losing detail in the highlights and shadows), then change the mix of colors with a few simple controls. You don't need 10 years' experience operating a million-dollar laser scanner to use Photoshop.

Photoshop has a nifty new selective color correction feature that lets you specify the precise amount of ink applied to a particular color channel in absolute or relative amounts. You can also replace colors to swap all or part of one color with another hue.

It is no longer necessary to convert from RGB to CMYK mode to see how an image will look using the other color model. Instead, CMYK images may be previewed and you can receive a "gamut warning" that highlights any areas that can't be reproduced within the CMYK color model.

THE DIGITAL DARKROOM

The term *digital darkroom* has, of course, become a cliché because simple analogies can save a ton of explanation. Despite this, Photoshop does so many other things like a real photographic darkroom that photojournalists see it as the best thing to hit the field since the zoom lens.

Most photographers, especially those with commercial studios, will know about masking. There is even a technique called *in-camera masking* that works a lot like Photoshop's Quick Mask feature. Selecting the best exposure or color balance from an array of near-duplicates or from a test strip is a time-honored darkroom procedure.

The analogies run much deeper than that, however. Darkroom workers commonly lighten certain areas of an image by waving a dodging tool (often a piece of cardboard taped to a length of clothes-hanger wire) between the enlarger and printing easel during the exposure. Other areas may be darkened, or *burned in*, during a subsequent additional exposure, made through the space between two cupped hands, also kept in motion to feather the effects.

Photoshop's "lighten/darken" icons resemble a dodging frisket and a cupped hand and are intuitively usable by anyone with photographic experience—and almost everyone else. A copy of a selection can be moved to a buffer by "taking a snapshot" and masking out areas of an image with an overlay that looks like a sheet of Rubylith film etched with an X-acto knife.

MASKING

Masking in the digital darkroom is, if anything, even more useful than the masking techniques used in conventional photography. It's certainly a lot easier to work with. Photoshop has become extremely strong in the masking arena, since it supports soft-edged and/or semitransparent masks, which are incredibly useful. Not only can you mask off an image area, but it is possible to feather the effects and amount of protection using the program's masking tools.

Masks can be deposited in their own layers, or channels, saved with the image, and then called up when necessary to isolate an object that you want to copy or retouch separately. Creating, modifying, saving, and recalling multiple masks can be a time-consuming procedure with some image editors.

It is possible to edit the new mask in its own channel, use it immediately, or save it for later application. Each time the image is loaded, the extra layers you've created appear in a Channels window along with the Red, Green, and Blue (or other color) channels.

Using Photoshop, it is possible to turn any selected area into a mask by clicking on the **Quick Mask** icon. The Quick Mask feature is another example of a complicated procedure made easy. Think of a mask as a transparent overlay with areas of density that hold back, or protect, portions of an image. Quick Mask is shown in Figure 9.6.

FIGURE 9.6

Quick Mask mode.

LAYERS PALETTE

The new Layers palette in the latest versions of Photoshop makes it easier than ever to composite multiple images and to draw, apply effects, or use filters in individual layers without affecting other portions of the image. This makes it easy to try various types of effects quickly and to save different effects to different files.

Layers are probably the best place to explore Photoshop's undo capabilities. In difficult or extensive retouch situations, Photoshop's layer mask capabilities give great flexibility. Just copy the image on top of itself, onto a new layer. The retouching is then applied to the top layer, without affecting what is underneath. If you decide you don't like some part of the retouch, just implement a layer mask that excludes this area. If you decide you do like the retouch in general, but that you went too far, you can paint a semitransparent layer mask using any tool, such as the airbrush, so that the final product contains both the flavor of the original and your overly ambitious retouch.

OPTIONS GALORE

Adobe hasn't let Photoshop become constrained by the darkroom paradigm. You'll never mistake one of its painting tools for a spotting brush. A simple brush can assume any of 10 default sizes, from 1 to 100 pixels in diameter, plus any custom shape or size you care to design. Dial in your choice of opacity, from 0 to 100%, and then decide whether you want the brush to apply

a hard or feathered edge. Next, choose the effect the brush has on the image: it can lay down an even layer of tone or modify only pixels that are either lighter or darker than the foreground color.

Alternatively, a brush can change only the hue or only the saturation of the pixels it passes over, or both. If that isn't enough, brushes can assume a dissolve mode that adds random noise and color, or they can act like a bleach to mute hues. Other painting/drawing tools, such as the airbrush and pencil, have similar flexibility. Figure 9.6 shows Photoshop's tool palette.

FIGURE 9.7

Adobe Photoshop has a wide range of powerful tools.

The biggest advantage Photoshop has over a real darkroom is in the strength of its selection tools. Fancy filters and tricky special effects are of little use if you can't control exactly where they are applied.

Photoshop has the rectangular, circle, freehand (lasso), and magic wand select tools you'd expect to find in a 24-bit image editor. They can be used in combination to extract a precise area from an image without tedious manual tracing.

Don't worry about maintaining a steady hand with the lasso. You can draw roughly in freehand mode, then adjust the borders of a selection to clean up areas where you rushed or a got a little sloppy. Add portions of a selection a little at a time, or subtract parts that were selected in error.

If you hold down the **Shift** key, any new area selected is added to the current selection, even if you switch selection tools. Holding down the **Control** key (on the PC) or the **Command** key (on the Macintosh) while you use a tool causes areas to be subtracted from the current selection. Selections can grow or extend to include adjacent pixels that fall within a tonal tolerance range you specify, or they can be set to include similar pixels anywhere in the image.

New Lighting Effects and Filters

Photoshop 3.0 adds a new Lighting Effects filter that lets you create multiple light sources with various positions, intensities, and colors and then add their effects to your image. There is also a new Dust and Scratches plug-in to remove or reduce the appearance of dust and scratches on images that have been scanned from photographs. You can also create your own filters with the new Filter Factory plug-in.

Photoshop Output

Since the images you modify with Photoshop may be created by or destined for other applications, the file formats it handles are important. In addition to its proprietary Photoshop format (PSD), the Adobe flagship can import and export PICT, Windows bitmaps (BMP), PCX, TIFF, TARGA, CompuServe GIF, and Scitex formats. It's important to use Photoshop format while working on an image to keep all the channel information and masks in a single file, then export to TIFF, Scitex, or another format, depending on your final application. Photoshop's PSD format includes its own lossless compression scheme that can save some disk space. On the other hand, Photoshop files cannot be printed directly from other applications.

If you're planning to spend 30 minutes or more retouching images, Photoshop's format is the way to go. If you're producing work in volume and doing simple color adjustments, you'll want to work in TIFF or EPS format, since you'll otherwise have to open and resave every image later in a printable format. If your work falls somewhere between the two, you'll want to save in Photoshop format most of the time.

There are certainly other options. Photoshop imports and exports Pixar PXR files, as well as EPS, along with non-PC formats like Amiga IFF, PCPaint, or PixelPaint (but *not* the PICT format supported by Photoshop/Mac.) Kodak PhotoCD files can be imported, but not written (at least not without special software that's only just now coming to market). Photoshop also supports the relatively new JPEG (Joint Photographic Experts Group) format.

The JPEG format can produce smaller versions of large files by quantizing blocks of pixels, discarding some information, and storing the image in a special compressed format. The quality lost varies by the type of image; a 2.5Mb test image squeezes down to just 50K at the maximum compression ratio, but gradients (such as sky) have a blocky, mosaic appearance that is not acceptable. Fortunately, you can choose what compression/quality level you want. JPEG can be useful for archiving evaluation copies of images stored at full resolution offline (on removable media).

Other Image Editors

There are dozens of image editors for the PC, some priced as low as $100 to $149. I'm going to concentrate on the high-end products that are comparable to Photoshop, because it's important not to scrimp when planning to do heavy-duty work. Actually, you don't need to pay much more for any of the programs in this chapter. I recently saw the latest version of Photoshop advertised for $179 as an upgrade from another program.

FRACTAL DESIGN PAINTER

Fractal Design Painter is the program that pioneered what are called *natural effects*. That is, you can use Painter's tools to simulate the styles of artists using their brushes. Its /X2 extension, incorporated into the latest version of the program, adds the ability to work with individual layers as floating bitmaps, so you can make changes that can be moved, edited, or undone at any time.

What natural tools do is provide modifiable parameters that are less computer-like and more like the ones artists actually use. Painter lets you specify the number of hairs in your brush, the amount of jitter in your hand, and add in some random size, pressure, and have variation for good measure. Presets can mimic the brushstrokes of artists like Van Gogh, Seurat, or Monet. You can also add tiled patterns or textures.

The *liquid media* features let you simulate marbling effects and watercolor with nine new liquid brushes. One unique feature is the ability to record and play back an entire painting session, stroke by stroke. Teachers can use this capability as an instructional tool.

Of course, the standard features required in an image editor are also there: bit-mapped design tools, text capabilities, and photo-imaging filters and effects, along with the ability to make color separations and photo-composites.

The latest version of Painter lets you apply visual effects to any separate layer of the image with independent masking controls. Each layer can be saved in a portfolio, where it is identified by a thumbnail image for later retrieval and use.

All these features come at a small price: active files must be stored in Painter's RIFF file format, which keeps track of the individual floating layers. (This is the same format used by ColorStudio, created by one of the founders of Fractal Design.) You can of course always export to another format when it comes time to use the images with another application. In practice, this limitation is no different from using the proprietary formats offered by Photoshop and other

image editors. Painter works only in RGB, so CMYK files must be converted to be edited by that program, then reconverted, resulting in some color/quality loss. Figure 9.7 shows an example of what Fractal Design Painter can do.

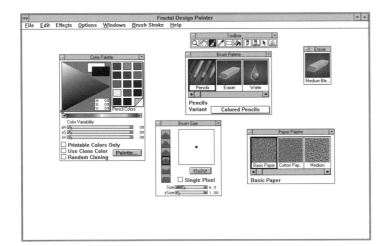

FIGURE 9.8

Fractal Design Painter offers unusual natural media tools.

PICTURE PUBLISHER

I've used Picture Publisher for many years, dating back to a weird version that had a special mode you had to use in order to view grayscale images in anything other than dithered mode. Since then Picture Publisher has been acquired by Micrografx, and in its latest incarnation it has been consistently voted as one of the easier-to-use image editors on the market. At $595, it's also several hundred dollars less expensive than most of its competitors (if suggested retail prices mean anything at all these days).

The ease-of-use features include an image browser that makes it easier to find files, a set of thumbnails that lets you see different effects filters in action (46 are available overall) so you can choose the one you want—sort of a pre-preview. Picture Publisher was also the first PC program on the market to let you open only a selected portion of an image (rather than the entire file) so you could work using the FastBits mode on small chunks of a larger image.

Picture Publisher also had object layers long before Adobe Photoshop, and it has painting tools with a flexibility to rival Fractal Design Painter. You get the same brushes, pens, and airbrushes that other programs provide, augmented with natural media such as crayon, chalk, watercolor, and oil. All of these can also be extensively modified.

Like in Photoshop, it is possible to paint masks onto the image using a brush, but Picture Publisher adds a novel Bézier curve editing feature to its edit mask mode. With this, you can

specify whether feathering takes place inside or outside the mask, and you can store masks in a separate alpha channel (Photoshop offers 16 separate channels).

PIXELPAINT PROFESSIONAL

PixelPaint was the first color paint program for the Macintosh, and for that reason it was snatched up by SuperMac, a major vendor of top-end monitors and 24-bit color cards. Despite some significant upgrades, PixelPaint languished for a while, and it is now being marketed once again by Pixel Resources. In its latest version, PixelPaint Professional is still considered one of the best paint programs available.

The latest version added natural media tools and floating paint layers that let you simulate brush strokes and other effects produced by non-computer artists. It has a full selection of pens, brushes, and line and shape tools. Only marquee and lasso selection tools are provided. You can, however, choose from several intelligent selection modes.

For example, as you might expect, the lasso shrinks to select a specified area. You can tell the lasso to select only one color, or you can define a depth of color range. The lasso will automatically slip to ignore colors it passes over that are outside that range. This feature is useful for selecting parts of a scanned image.

The marquee and lasso allow you to perform many transformations on the selected area. You can flip an image, trace edges, distort, change perspective, rotate, and warp the selection.

PixelPaint supports both Bézier and spline curves, but you can't see the curves themselves until you have laid down all the control points.

This product provides very good color management tools. A wide range of palettes are available, including Rainbow, Fleshtones, Grayscale, PaintJet (corresponding to the colors available with the HP PaintJet printer), and System. The program imports MacPaint, PICT, PICT2, TIFF, EPS, and Startup Screen files. It exports PICT, PICT2, Startup Screens, PixelPaint Stationery (a proprietary format), grayscale, and color EPS files. Only grayscale TIFF files can be exported.

PixelPaint Professional allows you to open as many documents as you have memory for and to work with four 256-color palettes at a time or one in 8-bit mode.

If you want to make your own color separations, you can choose one of the most common models, CMYK, HSV, RGB, or Pantone. In the Pantone window, an entire page of 49 swatches is on view at once—simply type in a PMS number to choose a color. The standard Apple Color Picker wheel is also available—choose a color by clicking on it in the wheel and control intensity or brightness with slider controls.

The program also has a color mixer that allows creation of colors the same way oils are mixed. You can also use the alpha channel (32-bit mode) for specialized transparent masking techniques (e.g., drop shadows can be created to allow the base image to show through).

PixelPaint is now one of the most powerful 24-bit color programs on the market. It adds powerful Bézier curve editing capabilities, as well as new painting implements, which include charcoal, pastel, and rubber stamp. A new magic wand and better cropping techniques are also welcome additions.

The original split-screen Zoom of earlier versions of PixelPaint has been replaced with a full-screen Zoom, and the program now uses virtual memory to handle much larger images, up to 4000 x 4000 pixels.

Live Picture 2.0

Live Picture 2.0 is an innovative image editor that its distributor, HSC Software, has valiantly tried to portray as a complement to Photoshop, rather than a competitor. HSC would like to see you use both: Live Picture for manipulating images as large as 500Mb in real time and Photoshop for smaller images and applying filters and other effects that Live Picture doesn't support.

I hadn't planned to give Live Picture much coverage in this book, since it was priced at an astounding $3,995 when I began writing the first chapters, but since then, HSC has reduced the price—first to $995 and then to $695, and you can find it discounted for much less. Because of this. Live Picture has become a mainstream image-editing option.

You will, however, need a nonmainstream Macintosh to run Live Picture. I couldn't even get Live Picture to load on a Quadra 650 equipped with 24Mb of RAM until I "fooled" the program into thinking more memory was available by using RAM Doubler. Virtual memory routines are no substitute for the real thing, however, and you should have 48Mb to 64Mb or more to run Live Picture. In exchange, you'll gain the capability to edit very large images at speeds you won't believe are possible.

Live Picture converts your images—including those with alpha channels—into its proprietary IVUE format, which, instead of applying effects and edits directly to the pixels, describes each change in mathematical format and saves it in a separate file. This *functional interpolation transformation system* (FITS) lets you work with large images in real time. That is, Live Picture works orders of magnitude faster than Photoshop on large images, but it takes a fair amount of time to convert the image into the IVUE format, so it makes sense to use Live Picture when you have a large file and you intend to do a lot of work on it.

When editing with Live Picture, the original file is not effected—when you're finished editing, you use Live Picture to export a copy at the resolution of your choice, along with color separations if you choose. Your edits are applied in batch mode to create the final file. An example of Live Picture is shown in Figure 9.9.

FIGURE 9.9

HSC's Live Picture.

Live Picture does not have the image manipulation tools that Photoshop has, and those that are duplicated work in quite different ways. For example, when cloning portions of an image (copying with a paintbrush tool), Live Picture uses a separate layer for each image source rather than painting on top of the image in a single layer.

Live Picture is strongest in compositing and working with large images at high resolutions. Each image is placed in its own layer, which may be one of several different types, such as monocolor, multicolor, distort, clone, paint, image insertion, or color correction. It takes a while to get used to working in that mode, especially since layers can't be easily converted from one type to another.

On the other hand, since the original is not effected and each editing change is stored in a separate FITS file, Live Picture gives a whole new meaning to the term *undo*. You can undo whole sets of changes easily, since they are applied to individual layers and not to the entire image until you export it.

Live Picture provides four-point perspective control of flat images, a limited set of brushes, and the ability to create clipping paths.

Because Live Picture doesn't work directly with CMYK files (IVUE files are a form of RGB), those who work in that mode will be unhappy until they examine the program's highly customizable separation control features. Limits can be set for black ink and total ink, UCR or GCR can be used, or the program can create the separation for you. As of this writing, third-party color management systems are not supported.

Live Picture and a similar product from Fauve called xRes may not be quite ready for prime time, but anyone who works with high-resolution digital images should become familiar with these products and grab one when a few more kinks are worked out.

Filters

I've written a whole book (*Outrageous Macintosh Filters*, MIS:Press) that deals with nothing but the magic filters can perform on images. They can transform a dull image into an Old Masters painting with delicate brush strokes or create stunning, garish color variations in a mundane photograph. they can blast apart images in a cascade of sparkling pixels or simply add some subtle sharpness or contrast to dull or blurred areas. Plug-in image processing accessories have the power to effect a complete makeover on all or parts of a scanned photo or bit-mapped painting you create from scratch. You can also use these add-ons to produce undetectable changes that make a good image even better.

Photoshop-compatible plug-in filters are actually miniature programs in their own right, designed in such a way that they can be accessed from within an image editing application, to manipulate the pixels of a file that is open in the parent application. Some plug-ins can also load files on their own.

Image processing filters resemble photographic filters in some ways (indeed, one company, Andromeda, specializes in filters that reproduce many of the effects photographers have been getting from the Cokin filter series). You can buy special effects filters to screw onto the front of a lens to provide wild diffraction, break an image into dozens of "bug's eye-view" elements, and even blur an image across the board—or only selectively at the edges.

The ease with which plug-ins can be integrated with Photoshop is undoubtedly one of the reasons behind the popularity of Photoshop—and of the Mac itself—within the graphics community. As good as Photoshop is, its modularity makes upgrading the program or adding specialized functions simple. Even though version 2.5 of Photoshop had an amazingly long life in computer-world terms, the capabilities of the program changed vastly when Photoshop 3.0 was introduced. Improved support for products like PhotoCD, scanners that weren't even on the drawing board when Photoshop 2.5 was conceived, and incredible new add-ons like Xaos Tools' Terrazzo were all seamlessly integrated by most users without missing a step.

Now that a new version of Photoshop is here, we can expect a new round of add-ons that take advantage of its new layering capability and other features. Alien Skin's Black Box 2.0 is among the first of these.

WHAT KINDS OF PLUG-INS ARE AVAILABLE?

The plug-ins available for Photoshop and compatible image editors fall into several broad categories:

- ❑ **Acquire/import/export modules**. These are add-ons that provide access within your image editor to file formats not normally supported by the program and to special hardware devices, such as slide, flatbed, or drum scanners. Once a plug-in of this sort

has been installed, it becomes part of Photoshop. Scanners were originally furnished with clumsy Desk Accessory scanning modules or "lite" editions of image editors that could do little except scan images and make modest changes.

While bundled programs are still included with scanners, it is becoming more common to just include an Acquire module that can be plugged into the purchaser's own copy of Photoshop or other editor. There are also third-party scanning plug-ins, like ScanTastic from Second Glance. By using plug-ins, you don't have to learn a new program to operate your scanner, and images you capture are available immediately.

Other Acquire modules allow importing new or specialized format images, such as PhotoCD, or do things like work with portions of an image without opening the entire image.

❑ **Production modules.** These are filters designed to streamline color correction and separation steps and then generate files in Scitex format. Alaras Tropix is a filter in this category. LaserSeps and PhotoSpot from Second Glance Products are others.

❑ **Image-enhancement filters**. I use this term for filters that improve the appearance of images without making basic changes in the content of the images. The term must be applied loosely, since some of these can make dramatic modifications. Unsharp Mask, Dust and Scratches, and similar filters are all image enhancement plug-ins. Intellihance filters—which can automatically improve problems with tone, brightness and contrast, and other parameters—also fall within the enhancement category. Blur filters are also image enhancement filters; there are many images that can be improved through a little judicious blurring. This kind of filter can be applied either to an entire image or to just a portion that you have selected. Figure 9.10 shows an image that has been "fixed" with an enhancement filter.

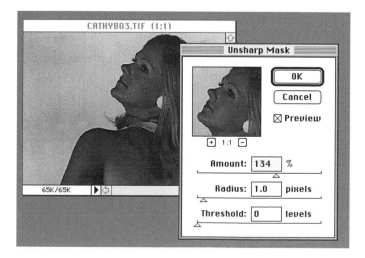

FIGURE 9.10

Image enhancement filters allow you to fix many photographic problems.

❑ **Attenuating filters**. I borrowed this word from the photographic world to describe filters that act like a piece of glass or other substance placed between the image and your eye, superimposing the texture or surface of the object on your picture. Think of a piece of frosted glass, a translucent scrap of canvas fabric, or a grainy sheet of photographic film. These, or any of dozens of other filters, including most Noise and texturizing filters, can add a texture or distort your image in predictable ways. Attenuating filters may be applied either to a whole image or to just a selection. Figure 9.11 shows a filter of this type at work.

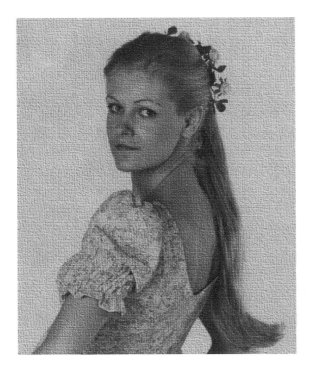

FIGURE 9.11
A canvas texture has been applied with a typical attenuating filter.

❑ **Distortion filters**. These filters actually move pixels from one place in an image to another, providing mild to severe distortion. Filters that map your image to a sphere, immerse it in a whirlpool, or pinch, ripple, twirl, or shear bits here and there can provide distortion to some or all of an image. The Vortex Tiling filter in Kai's Power Tools is a stunning example of a distortion filter. Figure 9.12 shows Vortex Tiling applied to an image.

FIGURE 9.12

The Vortex Tiling filter in Kai's Power Tools provides an amazing effect.

❑ **Pixelation filters**. Adobe's own terminology is good enough for me to use in referring to a group of filters that add texture or surface changes, much like attenuating filters, but that take into account the size, color, contrast, or other characteristic of the pixels underneath. These include Photoshop's own Crystallize, Color Halftone, Fragment, and Mezzotint filters, Adobe Gallery Effects' Dry Brush, or Kai's Power Tools' Pixelwind. The Pointillize or Facet filters, for example, don't simply overlay a particular texture—the appearance of each altered pixel incorporates the underlying image. Figure 9.13 shows a pixelation filter's effects.

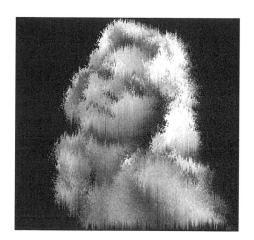

FIGURE 9.13

A pixelation filter produced this digital image.

❑ **Rendering filters**. Again, Adobe's terminology is a good way to describe filters that create something out of nothing, in the way that a 3-D rendering program "creates" a shaded model of an object from a wireframe skeleton. These filters may or may not use part of the underlying image in working their magic: Photoshop's Clouds filter creates random puffy clouds in the selected area, while Difference Clouds inverts part of the image to produce a similar effect. Lens Flare and Lighting Effects generate lighting out of thin air, while Gallery Effects' Chrome filter produces Terminator 2–like surfaces. Alien Skin's Drop Shadow filter belongs in this category, as well: it takes the edges of a selection and creates a transparent drop shadow "behind" it. Figure 9.14 shows a sample of a lighting effect created entirely in Photoshop.

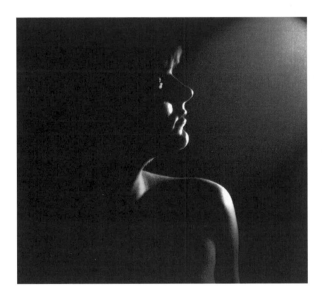

FIGURE 9.14
Photoshop-generated lighting effect.

❑ **Contrast-enhancing filters**. Many filters operate on the differences in contrast that exist at the boundary of two colors in an image. By increasing the brightness of the lighter color and decreasing the brightness of the darker color, the contrast is enhanced. Since these boundaries mark some sort of edge in the image, contrast-enhancing filters tend to make edges sharper. The effect is different from pure sharpening filters, which also use contrast enhancement. Filters in this category include all varieties of filters with names like Find Edges, Glowing Edges, Accented Edges, Poster Edges, Ink Outlines, and even most Emboss and Bas Relief filters.

❑ **Other filters and plug-ins**. You'll find many more different add-ons that don't fit exactly into one of the preceding categories or that overlap several of them. Xaos Tools' Paint Alchemy is a kind of pixelation filter, but it has so many options for using varieties of brush strokes that it almost deserves a category of its own. Terrazzo,

another plug-in from Xaos, creates repeating tile patterns from your selection, and so it is a distortion filter, but you can apply the patterns so they attenuate your image. KPT Convolver is a kind of "filter's filter," which is used to modify the behavior of other filters. Figure 9.15 shows an image that has been modified with Terrazzo, which can create an infinite number of textures from your own images.

FIGURE 9.15

Terrazzo seamlessly tiles portions of your image in a kaleidoscopic effect.

The Next Step

We've covered all the tools needed for digital photography. In the next section, we'll look at some specific applications for electronic images, with step-by-step descriptions of how their evolution.

CHURCH

Even a relatively low-resolution digital camera like the Fujix DS-100 is suitable for many "applied photography" applications. such as this church image.

FUJI PHOTO FILM USA

FRUIT

Studio photography can be fast with a digital camera.

FUJI PHOTO FILM USA

CLOWN CAMERA

This "self-portrait" of a Fujix DS-505 camera was captured by another example of the same camera.

FUJI PHOTO FILM USA

DIGITAL PORTRAIT
This impish redhead was captured
in a digital portrait by Connecticut
photographer Mike Ulsaker.

MIKE ULSAKER, ULSAKER STUDIO, INC.

ANOTHER DIGITAL PORTRAIT
Mike Ulsaker is a master of
digital "people" pictures, proving
that these cameras have a place
when photographing models.

MIKE ULSAKER,
ULSAKER STUDIO, INC.

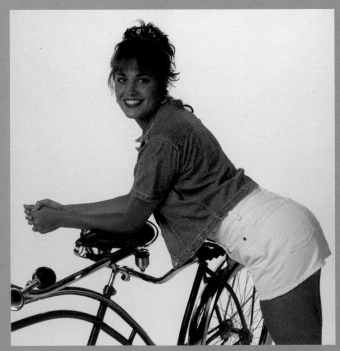

PRODUCT PHOTOGRAPHY

Digital photography is perfect for photographing products accurately in high volumes.

MIKE ULSAKER, ULSAKER STUDIO, INC.

GUITAR

This dramatic closeup captures the feel of the entire guitar from just one portion.

MIKE ULSAKER, ULSAKER STUDIO, INC.

GLASSWARE

Lighting helps capture the shape and texture of this glassware.

MIKE ULSAKER, ULSAKER STUDIO, INC.

Hmm...

San Francisco coach George Seifert watches as a play unfolds in Super Bowl XXIX.

Victory

San Francisco quarterback Steve Young looks for a receiver in Super Bowl XXIX in Miami.

THE SNAP

San Diego Chargers quarterback
Stan Humphries prepares to take the snap
from center Courtney Hall as guard
Joe Cocozzo (left) steels himself for
the San Francisco rush.

PAUL SPINELLI, NFL PROPERTIES, INC.

PASS PLAY

Steve Young looks past San Diego defensive end
Chris Mims for a receiver.

PAUL SPINELLI, NFL PROPERTIES, INC.

PUMP CAR

Dallas photographer Bob Shaw originally created the image of the men in an assignment for 3M Healthcare. He later put it together with the background elements to create this final image, which was output as a fine art IRIS print on watercolor paper.

BOB SHAW, POWERHOUSE PRODUCTIONS

GAMBLING IN DALLAS

Bob Shaw layered more than 30 different images to create this photograph for the Dallas city magazine "D".

BOB SHAW,
POWERHOUSE PRODUCTIONS

MOTHER EARTH
Bob Shaw was asked by a local lab/service bureau to experiment with photo CD scans, and this is the result.

BOB SHAW, POWERHOUSE PRODUCTIONS

INDIAN SKY
Bob Shaw created this image for his portfolio from six elements including an Earth model painted by artist David Fricks.

BOB SHAW, POWERHOUSE PRODUCTIONS

An illustration for Johnson & Johnson's magazine "ASEPSIS", this image is an attempt to show sterile fields in surgery.

BOB SHAW, POWERHOUSE PRODUCTIONS

SOAP
Braun Photography photographer Cathy Morrison created this brightly-colored still life.

BRAUN PHOTOGRAPHY/
CAREY COLOR

SELF PORTRAIT
Marc Braun used his digital camera to photograph itself.

BRAUN PHOTOGRAPHY/
CAREY COLOR

MASK

Marc Braun lit the mask's eyes from the back to produce this startling image.

BRAUN PHOTOGRAPHY/CAREY COLOR

COAT HANGERS
This image was created by Braun photographer Mark Galan.
BRAUN PHOTOGRAPHY/
CAREY COLOR

APPLE
Another image from Mark Galan,
of Braun Photography Studio.
BRAUN PHOTOGRAPHY/
CAREY COLOR

CHOCOLATES
Virginia Braun came up with the concept and art directed this shot.

BRAUN PHOTOGRAPHY/
CAREY COLOR

CHEESE
Virginia Braun came up with the concept and art directed this shot.

BRAUN PHOTOGRAPHY/
CAREY COLOR

PARK

Tom Hopkins captured this image in a park in San Jose, Costa Rica.

© 1995 BY TOM HOPKINS

OX CART

National ox cart day in Costa Rica was the inspiration for this close-up.

© 1995 BY TOM HOPKINS

OLD/NEW

A city scene in San Jose, Costa Rica contrasts the old with the new.

© 1995 TOM HOPKINS

CASTILLO

This shot of the Segovia, Spain castle in which Isabella was crowned was digitally processed to de-emphasize a cluttered background.

© 1995 DAVID D. BUSCH

AQUEDUCTO

An ancient Roman aqueduct, processed using Kai's Power Tool's Vortex Tiling.

© 1995 DAVID D. BUSCH

REFLECTIONS
The same image processed
with four different filters.

© 1995 BY DAVID D. BUSCH

DREAM
Alien Skin's Swirl filter was applied separately
to the red, green, and blue layers of this image.
Then, a copy of the image was processed using
Kai's Power Tools PixelWind filter, and the two
versions merged using a layer mask to provide
some gradation from left to right.

© 1995 BY DAVID D. BUSCH

PLAQUE
Photoshop 3.0's Lighting Effects filter can add
directional lighting and texture at the same time,
as in this image that resembles a metal plaque.

A photo of the author taken with a Kodak DCS-420 digital
camera, then manipulated in Photoshop.

REV. GARY DAVIS
Digital manipulations salvaged this 25-year-
old image of the late blues singer. All prints and
negatives of the original were lost, so the author
scanned a fading 35mm contact sheet, and
applied digital effects to produce this portrait.

<div align="right">

CHAPTER 10

</div>

NEWS PHOTOGRAPHY

News and digital photography were made for each other. All the strengths of electronic imaging—fast turnaround, low media costs, and electronic transfer of images—can be put to work effectively in spot news photography, while the weaknesses, such as low resolution, often aren't a primary concern in this field. This chapter will discuss some of the applications for digital cameras in news photography and show you how some leading organizations are leveraging their investments in computerized technology.

Why Digital Photography?

Digital imaging made strong inroads at newspapers and other news organizations early in its development because the technology is a good match with the needs of fast-breaking news events. However, several developments that preceded digital photography actually helped drive the transition.

First, newspapers began to see a real need for good-quality editorial color, not necessarily as a service to readers, but because color made good economic sense. Economics at newspapers usually involves advertising dollars more than circulation revenues so, as you might expect, the impetus for color came from the advertising side of most publications. In the late 1970s and early 1980s, advertisers began requesting, and paying for, more pages of spot color or full color as a way of making their ads stand out and catch the attention of readers. Color newspaper ads were a less-expensive means of distributing a message than direct mail to households, and it was often as effective as broadcast media if the ads were attention-getting.

Soon, many newspapers were experimenting with run-of-press (ROP) color several days a week, eventually expanding in some cases to color every day. Of course, an advertiser may need only a single page or corner of a page for a full-color ad, which provides the opportunity for the editorial department to grab an almost-free ride with an editorial color photo or two on the same sheet.

Before long, newspapers found that editorial color pleased readers. Back in the days when more larger cities had competing dailies, color-using pioneers discovered that street sales of issues featuring color on the front page topped those of their rivals. Circulation boosts help raise ad rates, and by the time *USA Today* helped make daily editorial color a standard feature, the question was no longer "Should we use color?" but "How many color pages can we get?"

Originally, editorial color news coverage was limited to more feature-oriented images, since it took a few hours longer than black-and-white images to get color negative film processed and ready for the press. Today, mini-labs and other fast processing options have narrowed the time gap between color and black-and-white film, but there is still a delay between when a news image is exposed and when it is ready for the photo editor's review.

Digital photography arrived at the perfect time to answer newspapers' need for speed and growing appetite for color images. Electronic images don't have to be processed. A photographer can rush back to the newspaper, download images to a computer, and immediately select the best shots. Even when digital images are physically transported, just as film must be, the electronic shoot saves half an hour or more over photography that requires conventional processing.

But what if the event is located so far from the newspaper offices that transporting either film or magnetic media introduces unacceptable delays? Sports events such as Super Bowls or the Olympics, state or national elections, important disasters, and other news often lure photographers far from their home base.

In the past, it's been common for traveling photographers to set up darkrooms in hotel rooms using a few blankets draped over windows and doors to convert a bathroom into an acceptable wet work area. Others have converted vans, set up tents, or assembled even more bizarre makeshift labs on the spot. Needless to say, more forgiving black-and-white developing setups lend themselves to these situations better than finicky color cycles, which may demand chemicals at plus or minus half a degree of optimum throughout the process. Camera and film vendors often take pity on working photojournalists by setting up full-blown processing labs in press tents at major events. However, such facilities aren't always available, and when they are, there may not be enough to go around.

Of course, even if you can get your film souped 1000 miles from home, what do you do with it, then? Convert it to digital format and transmit it back to the office? Certainly, that's an option, but why not just originate the images digitally in the first place?

Digital Strengths

In news photography, digital cameras have all the capabilities required for fast-breaking events. Consider the following advantages.

Digital cameras are available built on the Canon camera bodies favored by photojournalists. They can also shoot color or black-and-white images using the full complement of lenses and aperture/shutter-speed combinations available in conventional photography. The resolution of digital cameras is at least acceptable for news applications, where images will be two, three, or four columns in most cases, and not ordinarily enlarged beyond that. If higher resolutions are required, the Kodak DCS-460 is available for full-color, and the black-and-white version of the Kodak DCS-420 provides full 1500 x 1000 resolution in monochrome—where color is not required.

As mentioned previously, some digital cameras have the effect of extending the effective focal length of lenses, which gives sports photographers more telephoto for their money. Most digital cameras, apart from the ultra-high-resolution models, can emulate motor drives, capturing several frames per second, although the number of frames you can fire off before the images must be stored on the internal disk is limited to seven to ten.

Popping out a digital camera's hard disk can be much faster than changing a roll of film. An assistant or photo editor on-site can be previewing images taken one minute earlier while a shoot is still underway. As long as the removable media hold out or can be downloaded and erased, digital photo sessions can be open-ended.

Digital images are already in the correct format for transmission by conventional telephone modem, cellular phone modem, satellite uplinks, or other means. Of course, digital pictures may be from 900K to 1.5Mb or more in size, and they take a minute or two (or five, or ten) to transmit. In some cases, however, selection of images can be made at the news event, so only a few images will need to be sent immediately, with others following for later editions. Moreover, compression schemes can squeeze images down and speed up the rate of transmission.

Digital News Photographers at Work

Of course, not all news organizations are ready to switch to digital systems anytime soon. The 1995 Super Bowl and Pro Bowl, for example, provided the opportunity for two veteran shooters to experiment with a digital camera alongside cameras with traditional film.

For Paul Spinelli, a veteran football photographer and executive with NFL Properties, and Fred Larson, photo sports editor of the *San Francisco Chronicle*, the Super Bowl in Miami provided a close encounter of the digital kind.

Between the Pro Bowl in Hawaii and the Super Bowl, Spinelli estimates that some 50,000 images were produced by his crew of 15 contract photographers. Spinelli is director of photo-

graphic services for the Creative Services Division of NFL Properties, Inc., based in Los Angeles. His group provides football images to news media, book and calendar publishers, and sports card and memento producers. The NFL crew was also working on deadline to furnish illustrations for the *Official Super Bowl XXIX Book.*

On Super Bowl Sunday in 1995, both Spinelli and Larson took to the field with new prototype digital cameras designed by Kodak and Canon. Spinelli used the Kodak professional EOS-DCS 5 digital model equipped with a 1.5 megapixel CCD sensor that captures 36-bit color image at exposures equivalent to 400 ISO. It has a 2.5 lens focal length factor and captures 10 images in approximately four seconds.

Larson used the EOS-DCS 3 model, which has a 1.3 megapixel sensor, 1.6 lens focal length factor, and exposures equivalent to 1600 ISO. It captures 12 images in a four-second burst. Both cameras use removable PCMCIA storage options and are compatible with Canon EF lenses and EOS accessories.

Larson says he volunteered to use the new digital camera because he wanted to know about it. Digital technology is not the future, Larson says—this technology is *now.* Larson's digital images must have pleased Gary Fong, director of newsroom technology at the *Chronicle.* Larson's digital images appeared on the cover of both the Sports and the A-1 sections of the *Chronicle* the day after the Super Bowl.

Larson was a photo stringer for UPI before moving to the *Chronicle,* where he has spent the last 15 years. Now his post as photo sports editor gives him the ability to plan the paper's sports photo coverage while allowing him to continue as a shooter. The Super Bowl assignment called for colorful action images for fans thousands of miles away, and he had to get those images to the *Chronicle* in time to make up the next edition. Digital technology provided a very practical option.

Larson selected a Canon 300mm EF lens for shooting the game, which he used wide open at f2.8. After the first quarter ended, Larson headed out of the stadium to the trailer he shared with the Associated Press (AP). There, he downloaded his images to a Macintosh computer loaded with Adobe Photoshop. After selecting and editing images, he sent them to the *Chronicle's* Leaf Desk using a modem and phone lines. Larson said that it only took about 30 minutes from the time he shot the images until they arrived at his paper, including his walk to the trailer and his image editing work.

Spinelli also shot with a digital camera, using a Canon EF 200mm f1.8 lens. With the digital camera's conversion factor, the lens became a 500mm f1.8, which is phenomenal for football, according to Spinelli. The digital images were posted to PressLink for service to media worldwide. During the game, uploads were done from computers located in the Kodak Press Center set up on site. Images were also output using a Kodak XLS digital printer. The resolution Spinelli saw on thermal prints was good, he says, which included one phenomenal shot of Steve Young hugging the Super Bowl trophy.

The NFL needs the ability to produce large final images for posters, calendars, and full-page book spreads. So Spinelli also relies on high-quality film images. He had been in Miami for several days for pregame coverage and to set up processing for his team of photographers. They were shooting with Kodachrome 200 film and new Kodak Ektapress Plus 1600 Professional Film, coded PJC. For pregame activities, Spinelli set up headquarters in a Miami hotel where film images were edited for various projects. Some images were scanned and uploaded for PressLink's on-line customers.

Spinelli's Super Bowl imaging SWAT team lined up BWC Lab in Miami to process the Kodachrome film and Dale Laboratories to handle the Ektapress film developing and processing work. During the game, the Kodachrome was pushed more than two stops, Spinelli says.

Both film and digital capture technologies have a place in the imaging world, Spinelli believes. But for tight deadlines digital cameras provide a real speed advantage. Larson agrees, noting that he is constantly up against deadlines, fighting time.

Both photographers found that today's digital cameras operate much like their film-based counterparts. During the game, Spinelli switched back and forth with ease between traditional Canon EOS cameras and the Kodak modified digital model, and Larson notes that none of the traditional artistry has suffered because of digital technology.

The Next Step

In the following chapter, we'll look at applications for digital cameras in portrait, industrial, and illustration photography. Chapter 11 also includes an interview with digital studio pioneer Marc Braun, who discusses where he thinks the technology will take his field in the next few years.

Photo Illustration and Industrial Photography

To those outside the industry of photography, the use of digital imaging in studio photo illustration, commercial photography, or industrial applications may not seem to have overwhelming advantages. After all, these types of photography don't have the same deadline pressures as news photography (or do they?), and the superior resolution that film offers would seem to be a definite plus.

In some commercial applications, such as catalog work, however, digital photography has become *the* way to go. It also lends itself to other kinds of illustration. This chapter will look at the strengths of digital photography in these fields and will include some comments from one of the more innovative photographers.

Why Digital Photography?

I asked this question in Chapter 10, but the answers are somewhat different when it comes to photo illustration, studio photography, and industrial work.

Certainly, time can be an important consideration. Ohio photographer Marc Braun told me about a client who came into his studio in the morning, helped set up a digital shot, and was on press with the image that afternoon. For advertising pieces, which must be turned around quickly, digital images have no match. It doesn't matter that the time constraints come from dawdling on the part of the client, unexpected promotion opportunities, or competitive

pressures. The fact remains that digital images can be captured and delivered more quickly than those produced on film—even with the widespread availability of in-house photolabs.

Image quality is also important, but most digital camera backs offer enough quality to meet demanding needs. Braun told me he produces images that are enlarged to 11" x 17" all the time. Shooting with digital camera backs can be slow, requiring several minutes to produce a triple exposure through red, green, and blue filters, or with a scanning mechanism like that found on the Dicomed back. However, when you compare the time needed to set up a shot with the time actually needed to make the exposure, slower digital cameras don't necessarily create much of a bottleneck.

Other features of digital cameras that may be useful in studio and industrial applications include the ability to link a camera to a computer and preview images before they are taken. This can be helpful in fine-tuning a setup. In industrial photography, this capability—coupled with remote control—allows digital cameras to be used effectively in remote monitoring situations. An assembly line, product conveyor, or other factory scene can be photographed continuously at frame rates that are slower than those produced by video cameras, but with better resolution. Images can be sent to a computer located some distance from the monitoring point and then stored on a large hard disk for review at any time.

Industrial photographers who must document processes for quality or certification studies also like the speed of digital cameras and the ease of converting images to computer format for use in desktop publishing or other applications. Medical photographers may also use digital images. Ophthalmic photography, for example, uses special camera setups to photograph the fundus (back inside surface) of the eye. Fluorescein dye injected into the patient's blood stream glows when illuminated by ultraviolet light, and the resulting patterns of blood vessels in the fundus can be used to diagnose many illnesses.

Shootout

Braun told me about a two-day digital camera shootout he participated in, sponsored by Dodd Camera and Video's professional imaging division. Five different digital systems were available for photographers to use in actual photographic situations. While the photographers who hadn't already adopted digital photography were enthusiastic about the equipment, Braun still saw some reluctance to make the heavy investment in required equipment, and he noted that some of the photographers balked at what they saw as a heavy learning curve. Busy photographers don't have a lot of time to learn how to use a new technology quickly.

John Popp of Dodd's professional division, posted some comments about the shoot-out on America Online shortly after the event concluded. He noted that the Leaf digital camera back seemed to provide the best image quality, although most of the photographers felt the Sinar setup was a little bit cumbersome. The same back used with a Hasselblad body was the

preferred setup. Popp said the images provided excellent quality, saturation, and detail beyond what one might expect from a 12Mb file.

According to the Dodd executive, all of the photographers agreed that the Dicomed had the most image detail with less saturation than the Leaf. However, the inflexibility and expense of converting images, and the lengthy scan times were viewed as major drawbacks, leading some photographers to question the system's viability in heavy production. This camera certainly has its place, but not in the volume/production shop, Popp observed.

The Kodak DCS-460 was the favorite of many, although the image quality and resolution were not as good as some of the other cameras, Popp said. The images were very sharp and provided enough resolution to keep most of the photographers happy. The ease of use, flexibility, and speed of this system were among the positives. The negatives included the color aliasing along areas of contrast. The integrity of the media was also a concern. One of the PCMCIA hard drives fell to the floor from a tabletop and was damaged, destroying an hour's worth of work. If you are intending to use or buy this camera, make sure you purchase the Adaptive Solutions Powershop board. The images retrieved with the board were far superior to those acquired without it, according to Popp.

Many in the shootout felt the other cameras were best suited to single markets or had limited uses. The Fuji/Nikon digital camera was viewed as a model that fit the photojournalist market very well. The limitations most often mentioned were the maximum aperture of f6.7 and the inability to tether directly to a computer in production situations.

The Kodak DCS-420 was seen as flexible as being as flexible as its big brother without the same exposure range or resolution. The ability to be attached directly to a computer was a big plus for production situations, although image quality was not as good as the Fuji/Nikon. Again, Popp says to consider the Adaptive Solution Powershop board.

The Fujix HC 1000 provided excellent image quality and saturation, according to Popp. The small file size of about 3.8Mb limits the camera's uses but shows that all small files are not created equal. The images printed on the Fuji PG3000 were among the best, although they were limited in size (printed at roughly 5" x 7").

The Leaf Lumina was probably the least appreciated camera. The need for hot lights and flat images were viewed as drawbacks. However, some of the new accessories were seen as a great way to get maximum flexibility out of the camera, which the photographers felt was probably best suited for copystand work.

Digital Studio Photographers at Work

Braun, whose work earned the most pages in my photographer's showcase, is a big believer in digital photography. In fact, in 1993 he almost gave up conventional film for digital imaging completely, even though he had to sell his 20-year-old studio to finance the switch.

Based in Akron, Ohio, Braun saw the future dominance of digital photography in studio work, and he felt that an early start would give him a jump on the competition. Already an accomplished computer user, he wanted to move into the digital realm in a big way, so he merged with Carey Color of nearby Medina, Ohio. Carey Color is one of the largest prepress companies in the nation, and it was already accustomed to spending a lot of money on digital equipment.

Braun told me that photographers looking to get into digital photography can get by with an investment of about $20,000 if they already have a computer system that can handle imaging, but they had better plan on spending $40,000 to $60,000 if they need to purchase a top-quality computer. His plans were even more ambitious, and he would have had to wait years to accumulate the $100,000 to $200,000 he hoped to spend on digital studio equipment.

In the end, the merger helped both firms. Braun Photography now offers complete client service, from photography, through retouching and manipulations, right to the finished catalog page, while Carey Color gained access to Braun's photography expertise and studio equipment and can now add photography to its list of customer services.

Working closely with Girard (Gary) Moravcik, president of Carey Color, Braun set up the new digital studio. They bought Sinar p2 4 x 5 view cameras with Expolux Digital Shutters. Sinaron digital lenses designed to work with the Leaf System, in focal lengths of 40mm, 80mm, and 135mm provide the equivalent of normal, slight telephoto, and longer lenses with the reduced image area of the Leaf back.

Braun and Moravcik chose the Leaf System, which offers monochrome or three-exposure color through red, green, and blue filters. The Leaf digital back captures 15 bits of grayscale data (16,384 shades of gray per color), with a dynamic range of 11 f-stops. The exported file sizes are 4.2Mb grayscale or 12.6Mb color. The Leaf back also contains a cooling chip system that regulates temperature and reduces noise.

In our conversation, Braun pointed out that 11 f-stops is a considerably longer dynamic range than he was able to get with conventional film, which he says is more in the four- to six-stop range. There is more detail in highlights and shadows, and he finds that lighting is critical. He uses gobos and reflectors heavily to get the lighting ratios required in his demanding studio work. His Broncolor strobes allow controlling lighting in 1/10th stop increments, and the electronic shutter is also variable in the same small steps, maintaining the degree of control required.

Braun says it initially takes longer to produce digital images, and there is more work involved, but in production environments the greater control and inherent speed of digital imaging provide big paybacks quickly. One recent job Braun's studio worked on involved 1200 individual shots, and another involved 500 shots. These projects were completed in far fewer days than if the studio had still been using conventional film, he notes.

Braun and his team of four photographers monitor the digital images directly on a 20-inch high-resolution Radius color monitor connected to a Macintosh Quadra 950 computer. When the image is exactly right, the exposure is made.

The Mac can store images on a 2.3-gigabyte removable hard drive, SyQuest cartridges, an optical disk drive, or floppy disks, in the case of low-resolution images. A Fuji Pictrography 3000 printer produces beautiful, full-color, continuous-tone photographic prints, in either 5" x 7" or 8" x 11" sizes, up to 400 dpi. With new software, the studio is now able to produce the equivalent of CMYK proofs.

Once the image is saved, Braun and his staff do any original retouching or color enhancement that is necessary. Following client approval, the image is converted through custom-developed software to CMYK files ready for film output. At the same time, Braun provides low-resolution files that can be plugged into the client's page layout program for design purposes. He can also make CD-ROMs, and he burned one for me with the sample images you see in this book.

Braun still uses conventional film, often scanning it with the Leaf camera back. Some 98% of his work for clients such as Firestone and Goodyear Tire companies, Sears, Rubbermaid, the University of Akron, Stouffers, Quaker State Oil, Genie, Plastikote, and Matco Tool is digital. Braun keeps himself and his three other photographers busy in two shifts, from 8 A.M. to midnight, and he hopes to add a third shift from midnight to 8 A.M. The staff attended intensive training in Photoshop and other software applications.

Braun's studio space is large enough to accommodate vans and small trucks, and he just added another 1500 square feet, which will be used as a storage and prep area, freeing more of the original space for use in studio work.

Braun told me that he views digital photography as a return to photographers of the control and responsibility they had when he started in the field 20 years ago. Until he converted to digital imaging, the trend had been to take more functions out of the photographer's hands and into those of the art director or another middle-person. Now, Braun is working more closely with these people and the clients than he had in recent years.

Braun looks forward to systems with even higher resolutions that will give digital studio photography even more of an edge over conventional camera systems. He is surprised that more photographers haven't switched, but for now he is enjoying the competitive advantage his early start gave him.

The Next Step

While portrait photography is in many ways similar to photo illustration—both involve heavy time spent in the studio—it has some special needs, and we'll look at these needs in the next chapter.

CHAPTER 12

PORTRAIT PHOTOGRAPHY

Photography of people is one application for digital photography that will likely become widely used in the near future. As with news and illustrative photography, there are aspects of portraiture that fit in well with the capabilities of digital imaging. In this chapter, we'll look at some of those aspects.

Why Digital Photography?

Traditional portrait photography has always been something that took a bit of time, although the investment on the part of the photographer and subject is somewhat less than that required for a painted portrait. However, the time spent was worth it. Before the invention of photography, it was unlikely that a person knew what his or her own grandfather or great-grandfather looked like, unless they lived long enough to meet them or came from a wealthy or royal family that could afford to commission a painted portrait.

So, the time spent producing a photographic portrait seemed like a small price to pay. The original Daguerreotype portraits of the 19th century took a few minutes to expose but were often processed on the spot and given to the client to take home. The portrait subject, of course, received the original image, since there were no negatives involved and no duplicates unless the Daguerreotypist photographed the original with the camera.

Somewhat later, photographic portraiture evolved into an even more involved procedure, with a sitting followed some time later by a session at which proofs were reviewed and the client made the final selection. Prints might then be delivered at yet another session.

While there is something to be said for the opportunities that can crop up when you get a client back to your studio three or more times, this procedure has its drawbacks from a marketing standpoint. For one thing, enthusiasm is always highest at the original sitting and has cooled off by the time the proofs are available. Clients may have other things they'd rather spend their money on, or have second thoughts about ordering that big print originally desired.

Digital portraiture, on the other hand, offers an immediacy not available with traditional film alone. You can snap off a series of poses, either captured 100% digitally or using a system that grabs a digital version at the same time an image is exposed on film, then show the subject the digital images immediately and write up the order. Big prints can be sold by displaying them on a large screen or projecting images into a frame that shows how the image will look on the wall in the larger size. Photographers have been doing this with conventional proofs for a long time, and digital imaging just refines the technique.

The digital image also has some advantages when it comes time to retouch a portrait. You'll find that Photoshop can do all the corrections that you might have used dyes for in the past, in addition to others. Removing bags under eyes, cleaning up a teenager's complexion, de-emphasizing large ears, and softening of wrinkles are all child's play for an accomplished digital worker.

The chief disadvantage of digital portraiture is that the output options are a little more limited. Most studios can equip themselves to print directly to dye-sublimation printers, but those capable of larger than 8" x 10" size are expensive and are still limited to only a few paper surfaces. If the full range of paper surfaces and texturizing effects that portrait photographers commonly sell is desired, them image may have to be output to film and turned into conventional prints. Look for these limitations to vanish in the near future as photographic and digital printing technologies converge.

WHAT TOOLS?

Although some photographers are able to take portraits using digital studio cameras—check out Mike Ulsaker's work in the color insert in this book—most portraiture calls for instant, one-shot exposures like those provided by the Kodak, Nikon, and Canon cameras discussed in Chapter 5. Anyone doing portraiture, wedding photography, or similar work with 35mm cameras will find one of these suitable. Outdoor portraiture, school photography, candid portraits, candid weddings, Little League and other children's sports photos, and many other kinds of people shots can be easily adapted to digital imaging.

The Kodak DCS-460, in particular, with its 3000 x 2000-pixel resolution, offers enough resolution to make good-quality 11" x 14" prints. Most of the other cameras, though, are best limited to 8" x 10" or smaller prints and so may not be suitable for formal portraiture that will be enlarged to 30" x 20" or larger. If you've been using 4 x 5 or larger format sheet film cameras for your portraits, you won't want to use one of these 35mm digital cameras.

In the near future, digital studio portraiture will probably be limited to digital proofing systems that show lower-resolution versions of images also captured on film. Portrait subjects can review their poses and make a selection immediately. Then the film can be processed and printed conventionally.

Outdoor and in-home portraiture should lend itself to some form of digital photography much sooner, although I think that weddings are probably the most natural application for this technology. Some wedding photographers like to select their own best shots and present them in an album the couple can use to make a final selection, but the problem with this approach is that the review must often take place long after the honeymoon. Digital images, on the other hand, may be reviewed as soon as the pair return, or even right at the reception (if you think photography holds a high enough priority at that special time—I personally don't).

Digital Portraiture at Work

Digital photography in one area of portraiture has already taken off in a big way following an agreement between Kodak and First Foto, a leading supplier of in-hospital photo services. The new approach will mean a shorter wait for doting grandparents and others eager to see the first portrait of a new arrival.

First Foto will pursue technology with the Eastman Kodak Company to add digital imaging to the photo services it provides for 75% of the births in the United States. First Foto president and CEO Jim Willcox says that while conventional photography still offers the highest-quality image, the company recognizes that digital imaging services will play an important role in the future. The company will use Kodak film, paper, digital cameras, image management software, digital printers, and other services to create electronically enhanced announcements, available to parents shortly after the birth. In addition to rapid access options for customers, this step can lead to new digital imaging services such as a baby's portrait on a cup, framing options and customized portrait backgrounds, according to Willcox.

First Foto, a division of HASCO International, serves 2650 hospitals in the United States and Canada. The company has supplied new baby portraits for more than 40 years and was the first in its industry (in 1969) to offer color photography.

Look for digital portraiture to make other inroads in the future. Fast turnaround and the flexibility of this technology offer significant benefits.

The Next Step

We've looked at three photographic applications for digital technology. In Chapter 13, I'll describe some of the darkroom magic you can perform with digital images and software such as Adobe Photoshop.

CHAPTER 13

YOUR DIGITAL DARKROOM

The darkroom is where many images come to life, particularly those images exposed on color or black-and-white negative film. While transparencies have a what-you-see-is-what-you-get kind of permanence—at least until retouching, duping, sandwiching, compositing, and other techniques come into play—negatives are a kind of do-it-yourself image kit, containing many different elements that can be accentuated, added, subtracted, duplicated, or otherwise enhanced through darkroom magic.

Some photographers, from Man Ray to Edward Weston, have built at least part of their reputations on the exquisite appearance of their lovingly and painstakingly prepared prints, while others, such as Weegee, used darkroom manipulations to create images that couldn't be achieved with the camera alone. Both of these photographic traditions are being carried forward in the digital darkroom with tools such as Photoshop. This chapter discusses some of the digital darkroom tools and shows how they parallel familiar techniques you may have already mastered in the darkroom.

Amazing Parallels

Coming to computer imaging from a photographic background, I've always found it fascinating that so many photo tools have counterparts in the digital realm. Because these programs were designed to be used by nonphotographers as well as by photographers, the photo-orientation is not always emphasized or evident. This next section will provide a summary of some common techniques or tools you may be familiar with and can adapt to fairly quickly when working with digital images.

VARIABLE-CONTRAST/GRADED PAPERS

Black-and-white enlarging papers are produced in differing contrasts to give the darkroom worker a way of adjusting the snappiness of an image. A thin negative can be improved by printing on a higher-contrast paper, while an overexposed negative with blocked up highlights can sometimes be salvaged by printing on a lower-contrast paper. New images can be created by printing an image on paper with a contrast grade that is somewhat extreme, as shown in all those grainy, high-contrast images that inundated the photography magazines when Agfa's unique #6 paper was initially introduced.

Variable-contrast papers, which use filters to activate the appropriate contrast sensitivity in a sheet, were introduced as a way to decrease the number of paper options needed to meet the needs of a broad range of negatives. Instead of stocking a particular brand in five different grades, four sizes, and three surfaces, darkroom workers could reduce their stocks from, say, 60 types of paper to a dozen by using variable-contrast papers.

Color papers have always had a more limited range of contrasts. There may be a "flat" version from a vendor that is suitable for general-purpose or portrait printing and a "plus" version with snappier contrast for commercial photography, but not too many choices beyond these two.

A digital darkroom has an infinite number of paper grades available for both color and black-and-white work. When you're just starting out with Photoshop, you may rely on the **brightness/contrast** controls, which allow making fine adjustments with real-time previews. Another "beginner's" tool is Photoshop's **Variations** mode, which lets you lighten or darken shadows, midtones, and highlights separately. As you hone your skills, you'll progress into automated tools such as **Equalize** to adjust the range of tones in an image and manual readouts like the histograms you'll find in the **Levels** control to manipulate tonal range in a graphical manner. Figure 13.1 shows the **Levels** control in Photoshop.

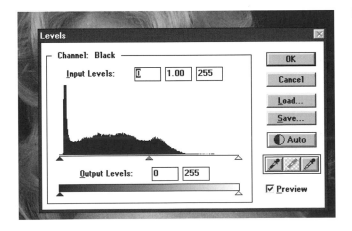

FIGURE 13.1

Levels control.

134

If your favorite reading material includes the characteristic curves typical of various films and you can think of terms like shoulder and toe without anthropomorphizing them, you'll eventually come to depend on the **Curves** controls found in Photoshop and other image editors. Anyone who has struggled to control contrast, brightness, saturation, and similar parameters using conventional photographic techniques will love the digital darkroom.

SANDWICHING/DOUBLE EXPOSURES

There are two techniques that are not uncommon when working with an enlarger. One technique is to sandwich negatives and print them together. Another more common technique is to print double exposures or to use other multiple printing techniques with the enlarger.

The digital darkroom has taken these techniques to a new level. You can combine any two images easily, store them in separate layers, and manipulate them before combining them to create a final image. Elements can be feathered or faded into one another quite accurately. If a desired effect does not turn out as expected, there's no need to make another "print." Just revert back to a previously saved version that was stored before the most recent changes were made.

Color corrections can be done on individual color channels or on the image as a whole, which is another big advantage the digital realm has over the conventional darkroom.

DODGING/BURNING

Some photographers hold back or burn portions of an image almost by instinct, sometimes whether the image needs it or not. During a 60-second exposure it's occasionally hard to keep your hands out of the light path, dodging here, burning there to lighten the shadow on a face or darken a highlight that looks a little dense in the negative.

The digital equivalents in Photoshop have little "hand" and "dodging tool" icons that will be instantly familiar to photographers. The control they provide is astounding: the amount of dodge or burn can be adjusted down to a very tiny percent, and the tools can grow from a few pixels wide to a large paddle-like gadget. If you err, the most recent density correction can be removed with **Undo**, or a whole set of changes can be erased by deleting the layer and starting over with a copy.

The image editor's selection tools can be used to ensure that the lightening or darkening will be applied only to the selected area. Anyone who has burned in a photo with their hands and noticed that a corner or some other area of the image wasn't properly masked off will appreciate this ability.

Other advantages are more subtle. In order to have enough time to dodge or burn properly, you may have stopped down a few extra f-stops or added a neutral density filter to lengthen the exposure time. These techniques often leave a really dim image that is difficult to work with

and make it more likely that the enlarger might be jiggled a bit during the exposure. With the digital tool, you can take as long as you like and zoom in to work with a closeup image if so desired.

The downside of all this is that it may be difficult to gauge the size of the dodging/burning tool, since the cursor/icon doesn't change shape, unless you know to choose **Precision Tools** under General Preferences. Another downside is that where you could cut out a custom-made dodging or burning tool in an odd shape from any old cardboard you might have had at hand, digital tools are always round. It may be difficult to apply the exact same amount of effect to an odd-shaped area, unless the time is taken to create a custom-shaped tool, which can be grouped, saved, and reused. The Precision Tools dialog box is shown in Figure 13.2.

FIGURE 13.2

Precision Tools lets you specify a more exact representation of Photoshop tools.

COLOR CORRECTION

Anyone who has played with color correction filters without the benefit of a color meter will know how difficult it can be to correct color casts while making a color print. I made my first color prints in a home darkroom many years ago using an old Unicolor kit to produce bizarre color test strips that yielded only ballpark estimates of whether I needed to add a CC5R (or was that CC10M?) to balance a given image.

Today, color correction is more automated, and the digital darkroom is no exception. You can use Photoshop's **Variations** mode to view possible color changes as a ring-around or use hue/saturation and color balance controls to make corrections visually. If the time is taken to calibrate your monitor to your software and to calibrate your system to the output devices that will receive the images, your digital color corrections can be quite satisfying. They certainly are easy enough to achieve, since corrections can be viewed in real time right on the display.

Photoshop also lets you correct color on a by-the-numbers basis, using the **Info** palette, which provides numerical readings that indicate, for example, whether a gray area is actually gray. The Info palette is shown in Figure 13.3.

FIGURE 13.3

Info palette.

TEST STRIPS

In the darkroom, test strips are most often used to compare different exposure or color correction combinations side by side. This comparison is not as useful in the digital realm, where changes can be viewed directly, but the test strip lives on in the form of matrixes you can easily prepare to show how different degrees of a particular effect or filter would look with an image. KPT Convolver, in fact, is a plug-in filter that lets you view an array of effects applied to the same image, using sharpness, embossing, blurring, and other specified parameters.

OTHER DARKROOM TECHNIQUES

Other techniques applied in the darkroom can also be duplicated on the computer. If you've ever used a diffuser while printing to soften an image, you'll find quite a few different diffusing and blurring effects available for digital image editors. Keep in mind that blurring tends to appear to spread the lighter areas into the darker areas, so the effects are quite different when working with a negative image rather than a positive one (e.g., in the camera). Digital diffusion/blurring can be applied in either the positive or negative mode, since an image can be inverted with the click of a mouse.

Grain and texture screens, mezzotints, reticulation, solarization, and other common darkroom techniques all have their counterparts in digital imaging. Effects commonly associated with more advanced prepress operations, such as unsharp masking, can even be applied without extra time-consuming darkroom steps.

Compositing

The digital darkroom lends itself to complicated compositing effects. Image editing software has some powerful features that streamline the complex selection, masking, color-balancing, and drawing tasks involved in this process. Some of these will be described in the next section.

SELECTION TOOLS

Manipulating portions of one or more images often involves selecting a specific section and cutting, enlarging, or pasting it in another position. The ability to accurately grab one part of a photo can be crucial. Selection tools include:

❑ **Rectangular and oval marquee tools**. These tools let you select portions of an image that are rectangular, square, oval, or circular. They may be the easiest tools for grabbing items such as wheels, human eyes, or walls. It is important to learn how your image editor's shape selectors work.

In Photoshop, these tools can be constrained to generate perfect squares or circles by holding down the **Shift** key while dragging with the mouse. Hold down the **Alt** (or **Option**) key, and the shape will be drawn from the center outward, rather than from the corner where you start dragging. This can be useful if you happen to know, or can estimate, where the center of a selection should start.

❑ **Lasso tool**. The lasso tool lets you draw selections freehand. In Photoshop, it's represented by an actual lasso icon, with the "hot" spot being the end of the "rope." Keep the **Caps Lock** key on to turn the Lasso's cursor into a more useful crosshair.

❑ **Magic Wand tool**. The magic wand tool of any image editor chooses adjacent pixels that fall within a tolerance range specified in a dialog box. (Double-click on Photoshop's **Magic Wand** to bring up the dialog box.) This tool can be used for selecting areas that have similar tones, such as sky or walls.

It is also important to know how to add to or subtract from selections. Any of the tools just described can be used to add to the current selection by holding down the **Shift** key while specifying a new portion. Hold down the **Control** key to remove portions that are already selected from the current selection.

Note that areas added to a selection don't have to be adjacent. You can select a square area in an image, hold down the **Shift** key and select another square area elsewhere in the image. Both selections would be part of the same overall selection.

Although the Lasso is probably the most useful tool for adding or subtracting small portions at the edges of selections, don't forget about the Magic Wand. If a selection includes most of what you want, but there is an area of consistent (or similar tones) that you want to add (or subtract), choose the **Magic Wand**, hold down the **Shift** or **Control** key, as appropriate, and then click in the other area.

Another key function is the ability to invert a selection. You may want all of a human figure in your selection, but find that it's easier to select the plain background instead. Do that, then invert the selection (in Photoshop, use **Select>Inverse**). This capability is also helpful when you want to apply one filter to an area of an image and then apply a second filter to everything *except* the first area.

An image editor may have additional selection parameters, such as the ability to create a "fuzzy" or *anti-aliased* border of pixels around a selection so you can cut and paste with a smooth transition instead of a sharp outline. Photoshop also allows you to "grow" a selection to encompass similar pixels adjacent to selected pixels, or to "select similar," which expands the selection to include all pixels in an image that fall within the range of the Magic Wand's current tolerance setting.

Photoshop and other programs have Bézier curve selection tools. They are a way of representing a curve with great flexibility. Bézier curves are adjusted using endpoints and anchor points. A curve is drawn by placing endpoints and then adjusting the anchors, or control points, to modify the shape of the curve. Bézier curves can be used to produce highly accurate—yet smooth—selections in drawings.

You might want to use a Bézier curve to isolate the curve of a sleek sportscar, if it doesn't happen to rest against a clean background that you can "grab" with the Magic Wand. Other curved shapes can be outlined using Bézier tools much more quickly than through freehand drawing.

CUTTING AND PASTING

It is also important to learn how your image editor handles cutting and pasting. Generally, you'll be most interested in ways you can modify how an image is pasted into another image. These include:

❏ **Paste Into**: Image information that is copied or cut is pasted into the selected area only. Portions that don't fit are obscured by the original image. This can be used to paste some mountains into an empty sky area, so that the base of the mountains is obscured below the horizon.

❏ **Paste/Composite Controls/Merge**: Image editors may have a dialog box that lets you either specify the transparency or opacity of the selection being pasted or control

how it blends with underlying tones or colors. There are several modes used to merge layers or pasted elements. The most commonly used have the following effects:

- **Normal**: Each pixel is applied just as it was originally, except for other effects (such as Opacity or Blend If:) that might have been specified.

- **Darken**: Pixels in the selection are applied only if they are darker than the pixel in the underlying image. When used with color images, the color balance can change.

- **Lighten**: Pixels in the selection are applied only if they are lighter than the corresponding underlying pixel. When used with color images, the color balance can change.

- **Hue**: The hue values of the selection are used with the saturation and luminosity values of the underlying image. Chapter 12 explains the Hue-Saturation-Lightness color model. This option has no visible effect on grayscale images.

- **Saturation**: Similar to the hue option, but Photoshop uses the saturation value of the selection and applies it to the hue and lightness values of the original image.

- **Color**: Uses both hue and saturation values of the selection, retaining the luminosity value of the underlying image.

- **Luminosity**: Applies the luminosity values of the selection to the hue and saturation values of the original image.

- **Multiply**: Mixes the colors of the selection and original image, producing a darker image with the combined values of both. The Photoshop manual accurately compares this effect to superimposing two color transparencies on a light table. Visualize two color slides and the areas that overlap: a medium blue and a medium red pixel would produce a darker magenta pixel.

- **Screen**: Subtracts the colors of the selection and original image, producing a lighter image. Again, the Photoshop manual comes up with a good analogy: superimposing two negatives and then printing them onto photographic paper. A medium blue and a medium red pixel would produce a darker magenta pixel—*in the combined negatives*—and print as a lighter, green tone (the opposite of magenta) when reversed as a photographic print.

- **Dissolve**: Atomizes the pixels in the feathered edges of the selection, producing an interesting edge effect.

❑ **Black Matte/White Matte**: Feathered selections dropped into a black or white background produce a feathered edge of the opposite color of the background. The **Black Matte** and **White Matte** options eliminate this objectionable transition.

Some of the calculations modes are shown in Figure 13.4.

FIGURE 13.4

Calculations modes.

Reusing Selections

The ability to reuse selections is important, especially when images must be changed or when you wish to perform multiple operations on a particular portion of the image at different times.

Most high-end image editors let you save selections and either apply an identifying number or a name given to each selection. Fractal Design Painter, for example, lets you store selections in one or more *Libraries*, which can be accessed and used in any image, and load Encapsulated PostScript (EPS) files as selections.

The selection information is stored with the image as well, although you may have to use the image editor's proprietary file format to do this. Photoshop can save selections using either Adobe's PSD format or TIFF, but other programs may not be able to load TIFF files that have embedded selection information (called *alpha channels*).

Selections that have been saved and are available for reuse are usually called *masks* or *friskets*. If they can "float" above other portions of the image and be manipulated without affecting the rest of the image, such selections are said to be *layered*. Like many of the tools found in image editors, these terms came from the manual methods used by artists for decades or centuries before the advent of the computer.

Masks or friskets were originally nothing more than sheets of celluloid that were cut out with a sharp knife to isolate a portion of the image. Masks can also be created photographically. If an image editor has an *unsharp masking* option, it comes from the technique of producing a

slightly out-of-focus photographic image of an image (or portion of an image). Some masks are produced on a sheet of red film called Rubylith, which may resemble the mask layer in editors such as Photoshop.

Another way to reuse selections is simply to allow multiple "live" selections in a single document. Picture Publisher and Fractal Design Painter can do this. You may operate on each selection independently, so it's possible to perform an operation on one portion of an image, select another area and work with that, and then return to the other selection. In contrast, Photoshop 3.0 lets you create multiple unconnected selections in an image, but they are really all a part of the same selection.

SOFTENING SELECTIONS

Feathering or antialiasing are ways to avoid the sharp edges that would appear if a selection were made with a hard-edged tool like the Lasso. Antialiasing recalculates the edges of the selection to reduce the jagged edges, while feathering gradually changes the opacity of the pixels at the edge of the selection using a specified radius, so the selection "fades out." Your image editor may allow you to change a selection to a feathered selection after it has already been created.

Like masks, feathering had its beginnings with manual techniques. Airbrush artists originally feathered friskets by raising the brush slightly to allow the stream of paint to spray slightly beyond the limits of the mask. In the digital world, feathering is a good tool for pasting a selection into an image seamlessly.

OTHER SELECTION VARIATIONS

Each new image editor on the market refines the capabilities of its selection tools. Fractal Design Painter allows floating selections to be sent to the back, brought to the front, or moved forward or backward layer by layer. They can also be grouped or ungrouped, to turn several selections into a single selection or a grouped selection back to several selections.

You may also be able to grow a selection (add adjacent pixels within the current magic wand tolerance value) or add similar pixels (anywhere in the drawing that falls within the tolerance range) with your image editor.

Retouching

Photography has always been part craft, part science, and part fine art, with a little alchemy and magic mixed in. Many photographers in the mid-1800s were skilled woodworkers and machinists who built their own cameras, then mixed chemicals to sensitize photographic

plates. The highly creative images that were exposed during this era are a tribute to the versatility of these early artisan-artists.

Digital imaging cranks up the science component several notches, giving the artist in all of us more powerful brushes and an infinite palette of colors, tools, and effects. Retouching is one area that has seen the most dramatic changes wrought by computerized image editing software. A necessary evil anytime photographic images are used in desktop publications, presentations, or other work, retouching is usually poorly understood and imperfectly implemented.

The goal of simple retouching is to remove defects from a photograph. Of course, a defect is often in the eye of the beholder (if not in the bags underneath). A high school senior portrait showing less than silky-smooth skin is sometimes viewed as a disaster by those who have just traversed the rocky roads of puberty. On the other hand, removing the character lines from the face of a 60-year-old corporate chief executive could provoke outrage. Emphasizing that steely glint in the eye may be much more important.

In advertising photography, the product must be presented just so, and if 20 hours of retouching is required to achieve the desired effect, so be it. Since it may be prohibitively expensive to reshoot an entire photo series (thousands of dollars in location shooting, props, models, and stylists may be involved), it may be much cheaper to pour more money into retouching an original transparency.

In either case, the defects removed by retouching may, in fact, be minor. In the old days (less than a decade ago), nearly all retouching was done using the photographic media—negative, slide, or print. Skilled retouchers formerly used special dyes to smooth out the smiling faces of high school seniors right on the color negative film. Extensive work can be performed on medium- to large-format color transparencies (4" x 5" to 8" x 10" or larger). Frequently, color or black-and-white prints are *almost* good enough to use but will have a few white spots caused by dust on the negative. A few minutes with a spotting brush can clean them up nicely.

The retouching you see (or don't see) in those cover photos in supermarket tabloids (you know, the one with the Iowa farmer wrestling a 60-pound grasshopper to the ground) often combine composite photographic techniques like those discussed in the last section of this book with airbrush retouching—in effect, *painting* on a print.

Any of these techniques can be duplicated, and surpassed, digitally. You can use dodging and burning (discussed earlier) to improve portions of an image or you can use paint to remove double catchlights from an eye.

The most common defect you'll encounter in an original will be dust spots, especially when the photo was made from a 35mm negative or slide original. Because 35mm film must be enlarged at least 4X from its tiny 1" x 1.5" (24mm x 36mm) size (to 4" x 6" or larger), any dust present is also enlarged. It's difficult to keep a negative or slide 100% spotless, so prints (and reprints, especially) are likely to have at least a couple of these little devils. Unsharp masking, whether applied in the scanner or within Photoshop, is likely to aggravate any dust problem.

Dust on color or black-and-white negatives will manifest itself as white spots on the print. Dust that resides on a color slide will appear to be black when the transparency is viewed or printed. It is well known that there are two colors of dust—white dust, which settles on dark-colored automobiles, and black dust, which is attracted to white or light-colored automobiles.

Both kinds of dust are actually the same; the material on negatives is reversed from black to white, just like the rest of the image, when the negative is printed. If you happen to notice black specks on a print made from a negative or white (or, more often, colored) specks on a print made from a transparency, you probably have a defect in one (or more) of the film's emulsion layers, which make up the image.

Luckily, white or black, these specks are easy to fix, using an image editor's cloning capabilities to copy portions of the image without dust over to the dust spots or clumps in other areas of the image. Scratches and other defects can be corrected in the same way. Even problems within a difficult textured area can be treated effectively with the Clone tool. Although it can't be used in normal mode without destroying the texture, by setting the tool to **Darken** and cloning from an area that is marginally lighter than the area we are trying to touch up, we can fill in the white spots so that they become virtually unnoticeable, without damaging the texture.

The Clone tool, usually represented by a **Rubber Stamp** icon, duplicates part of an image, pixel by pixel, in a location of your choice. The stamp analogy isn't very good, however, since you're actually drawing with a brush that you can size and control in other ways allowed by your image editor (e.g., transparency of the image laid down or some other behavior).

Cloning can be used to copy portions of an image to another location in the same or a different image. If your desert scene is too sparse for you, a single cactus can be multiplied several times or even copied from a different desert altogether. You may add a window to the side of a building by "painting" one from another building using the clone tool. The clone tool is shown in Figure 13.5.

FIGURE 13.5
Clone tool at work.

The cloning brush will have several optional modes, depending on which image editor you use. A key parameter that can be set is how the tool applies tones from the point of origin to the destination point. I'll use Photoshop terminology to describe these differences, but your own image editor should have an equivalent of its own:

❑ **Clone (aligned)**: Once you determine the origin point, the clone tool maintains a fixed spatial relationship between it and the destination portion of the image, no matter how many times you apply the brush.

Cloning an aligned image makes it easy to duplicate objects from one portion of an image (or from a different image), since multiple brush-strokes can be used to copy the same object. If you make a mistake, just select **Undo** and reapply only the most recent strokes.

❑ **Clone (unaligned)**: In this mode, after you set the point of origin, each new click somewhere else in your image starts painting with pixels from that point, until the mouse button is released. This option is used to apply a pattern to an image, rather than to copy an object in multiple strokes.

❑ **Clone (From Saved)**: This mode can save your neck when you discover you've cloned too much of an image or have made any other sort of error that needs correction. The point of origin is automatically set to the equivalent pixel position in the last saved copy of the file, so, in effect, you can paint over a changed portion of the image with the original version. Use this option when you have done considerable work on a file since you saved it and you only want to cancel some of the changes you've made. The so-called Magic Eraser (in Photoshop, hold down the **Alt** key while using the eraser) can also change portions of an image back to its previous state, albeit not with the flexible brush sizes and effects of the Clone tool.

Some image editors clone portions of an image as they were when you started the process: if you start to copy an area that has been modified by cloning, you'll apply the original pixels, not the changed ones. This helps avoid repeating patterns that result when you clone a clone. If your program doesn't operate in this way (Photoshop, for example, doesn't), create a duplicate of your original image and clone from that to avoid the problem.

If a photograph is being retouched with no intention of adding or subtracting anything other than the defects, the Clone tool is useful for copying portions of an image over the parts you want to replace. In the next section, we'll copy skin tones from good portions of an image over dust spots and other artifacts.

MAJOR SURGERY

Some images may require major work and you may find yourself performing major surgery on photos in one of the following categories:

❑ **Photo restorations**. Pictures from 20 or more years ago may have been damaged by the ravages of time, and scratches may need to be removed, missing sections of the photo replaced, and perhaps facial features or other fine details may need to be reconstructed from the fragments that remain. A restoration is shown in Figure 13.6.

FIGURE 13.6
Photo restoration.

❑ **Photo travesties**. These are snapshots with major digressions from desired content. That is, there may be a tree growing from someone's head, an unwanted bystander gawking at the main subject, or some other pictorial clutter. Your job will be to remove these elements.

❑ **Major facial surgery**. The subject is wearing glasses in the photo but switched to contact lenses years ago. An unfortunate accident of lighting accentuated slightly protuberant ears, transforming them from an interesting characteristic to features that would make Dumbo blush. Bad shadows have given someone a double chin. They don't really look like this photo—can you improve it?

For these sorts of operations, you may need to combine many different digital darkroom techniques, from dodging and burning to cloning, copying, and pasting. Figure 13.7 shows this sort of work.

FIGURE 13.7
Major surgery with Photoshop.

Filters

Outside of the computer world, filters are relatively simple. They process things like air, water, motor oil, drip coffee, or smoke, letting the good stuff through while leaving bad things behind for collection or disposal. The only "parameters" you have to worry about are the size of the openings in the filter, which helps determine what can pass through and what remains behind, and the capacity of the filter before it is emptied, cleaned, or thrown away.

The *image processing* filter is even more powerful, functioning as a mini-application of its own. Image processing filters are found in the Filter, Plug-In, or Special Effects menu of an image editor. Although many programs have special filters that are proprietary to that software, a growing number have conformed to the "plug-in" standard set by Adobe for its Photoshop product. You'll find Fauve Matisse, PhotoStyler, Fractal Design Painter, Corel PhotoPaint, and others among these.

Plug-ins are image processing filters, usually kept in a single folder that the software examines each time it loads. Any plug-ins found during this process are automatically listed in the appropriate menu of the program and are available for immediate use.

Filters of this type perform some operation on the currently selected portion of an image (or the entire image if you have made no selection). As I noted, the filter is actually a mini-program that operates on the pixels of the selection in some way. A sharpening filter looks at each pixel in turn and at the pixel's tonal relationship with the pixels that surround it, then

increases the contrast so the image looks sharper. A blurring filter reduces the contrast. You can use the filters available in your image editor in a variety of ways, including the following:

- ❑ Blurring filters are used to reduce or eliminate the effect of artifacts such as dust in an image or to concentrate attention on the areas that you don't blur. Throwing a background out of focus with a blur filter makes the subject of a photograph stand out more sharply.

- ❑ Sharpening filters are a great way to bring fuzzy details into focus. You may find that fine lines that you want to see more clearly will indeed look much better through the extra contrast that sharpening adds. Don't overdo sharpening or the image will look extra contrasty and grainy. Photoshop's Unsharp Masking filter includes controls that let you localize the sharpening effect to a considerable extent.

- ❑ Distortion filters let you twist and twirl portions of an image to create special effects. You can add waves or whirlpool effects, pinch portions of an image, or wrap the photo around a sphere with the correct filter.

- ❑ Noise/despeckle filters either add or remove random pixels in an image. You can change a smooth background to one with interesting grain patterns or smooth out a speckled image with one of these filters.

- ❑ Stylizing filters perform other types of special effects, such as creating 3-D embossed looks, halftone-dot, or mosaic effects. Most vendors of image editors offer their own special complement of these filters.

Filters are an easy and fun way to experiment with special effects. They help add a desirable random quality to the sterile perfection often found in computer-generated images. Figure 13.8 shows a typical filter effect.

FIGURE 13.8
Typical filter effect.

The Next Step

We've finished with our "how-to" and "what-to" sections now. You've learned quite a bit about digital cameras, technology, and tools. In the final two chapters, I'm going to show you some digital images produced by working professionals and discuss a little of the future direction of the field.

CHAPTER 14

PHOTOGRAPHER AND ARTISTS' SHOWCASE

The 16-page full-color insert included with this book is intended as a showcase for the work of photographers, artists, and illustrators who are creating images with digital cameras and/or digital image manipulation programs. This chapter will discuss each of these workers and their images. You'll want to refer to the color insert to review each of the images discussed in this chapter.

Fuji Images

Although Fuji USA was eager to help with this book, the company's latest DS-505/515 cameras were still too new for them to have compiled a list of photographers in the United States that I could contact for pictures and anecdotes. They did, however, send some sample photographs and a camera for me to try out for a few weeks.

The photo of the bowl of flowers and the picture of the clown holding the camera were both captured with the Fujix DS-505 camera (shown in the clown picture). These images demonstrate how this flexible camera can be put to work in the studio with both still-life and human subjects. The resolution is high enough for images that will be printed in sizes up to about 4" x 5".

The bowl of fruit was captured with the Fujix DS-1000 camera, a $3,000 camera with a lower 640 x 480 resolution. However, this camera has a zoom lens and other professional-oriented features not common on digital or analog video cameras in the sub-$3,000 class.

Mike Ulsaker

Mike Ulsaker is a digital photographer based in East Hartford, Connecticut. He works heavily with a Leaf digital camera back mounted on a Hasselblad ELX camera body. Ulsaker's digital photo studio feeds images to an array of PowerPC-based Macintoshes, all equipped with 72Mb to 136Mb of RAM and multigigabyte hard disk drives, depending on the functions relegated to a particular workstation. For example, one Power Mac might be connected to the scanning system, which includes both Leaf Lumina and Leaf 45 scanners, while another is dedicated to a Scitex Iris 4012 printer. Still another Power Mac manages a writable CD archiving system, which uses both Yamaha 4X CD-ROM recorders (and a local 2-gigabyte hard disk drive) as well as 650/1200Mb optical disk drives. An AppleShare work server is connected to an optical disk jukebox, 5.25" and 3.5" optical disk drives, a SyQuest 44/88/200Mb drive, and a digital audio tape (DAT) drive. Everything is connected over an Ethernet network, and I've described only a fraction of the available hardware. Most of the Mac workstations have either one or two hot-swappable hard disk drives, which means a worker can unplug an entire hard disk and substitute another one in seconds. This allows for transportation of data from one machine even more quickly than the network allows, storing hard disks in a safe place, and other security functions.

Ulsaker's images are all gorgeous studio shots, ranging from the portraits of Eric and Erica to food and other product photography.

Paul Spinelli

For Paul Spinelli, a veteran football photographer and executive with NFL Properties, Super Bowl XXIX in Miami, Florida, provided a close encounter of the digital kind. While his crew of 15 contract photographers produced an estimated 50,000 images of the Super Bowl, Spinelli also participated in the testing of a prototype of a new digital camera, which later was introduced as the Kodak professional EOS DCS-5 digital model. Equipped with a 1.5 megapixel CCD sensor that captures 36-bit color images at exposure equivalents of up to 400, Spinelli gave this camera a real workout. It was equipped with enough RAM to capture 10 images in roughly 4 seconds, and the 2.5X multiplication factor of the optical system boosted the effective focal length of the lenses in use. For example, a 200mm telephoto became the equivalent of a fast 500mm optic, while a 400mm long telephoto was transformed into a 1000mm blockbuster.

Bob Shaw

Dallas photographer Bob Shaw melds conventional film images with the digital magic he performs on his Macintosh using Adobe Photoshop and Specular Collage software. Collage is a kind of predecessor to Live Picture in that it allows a user to work with many pieces of a high-resolution image using reduced resolution screen renditions. It is possible to experiment with filters and then command Collage to produce a final image that incorporates all the built-up effects.

One of the images, "Mother Earth," demonstrated to Shaw how digital image manipulation can help avoid reshoots that would result with conventional photographic techniques. To produce this image, he scanned 35 different photographs and used Photoshop to create a series of framed landscapes. Shaw used Kai's Power Tool's Glass Lens filter to map an image of an Earth model onto a three-dimensional ball.

Shaw's goal was to create an image that showed the serenity of nature while emphasizing the global ecological system. A chemical company liked the image but wanted to use it to illustrate how their engineers could produce new products while remaining true to the environment replacing the woman's face with that of a middle-aged man, to represent their average engineer. Shaw found a suitable photo in his files and altered the image quickly. No reshoot was required.

On another occasion, a health care company requested an image that represented "sterilization." Shaw photographed two models to represent the health care professional and patient, using a light-painting technique he has perfected to create highlights on the sheet. He then created rings with icy molecules and flames to represent cold and heat—the two primary forms of sterilization. In his image-editing software, he layered the rings and other elements to create a three-dimensional look. He added a lens flare to one version of the image using a Photoshop filter and created another version without the flare, and he submitted both to the client.

For other images included in this book, Shaw layered as many as 30 different elements ("Gambling in Dallas") or combined photographs of scale models with other images.

Marc Braun

As I worked on this book I was excited to discover that one of the most innovative high-volume illustration studios specializing in digital photography was located just down the road from me. I contacted Braun by telephone, fax, and E-mail, and a few days later I was standing in his Akron, Ohio, facility, ready to pick up his selection of sumptuous pictures you see in the color insert.

Braun opened his own studio in 1974 and used a merger in 1993 with Carey Color, one of the largest prepress companies in the United States, to fund a major investment in high-end digital equipment. This equipment included a Sinar p2 4 x 5 view camera equipped with

Expolux digital shutters and Sinaron digital lenses designed to work with the Leaf digital camera system. Everything runs through a Macintosh Power Macintosh 950 with a 2.3-gigabyte removable hard drive.

The photographs in the color insert from Braun's studio were taken by Braun and several of his top staff photographers.

Tom Hopkins

Photographer Tom Hopkins of Madison, Connecticut, recently took an assistant, a computer technician, a designer, a copywriter, two laptop computers, and a DCS-460 camera to Costa Rica to create a brochure that includes more than 60 of his own photographs. Hopkins, who has had assignments with Molson, Kronenberg, and pharmaceutical and sports magazines, wanted his sales literature to reflect his specialty—"lifestyle" photography. Hopkins shot digitally because few photographers have put out digital brochures and because he could see results right away—a big plus in a tropical country far from his traditional film processors. Both the separation house and the printer Hopkins is working with are extremely enthusiastic about working digitally and are donating time and services to the project. The brochures, which will be completed by the end of May, will be distributed to ad agencies and other potential clients. Since his return from Costa Rica, Hopkins has landed an assignment shooting digital stills for a Time-Life medical video. He is shooting nude models in silhouette with the DCS camera, and computerized internal organs will be dropped into the digital images for instructional purposes.

David D. Busch

It's hard for me to be falsely modest about my own work because, when compared to those of the other photographers and artists who contributed to this book, these images are deservedly modest! However, including a few of these digitally manipulated images provided an opportunity to demonstrate some techniques that are discussed in this book, as well as my earlier books on image effects and filters. The following list explains some of the steps taken to produce these images:

- ❏ **"Castillo."** This was an image of several of the towers of the famous castle in Segovia, Spain, where Queen Isabella was crowned. You've probably seen photos of this castle a thousand times in calendars, books, and publications, since it is the prototypical "castle in Spain" used to illustrate the concept. The usual view is taken from a road out-

side town, since the castle is perched on a cliff in quite a striking manner. This photo was taken from atop the ramparts at the opposite side, just across the moat. In the original, the Spanish plains below made an interesting background, but I decided that a more other-worldly look could be achieved with some judicious blurring.

I used Photoshop's Pen tool to carefully outline the castle with a precise path, then converted the path to a selection. Inverting the selection, I alternately applied a few doses of diffusion to melt the background into a fuzzy set of pixels, then added Gaussian blur enough times to produce the blue-to-brown gradation you see in the final image.

❑ **"Aqueducto."** At the other end of Segovia is the best-preserved Roman aqueduct outside Italy, which I've photographed on four or five different trips to this interesting town. One day while experimenting with Kai's Power Tools' Vortex Tiling filter, I discovered just how much subject matter can help this filter do its job. The aqueduct's stacked series of arches offers the perfect type of fodder for the whirlpool-drain effect of this plug-in.

❑ **"Reflections."** This is an experimental shot prepared for consideration for the cover of this book. It started out as a portrait of my favorite subject, Cathy, a former Barbizon model whose work I liked enough to marry her. I flipped the image horizontally and vertically and applied a different filter to each to show how various digital manipulations can produce quite different effects in the same photograph.

❑ **"Dream."** Cathy also posed for this image, a profile that was duplicated into several layers in a single Photoshop file. To one layer I applied a variety of diffusion filters, such as Kai's Power Tools' PixelWind filter. A second layer was treated with Alien Skin's Swirl filter, except I applied the filter three times using different settings for the red, green, and blue channels. I created a layer mask with a gradation for the diffused version, then merged the two layers to produce the final picture.

❑ **"Plaque."** I wanted to show how Photoshop 3.0's Lighting Effects filter can add directional lighting and texture at the same time. The grainy, raised embossing effect that is produced is quite different from any other embossing filter you're likely to see, because Lighting Effects lets you control the specular highlights to resemble brushed or polished metal, dull plastic, or other surfaces. I adjusted the hue and color balance of this shot to give it a coppery/bronze effect as if it were a metal plaque.

❑ **"Rev. Gary Davis."** I began my career shooting photos of blues singers such as Paul Butterfield, B.B. King, and Janis Joplin, along with rock bands of that era such as the James Gang, Blood, Sweat, and Tears; and many others. Some of the images became the property of the publication or record company, others simply got lost in several moves from Ohio to Rochester, and back to Ohio. I found that every print and negative I had of blues/folk artist Reverend Gary Davis was lost or damaged, but the 35mm contact sheets survived in decent shape.

Properly made contacts from those days can be very sharp, because photographers used special, slow, chloride-based contact papers that also had high resolution. With the negatives held tightly against the paper, emulsion-side down, it was possible to expose detail-rich contact sheets without the unavoidable loss of detail that results from an optical system. Given a high-resolution scanner (my ScanJet 3c's 600 dpi is enough), it's possible to get some amazingly good captures from scans of contact sheets, and I've done it many times in these situations. Sadly, the Davis pictures were made on a matte-finish paper and didn't have enough detail remaining to stand on their own, but they looked good enough when given an unsharp mask treatment, followed by a carefully designed regimen of pixelation. A few years after this picture was taken, I switched to making enlarged proofs by enlargement, using strips of negatives in a 5 x 7 enlarger and most of my "contacts" from those days have a bit more dust and other artifacts than you'd want for this technique.

The Next Step

In Chapter 15 of this book, we'll take a look at the future of digital photography—not so much where the technology is going, but what changes this form of imaging will bring to the way we work and create photographs.

CHAPTER 15

ISSUES FOR THE FUTURE OF DIGITAL PHOTOGRAPHY

Broadly predicting the course that technology will take in the future is not particularly difficult. The automobile—a vehicle that could propel itself and its passengers without the need for horses or other animal means of locomotion—was foreseen by many. The impact of future changes on our society is much harder to divine. Not one prognosticator predicted traffic jams, smog, drive-in theaters, or the suburbs that were a direct result of automotive technology. While the laws of physics and mechanics hold many surprises for us, they are still more predictable than human nature.

In one sense, the chief value of predicting the future rests in the amusement it may provide future generations. Edward Bellamy, in his 1888 book, *Looking Backward: 2000–1887*, insisted that in the 20th century it would no longer be necessary to go to concert halls to enjoy music. Average citizens would be able to listen to musical selections of their choice in the comfort of their own homes. Of course, Bellamy wasn't predicting radio, phonograph records, or even audio CDs. His idea was that we would use telephones (a relatively new invention in 1888) to call various symphony halls and listen to the live music in progress.

Predicting the future of digital photography is fraught with similar pitfalls. One part is easy, however. I can safely say that digital cameras in the very near future will have higher resolutions, greater sensitivity, and much lower costs than the cameras on the market today. I could describe cameras with 3000 x 2000 pixel sensors that equal the resolution of ISO 100

film yet contain enough fast static RAM to let you shoot 50 to 100 images at four to six frames per second. That's not even going out on much of a limb: millions of dollars are being poured into research to produce faster, better, and cheaper microprocessors and RAM chips, since the stakes involved in creating things like 64Mb or 128Mb memory modules or the next generation CPU are huge. They are basic components of the personal computer of the future. This technology will trickle down very quickly to the design of sensors and other components used in digital cameras.

Other predictions are not so easy. Will digital cameras replace film in all applications? Will new applications for digital photography be developed once sophisticated equipment becomes affordable? Will it still make sense to distribute digital images in the same old ways?

In this chapter, I'll tackle some of the key issues that digital photographers may be thinking about in the future. If you happen to have salvaged this book from a pile at a garage sale in the year 2005 and are reading with the added perspective of ten years, try not to laugh too loudly.

Copyright

Two things happened in 1978 that have effected photographers deeply. One event involved Congress passing a new copyright law that made it easier to protect photographs and other creative efforts and extended the protection for new works to the artist's lifetime plus 75 years. During the same year, personal computers from Apple, Radio Shack, and Commodore began to hit their sales stride, leading to the PC revolution that has given photographers more tools to use while at the same time making it more difficult to protect their images.

What good is a copyright in an age when copies of digital images can be made that are perfect, and pretty good duplicates can be made of analog versions by anyone with access to a scanner or color copier?

Software vendors discovered that exact copies of $595 programs could be made in five minutes on a $1 diskette. Music vendors found that proposed consumer digital audio recorders could make perfect duplicates of the audio CDs they priced at $15 and more. Even first-generation analog copies sounded virtually as good as the original. What to do?

Both industries attempted some extremely clumsy remedies. The computer industry tried elaborate copy protection schemes that had no effect on the activities of software pirates but inconvenienced legitimate buyers. The audio industry added a special chip to digital audio tape recorders that allowed the recorder to make perfect digital copies of a CD—but the resulting tape could not be duplicated. Both fields actually had more success by reducing the incentive to copy their products. If a fresh factory-packed audio CD cost $10.98 or if you can purchase a legitimate copy of Microsoft Word with all the manuals for $89 by upgrading from whatever you were using before, why steal either one?

Photographers are now facing the same problem. Every image you create in every format can be copied and reused without payment, although not legally. The process may be either simple or difficult, depending on the format and expertise of the person doing the copying. Transparencies can't be easily duplicated without using a photolab, slide scanner, or some other technology. Prints, on the other hand, can be copied using any flatbed scanner, providing a fairly good digital file. Even halftone images published in a book or magazine can be rescanned and blurred slightly to reduce or eliminate the screen dots.

It gets worse. Copy stations with high-quality dye-sublimation printers are appearing in camera stores and other locations. Kodak and professional photographers have had heated discussions about this innovation, and the Rochester company is taking steps to reduce the chance that Aunt Mary will bring in her niece's wedding photos for duplication rather than pay the original photographer. However, if the end user isn't too fussy about quality, color copies at self-service duplication shops can do a reasonable job of copying images.

The most dangerous possibility of all is that someone will gain access to your high-resolution digital image—essentially the same as a camera negative or transparency—and then be able to make exact duplicates at will. All of the photographers who contributed images to this book have expressed some concerns about this. In most cases, I had to assure them that the digital files would be handled by as few people as possible and that the SyQuest cartridges or CD-ROMs supplied would be returned immediately. In one case, we were given 4" x 5" and 8" x 10" color transparencies made from the original digital files. The chromes were used for reproduction and then returned; they, of course, couldn't be duplicated without losing a generation's worth of quality.

Most of the photographers supplied images that were created either specifically for promotional purposes or for an assignment that had limited applications and had already been paid for.

Of course, the copyright law may let you collect from those who use images without permission after the fact, if you're lucky enough to discover the usage and can prove it's your image. Proof may not be as easy as you think. Pursuing copyright defense through the legal system is, in any case, very expensive, and the results are uncertain. Worse, the law is not clearly defined in many areas. Just because someone flagrantly uses your image does not automatically mean you have an enforceable claim.

For example, consider the image in Figure 15.1, a view of Toledo, Spain, from a hilltop outside of town. The vantage point from this hill is perfect; El Greco used it several times to create paintings that now hang in the Metropolitan Museum of Art in New York City and the Museo del Greco in Toledo. This view is so popular that I own no fewer than five books that use photographs of it on their cover. All the photographs are by different photographers, but they are virtually identical except under very close examination. I discovered why this is so some years back when I drove up the hill myself and discovered a well-trod scenic overlook that must have been used by thousands of photographers, and by perhaps the Greek painter himself, over the years.

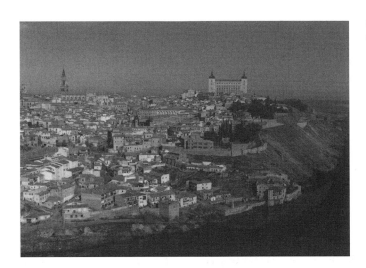

FIGURE 15.1
View of Toledo, Spain.

Some images, particularly news photographs, scenics, and other pictures that don't contain unique subject matter, are difficult to prove as your own. However, even the most unusual image must be solidly established as belonging to you if you expect to recover damages. This is true if the image is reused in its entirety, and more difficult if parts of the image were "sampled." I won't get into the differences between new works and derivative works, or things like "fair use." There are plenty of law-and-the-photographer books available that address these issues.

Instead, I'll tell you some of the ways digital photographers can "mark" their works much as they use an ink stamp, embossing, or some other device on conventional photographs.

One way to protect work is to include information in the file headers of the digital files. A little expertise and the right disk editing tools can let a photographer insert a code or text signature in the file in a place where it won't affect image quality. Of course, anyone with the same expertise and tools can take it right out.

Another method involves overprinting the digital image with a faint watermark, which (supposedly) doesn't interfere with evaluating the image, but makes it impossible to duplicate or use the file without reproducing the watermark. Of course, you still have to supply the unaltered digital file for reproduction, so this form of protection is far from complete.

A third method is to use encryption, which works particularly well with images distributed on Photo CDs. Every Photo CD using the original format contains several copies of the image at five to six different resolutions. The low-resolution versions can be left unencrypted so that they can be viewed on-screen. Some distributors even give permission to reproduce these images, with proper credit, since they are suitable only for basic desktop publishing applications. Then, when a buyer wants to gain rights to a high-resolution version of an image, a decryption code can be purchased by paying the necessary fee.

Encryption is a good solution, but distributing images on Photo CDs is inefficient in some cases. You might have to send along a hundred different Photo CDs containing the various photos the client might want to view, whereas it might make more sense to burn a special CD-ROM with only the 100 images that fit the requirements. Moreover, even if a bunch of TIFF files are encrypted, you'd have to create a special low-resolution version of each one so the client can view the images on a screen.

A Portland, Oregon, company named Digimarc Corporation is developing a scheme that may solve most of the problems inherent in other image identification methods. It involves embedding a random code pattern right in the digital file as a form of noise that is present at such a low level that it can't be detected with the eye. However, the code can be detected reliably even after the image has been subjected to the photomechanical reproduction process. That is, you can scan in a suspect image that has been printed in a book, magazine, newspaper, poster, or other medium and find the embedded digital signature using the right software. The encoded information is holographic, and the entire code can be read from any smaller portion of the reproduced image. Cropping work drastically won't disguise the code at all.

A lot of work remains to make this technology viable. When complete, however, it could be incorporated into a Photoshop plug-in, adding the codes to any images desired. It could even be included in a chip in copy print stations or photocopiers that would alert the machine that a copyrighted image was present. The code could include information on how to obtain permission, so if you tried to copy a certain image, a dialog box would pop up saying, "Call 800-xxx-xxxx to obtain a code, then key it in to proceed."

For photographers to recover damages, the reliability would have to be established in a court, much as radar gun manufacturers routinely send experts to testify about the accuracy of their devices the first time they are used in a given jurisdiction.

There are advantages to this method. The code can either be supplied to an image once it is finished or actually applied by the digital camera when the picture is first made. It will automatically be reproduced along with the file, and it can't be removed without destroying the image, unless you have the original creator's code. As with common encryption schemes today, both public and private codes can be incorporated—one code that allows verifying an image that may be freely distributed, and a second, private, code known only to the photographer. Using two codes prevents others from falsely stamping images with anyone else's code. Photographers who sell all rights to an image could remove their own code, allowing the new owner to embed one of his or her own.

The Digimarc system also bypasses having to encrypt the images themselves, so they can be freely distributed, viewed, and used. It doesn't stop unscrupulous people from stealing pictures, but it does make it easier to prove their theft if you catch them. Since Digimarc works with any digital file, including video, audio, or text, its broad commercial applications are an incentive to work out the last few kinks in the system.

Is Film Dead?

In the 1970s, when news film cameras began to be replaced in a few markets by electronic news gathering (ENG) equipment—portable videotape cameras and recorders—a trade paper rocked the industry by publishing an article with the headline, "Is Film Dead?" This article predicted that videotape would replace film in television news (which it eventually did, although film hung on for a few years as the favored medium for local television documentaries) and, eventually, in the production of theatrical motion pictures. A decade later, pundits were saying the same things about film in all still photographic applications.

Don't hold your breath. Motion pictures today are still shot on color negative film, and most still photographs are still produced using negatives or transparencies exposed in a camera. The advantages and disadvantages of electronic image capture versus film will change over the next few years, but the pros will continue to outweigh the cons for many film applications for quite a while.

Certainly, digital photography has already completely taken over some fields, such as catalog photography. But there remain other worlds to conquer.

Write-once, read many times (WORM) optical storage media is still the most efficient form of storage for images. I'm not talking about optical disk or CD-ROM, either, since I didn't specify *digital* storage. Photographic film is the oldest, cheapest, and most mature way of using optical techniques to store images. Even as digital storage drops to 10 or 20 cents a megabyte, it is still cheaper to keep the equivalent of an 18Mb digital image on a frame of film that costs pennies. The capture devices—conventional cameras—cost $1,000, not $30,000 or $10,000 or even $5,000.

There are other artistic reasons for retaining film capabilities, as anyone who shoots a lot of black-and-white film will testify. The film "look" may someday have a cachet of its own in an age of digital imaging. If you want the lowest-cost media, the broadest range of film speeds, spectrum sensitivity, and grain characteristics, film provides options that you needn't expect from electronic gear anytime soon.

Environmental and Health Impact of Digital Photography

The environmental effects of conventional photographic processes had their day in the sun in the early 1980s, when increased consumer attention on toxic chemicals caused many municipalities to take a close look at what photography labs and other small-scale operations were discharging in the sewage system. Many cities then severely restricted effluents, forcing some labs to have their liquid waste hauled away. This scrutiny also coincided with a drastic

temporary price spike in the silver market, with a rise from about 90 cents to more than $40 an ounce, which suddenly made silver recovery a lot more attractive.

Environmental concerns seem to cycle in connection with the economic factors that are tied in with them. A Kodak representative once told me about a naive dentist who was buying a lot more fixer than his purchases of X-ray film would indicate. It seems he was mixing the fixer and immediately dumping it into the silver recovery tank to retrieve all the silver he thought was in the solution. Of course, I also attended the early retirement party of a stripper in a prepress house who had invested $15,000 in silver because he had nothing else to do with the money and sold it six months later for $600,000.

Today, the environmental impact of digital photography is much less, because film and chemical vendors responded to the earlier crises with products that require much less in the way of chemicals that are considered toxic and with processes that allow regenerating fixer and replenishing most other chemicals. Silver recovery is also more efficient. Some types of photolabs, such as the mini-labs found in malls, are self-contained and require no plumbing connections at all.

So, any switch from film to digital imaging is likely to have its largest effect on darkroom workers, who would have less opportunity to breathe unpleasant or potentially harmful fumes or to plunge their hands into chemicals that may aggravate allergies. Those of us who spent decades sniffing acid stop bath won't miss it much.

Of course, digital photography has its own environmental and health hazards, not the least of which are electromagnetic fields emitted by monitors (most new displays conform to standards that severely limit the amount of radiation) and things such as repetitive stress injuries.

Pricing

Digital photography is likely to cause some changes in the way photographers price their work. Will day rates include the cost of carting along the computer equipment and assistant needed to download images on-site? Should rates be adjusted because no processing is required? Can you replace your stylist with a computer specialist and bill higher rates because the specialist gets more money?

How about the cost of supplying images to clients? Instead of circulating duplicate slides and sending camera originals or C prints only when absolutely necessary, can you use SyQuest cartridges at $50 a pop, or CD-ROM at $10 a disk? Will clients expect you to pass along the savings—if any—to them?

The problem is that photography has always been a difficult business to quantify. A shooting day you can bill for probably requires two days of preparation. An image of Toledo, Spain, from that hill may be worth quite a bit to someone who needs it taken at a certain day or time and doesn't want to fly to Spain to get it. But if all you need is any old picture from

that hillside, a stock house can provide it for a reasonable fee. My average-looking shot may be good enough, even when compared to one by, say, Ansel Adams, although Adams' will have a neat moon positioned in just the right spot and have a lot longer tonal scale.

Digital stock photography may revolutionize the industry in several ways, some good, some bad. Photographers will have many more outlets for distributing their photographs, and the availability to end-users will become much broader, but overall prices should come down significantly. I can remember when digital fonts used for desktop publishing cost $100 per typeface. Now you can buy a CD-ROM with 2000 decent typefaces for $5.00, and even professional-quality fonts are selling for a tiny fraction of their original price. When buyers can purchase traditional stock fodder for a few dollars, your own seaside sunsets, Yellowstone Park scenics, cute kid and kitten photos, and other efforts must either be cheaper (not likely) or better than the alternatives. Unless you're a "name" photographer, or you happen to grab a one-time shot of a news event, the days of collecting thousands of dollars for a single picture, year after year, may be over.

Look for new ways to bill for photography to emerge as digital photography becomes more mature.

Ethics

Anytime I interview a news organization about digital photography, one of the first things they emphasize—even if I never bring up the topic myself—is how they have measures in place to ensure that images are never, ever altered in a misleading way. Even something as innocuous as moving the pyramids around for a *National Geographic* cover or placing Oprah Winfrey's head on Ann-Margret's body for *TV Guide* sends shivers of terror down the spines of both journalists and their critics.

For thousands of years, "seeing is believing" was more or less true. Viewers of an early motion picture that showed a train heading straight at the audience fled the theater in terror, because they couldn't comprehend that this fuzzy, black-and-white image wasn't the real thing. Today, we're confronted with realistic photos of the President shaking hands with space aliens or Elvis attending the wedding ceremony of his daughter. It's hard to know what to believe.

As much fun as digital manipulation is, there are several areas in which it must be used with caution. The most obvious is in news photography. Picture editors have long worked with restrictions on what they could and could not do. Publishing a picture that shows a male politician hugging a lovely woman but cropping out his smiling wife standing right behind him would be misleading, to say the least. News publications keep such situations in mind. There are many ways to juxtapose images, crop, or otherwise present a photograph in a way that misrepresents the truth, even without digital manipulation, and newspapers are used to

dealing with this. Even the National Press Photographers Association (NPPA) concedes that color correction, dodging, burning, contrast enhancement, and other techniques that have long been used to improve an image without altering the meaning of its content are acceptable in the digital realm.

Strict rules govern images collected for evidence or forensic purposes in legal applications. Pictures must portray a scene accurately, to the extent that crime scene photographers often provide many different views and wide-angle perspectives to show the overall picture before zeroing in on a specific piece of evidence. An unbroken chain of possession must be established, proving that these are, indeed, the photos taken at that time and place, rather than some others that might have been substituted intentionally or by accident.

In this regard, digital photography may even have some advantages over conventional processes. Digital images don't have to change possession as many times, since a separate processing step isn't required. In addition, images stored in a vendor's proprietary, raw camera format have been accepted by courts as proof enough that they haven't been previously altered.

A third area in which photographers must be extremely careful is in advertising. Digital photography lends itself to the kind of manipulation that courts have frowned on as being misleading. You can do what you like to make a product look good, but it must still accurately represent the product to the consumer.

Many years ago there was a case in which a soup vendor put marbles in the bottom of a bowl of soup, to make all the vegetables rise to the top and make a photograph of the soup appear richer than it really was. Today, we'd probably just clone extra food chunks as required using Photoshop. However, any such manipulation could be done only to the extent that it didn't misrepresent the product, as the soup manufacturer found out. You can brighten a sweater, add drops of dew to a bowl of fruit, drizzle some digital juice down the front of a sandwich, but the final image must be representative.

You can compensate—but not overcompensate—for the vagaries of the reproduction process. One camera manufacturer was allowed to include photos in an advertisement that were actually sharper than those typically produced by the camera in question. (They were shot with a 120 SLR rather than the 35mm camera being touted.) It proved that by the time the ad was printed, the sharpness of the photographs was still less than similarly sized prints from the advertised camera. Lighting and other aspects of the images were all similar to what the camera could produce, even though a larger format was used.

Like journalistic and legal photography, advertising illustration is a field in which the pitfalls are well known, and most photographers, art directors, picture editors, and others know what to look for. There are several other areas, such as medical photography and industrial documentation in which deceptive manipulation is also a potential problem, but there is little incentive to falsify information in these arenas, so digital photography presents few problems at present.

Technology

Finally, there are some technological aspects of digital photography that should cause significant changes in the industry in the future. It's hard to predict exactly what these changes will be, because too many unexpected breakthroughs occur in relatively brief periods of time. It's been said that if you could have transported a jet fighter plane used during the Korean War to a period only 10 years earlier at the beginning of World War II and presented it to scientists they would have been astounded.

Today's Pentium and PowerPC microprocessors look terribly advanced to those of us who used 2MHz (not 133MHz) computers 18 years ago. In 1981, I predicted three-inch-wide hard disks that could hold 7500Mb as a joke, since hard disks of the day cost $3,000 and held only 5Mb.

So, digital technologies of the next few years and the implications they hold are difficult to predict. However, certain trends in place today should continue to be refined. Some of these include:

❑ **New markets.** The World Wide Web on the Internet might just collapse under its own weight, since mindless users are already eating up expensive bandwidth sending video or even their own personal phone calls over the system. (You can tune in and watch the snake collection of Guns N' Roses' lead guitarist, Slash, 24 hours a day if you know where to look.) However, if the system evolves into something with enough discipline to enable picture buyers to find what they want, it may be practical to sell digital images directly over the Internet to those who need them. Digital "money" is already available from several sources. All you need is a product, a way to promote it, and a forum for selling or distributing it.

❑ **Very low-cost storage.** Pinnacle has introduced 4.6-gigabyte optical disk cartridges that cost $200 (at this writing) and operate virtually as fast as hard disks. The reader/writer is priced at $1,500. CD-ROM burners that cost $500 are only months away, and the blank disks are already priced at $8 and dropping. Really cheap, widely accessible media could change the way we store, distribute, and sell images. You can already buy a CD-ROM with 3500 different books on it—a complete library—for $30. Won't some photographers be tempted to put their entire collection of old images on one disk and sell it for a one-time, all-rights price, since that eliminates the fuss and bother of tracking usage and billing for it?

The Next Step

I once visited photographer Maureen Lambray in her New York City studio soon after she completed work on her 1976 book, *The American Film Directors*. She told me that she was fascinated

with cinema because it is an artform that began not too long before she herself was born and many of its pioneers like Raoul Walsh, Howard Hawks, and Fritz Lang were, at the time, still alive and available for her to talk with and photograph.

Digital photography today is still very much in its infancy. Many of the pioneers who will be revered 20 years from now are still unknown today. You have a remarkable opportunity to get in on the ground floor of a new and growing technology that will change the way we produce and use images. The Fritz Langs and Alfred Eisenstadts of digital imaging are out there working right now, so don't miss this chance to work with them, or perhaps even become one of those leading lights yourself.

GLOSSARY

Each term I thought you might not understand is in this glossary. Definitions of many of the specialized terms and jargon you'll run across when working with digital photography and imaging software are included.

achromatic color	A color with no saturation, such as a light gray.
additive colors	The primary colors of light—red, green, and blue—which, when combined, produce white light.
airbrush	An atomizer used for spraying paint. Image editing software usually has an airbrush-like tool, which can apply a fine spray of a given tone to a specified area.
alpha channel	An optional grayscale "layer" of an image that can be created to store selections and other modifications and that can be saved with the image if it is stored as a tagged image file format (TIFF) or an image editor's proprietary format. *See channel.*
ambient lighting	The overall nondirectional lighting that fills an area. While ambient lighting is commonly a factor in photographic situations, it can also be applied as an effect in some image editing programs such as Photoshop.
analog	Continuously variable information such as a photographic print or time as represented by the sweeping second hand of a clock. **Contrast** *digital*.
anamorphic	An image that has been enlarged or reduced more in one direction than another. The image appears "squashed" or "stretched" in a given dimension.

antialiasing	A process used to reduce the impact of stair-stepping in the diagonal lines of an image. *See jaggies.*
archive	To store files that are no longer active.
aspect ratio	The relative proportion of the length and width of an image. A piece of 4" x 5" film has an aspect ratio of 4:5, exactly the same as an 8" x 10" print.
autotrace	A feature found in many object-oriented image editing programs or stand alone programs that allows tracing a bit map image and converting it to an outline.
backlighting	A lighting effect produced when the main light source is located behind the subject. If no other lighting is used in conjunction with backlighting, the effect is a silhouette. Backlighting can be simulated with filters.
back up	To make a copy of computer data as a safeguard against accidental loss. The copy that is made is called the *backup*.
bilevel	In scanning, a binary scan that stores only the information regarding whether a given pixel should be represented as black or white.
bit	A binary digit—either a 1 or a 0—that is the lowest level of computer information. Scanners typically use multiple bits to represent information about each pixel of an image. A 1-bit scan can store only black or white information about a pixel. A 2-bit scan can include four different gray levels or values—00, 01, 10, or 11. A 24-bit scan can include 16.7 million colors.
bitmap	A representation of an image in row and column format in which each individual pixel is represented by a number. Commonly, a *bitmap* is used to refer to a bilevel (black-and-white) scan, while a *bitmapped image* is often used when a raster-image processor can't locate the high-resolution version of an image and substitutes a lower resolution version called a screen proxy. *See raster image.*
black	The color formed by the absence of reflected or transmitted light.
black printer	The plate used for the black ink in the four-color printing process. It provides emphasis for neutral tones, detail in

shadow areas of the image, and a deeper black than can be provided by combining cyan, magenta, and yellow alone. Black printers can have different formats. A *skeleton black* adds black ink only to the darker areas of an image. A *full-range* black printer adds some black ink to every part of the image.

bleed An image that continues to the edge of the page. A bleed is accomplished by making the image extend beyond the edge of the page and then trimming the page to finished size.

blend Create a more realistic transition between image areas.

blur Soften part of an image, making it less distinct.

boot Start up a computer.

brightness The balance of light and dark shades in an image. *See luminance.*

buffer An area of computer memory set aside to store information. Digital cameras may have a RAM buffer that allows the camera to take two pictures in succession, then store them to a PC card hard disk or RAM card.

bug An error in a program that results in some unintended action.

bulletin board system (BBS) A computer system that has been set up as a clearing house for the exchange of information among other computer users via modem. Service bureaus often set up a BBS to allow transmitting files for output directly to the bureau.

burn In photography, to expose part of a print for a longer period, making it darker than it would be with a straight exposure. In lithography, to expose a printing plate.

bus A hardware interface used to connect a computer to peripherals or other computers. The SCSI bus or NuBus are both used by Macintosh computers.

byte Eight bits, which can represent any number from 00000000 to 11111111 binary (0 to 255 decimal).

cache A fast memory buffer used to store information read from a disk or from slower RAM that allows the operating system to access the information quickly.

calibration A process that includes making scanner output consistent and bringing the monitor representation of the image closer to the appearance of the final output.

camera-ready	Art work that is printed in hard copy form and can be photographed to produce negatives or plates for printing.
cast	An overall color imbalance.
charge-coupled device (CCD)	A type of solid state sensor used in scanners and video capture devices. Compared to older imaging devices, including video tubes, CCDs are more sensitive and less prone to memory problems that can cause blurring of images.
channel	One of the layers that make up an image. An RGB image has three channels: one each for the red, green, and blue information. A CMYK image has four channels: cyan, magenta, yellow, and black. A grayscale image contains just one channel. Additional masking channels can be added to any of these. *See alpha channel.*
Chooser	The Macintosh desk accessory used to select devices such as printers and to direct their communications through either the printer or modem port.
chrome	A color transparency, from film names like Kodachrome or Ektachrome.
chroma	Color or hue.
Cromalin	The DuPont trademark for a type of color proof used for representing how color halftones will appear on the printed page.
chromatic color	A color with at least one hue available, with a visible level of color saturation.
clipboard	A memory buffer that can hold images and text so they can be freely interchanged within and between Macintosh applications.
clipping	Compressing a range of values into a single value, as when a group of highlight tones are compressed to white or a set of shadow tones represented as black. *See threshold.*
clone	In image editing, to copy pixels from one part of an image to another.
CMYK	The abbreviation for cyan, magenta, yellow, and black.
CMYK color model	A model that defines all possible colors in percentages of cyan, magenta, yellow, and black.
color	*See hue.*

color correction	Changing the color balance of an image to produce a desired effect, usually a more accurate representation of the colors in an image. It is used to compensate for the deficiencies of process color inks, inaccuracies in a color separation, or an undesired color balance in the original image.
Color Key	A 3M product, consisting of a set of four acetate overlays, each with a halftone representing one of the colors of a color separation, tinted in that color. When combined, Color Keys can be used for proofing color separations.
color separation	The process of reducing an image to its four separate color components—cyan, magenta, yellow, and black. These separations are combined using an individual plate for each color on a press.
comp	A dummy layout that combines representations of type, graphics, and photographic material, also called a *composite* or *comprehensive*.
compact disk–(CD-ROM)	An optical disk device that uses pits permanently **read only memory** etched onto a disk by laser to convey bits of information.
complementary color	The opposite hue of a color, also called the *direct complement*. For example, green is the direct complement of magenta. There are also two other types of complements: the *split complement* (a color 30° away from the direct complementary color) and the *triadic complement* (a color 120° in either direction from the selected color).
compression	Packing of a file or image in a more efficient form to improve storage efficiency.
constrain	To limit in some way, as to limit the movement of a selection by holding down the **Shift** key as you begin to move it with the mouse.
continuous tone	Images that contain tones from black to white with a range of variations in between; a nonhalftoned image. The term is often shortened to *contone*.
contrast	The range between the lightest and darkest tones in an image. A *high-contrast* image is one in which the shades fall at the extremes of the range between white and black. In a *low-contrast* image, the tones are closer together.

copy dot Photographic reproduction of a halftone image, in which the halftone dots of a previously screened image are carefully copied as if they were line art.

crop Trim an image or page by adjusting the side or boundaries.

crop mark A mark placed on a page that is larger than the finished page to show where the page should be trimmed to final size.

cursor A symbol that indicates the point at which the next action the user takes—text entry, line drawing, deletion, and so on—will begin; the current position on the screen.

daisy-chain To connect peripheral devices in series, as with the SCSI bus. You can also daisy-chain Apple Desktop Bus (ADB) devices, such as the keyboard and mouse.

darken A feature found in many image editing programs that allows gray values in selected areas to be changed, one value at a time, from the current value to a darker one.

default A preset option or value that is used unless you specify otherwise.

defloat Merges a floating selection with the underlying image. The defloated portion of the image is still selected, but if you move or cut it, the area it previously covered will be filled with the background color.

defringe Remove the outer edge pixels of a selection to merge the selection with the underlying image more smoothly.

densitometer A device that measures the darkness of an image.

desaturate Reduce the purity or vividness of a color by adding the complementary color.

diffusion The random distribution of gray tones in an area of an image. *See mezzotint.*

digital Information broken into discrete groups, such as the pixels of a bitmapped image, or the numeric hours:minutes:seconds representation of time on a digital clock.

digital signal processor (DSP) A special coprocessor designed to work with the computer's CPU, applying large amounts of numeric calculations to data in real time.

digitize	Convert information, usually analog information, found in continuous tone images (or music), to a numeric format that can be accepted by a computer.
dot etching	A technique in photographic halftoning in which the size of the halftone dots is changed to alter tone values.
displacement map	A file used to control the horizontal or vertical shifting of pixels in an image to produce a particular special effect.
dithering	A method of simulating gray tones by grouping the dots shown on the monitor or produced by the printer into large clusters of varying sizes. The mind merges these clusters and the surrounding white background into different tones of gray.
dodge	In photography, to block part of an image as it is exposed, lightening its tones.
dot	A unit used to represent a portion of an image. A *dot* can correspond to one of the pixels used to capture or show an image on the screen, or groups of pixels can be collected to produce larger printer dots of varying sizes to represent gray.
dot gain	The tendency of a printing dot to grow from its original size when halftoned to its final printed size on paper. This effect is most pronounced on devices using poor-quality paper, which allows ink to absorb and spread.
dots per inch (dpi)	The resolution of an image, expressed in the number of pixels or printer dots in an inch.
download	Receive a file from another device. For example, soft fonts are downloaded from the computer to the printer.
driver	A software interface that allows an applications program to communicate with a piece of hardware, such as a scanner.
dummy	A rough approximation of a publication, used to gauge layout.
duotone	A printed image, usually a monochrome halftone, which uses two different colors of ink to produce a longer range of tones than would be possible with a single ink density and set of printer cells.
dye sublimation	A printing technique in which solid inks are heated directly into a gas, which then diffuses into a polyester substrate to

form an image. Because current dye-sublimation printers can reproduce up to 256 different hues for each color, they can print as many as 16.7 million different colors.

dynamic RAM Type of memory that must be electrically refreshed many times each second to avoid loss of the contents. All computers use dynamic RAM to store programs, data, video information, and the operating system.

emulsion The light-sensitive coating on a piece of film, paper, or printing plate.

emulsion side The side of a piece of film that contains the image, usually with a matte, nonglossy finish. This side is placed in contact with the emulsion side of another piece of film (when making a duplicate) or the printing plate. That way, the image is sharper than it would be if it were diffused by the base material of the film. Image processing workers need to understand this concept when producing images oriented properly for production. *See right-reading image, wrong-reading image.*

export: To transfer text or images from a document to another format. Some applications provide a **Save As...** option to save the entire file in the optional format, while others let you save a selected portion of the image or file in another file format.

extrude Create a 3-D effect by adding edges to an outline.

eye dropper An image editing tool used to "pick up" color from one part of an image so it can be used to paint or draw in that color elsewhere.

feather Fade the edges of a selection to produce a less-noticeable transition.

file A collection of information, usually data or a program, that has been given a name and allocated sectors by an operating system.

file format A set way in which a particular application stores information on a disk.

fill Covering a selected area with a tone or pattern. Fills can be solid, transparent, or have a gradient transition from one color or tone to another.

filter

Image filters are used to process an image—to blur, sharpen, or otherwise change it. Programs like Adobe Photoshop have specialized filters that will, among other things, sphere, change perspective, and add patterns to selected portions of the image.

fixed disk

Another name for a hard disk drive. Such disks are not commonly removed from the computer while in use.

flat

1. A low contrast image. 2. The assembled and registered negatives or positives used to expose a printing plate.

floating selection

A selection that has been pasted into an image from another image or layer is said to be *floating*. It is above and not part of the underlying image and can be moved around without affecting the image beneath. Once it has been *defloated*, the selection becomes part of the underlying pixels and cannot be moved or cut without leaving a hole.

For Position Only (FPO)

A notation scribbled on dummy copy and on images on a mechanical to make it clear that this artwork is not good enough for reproduction, but is included to help gauge how a page layout looks.

four-color printing

Another term for process color, in which cyan, magenta, yellow, and black inks are used to reproduce all the hues of the spectrum.

fractal

A kind of image in which each component is made up of smaller versions of the component. More recently, fractal calculations have been used to highly compress image files: when the image is decompressed, fractal components are used to simulate portions that were discarded during the archiving process.

frame grabber

A device that captures a single field of a video scanner or camera.

frequency

The number of lines per inch in a halftone screen. *See lines per inch.*

frisket

Another name for a mask, used to shield portions of an image from the effects of various tools that are applied to other areas of the image. *See mask.*

galley	A typeset copy of a publication used for proofreading and estimating length.
gamma	A numerical way of representing any input/output curve, such as the contrast of an image, shown as the slope of a line showing tones from white to black.
gamma correction	A method for changing the brightness, contrast, or color balance of an image by assigning new values to the gray or color tones of an image. Gamma correction can be either linear or non-linear. *Linear correction* applies the same amount of change to all the tones. *Nonlinear correction* varies the changes tone by tone, or in highlight, midtone, and shadow areas separately to produce a more accurate or improved appearance.
gamut	A range of color values; those present in an image that cannot be represented by a particular process, such as a fluorescent orange in offset printing, are said to be *out of gamut*.
gang scan	The process of scanning more than one picture at a time, used when images are of the same density and color balance range.
Gaussian blur	A method of diffusing an image by using a bell-shaped curve to calculate which pixels will be blurred, rather than blurring all pixels in the selected area uniformly.
gigabyte	Roughly a billion bytes of information; a thousand megabytes.
graduated fill	A pattern in which one shade or hue smoothly blends into another; also called a *gradient fill*.
graphics tablet	A pad on which to draw with a pen-like device called a *stylus*, used as an alternative to a mouse.
gray component removal	A process in which portions of an image, all which have three process colors, have an equivalent amount of their color replaced by black.
gray map	A graph that shows the relationship between the original brightness values of an image and the output values after image processing.
grayscale	The spectrum of different gray values an image can have.
halftoning	A method for representing the gray tones of an image by varying the size of the dots used to show the image.

highlight	The brightest values in a continuous tone image.
histogram	A bar-like graph that shows the distribution of gray tones in an image.
hue	A pure color. In nature, there is a continuous range of hues.
image acquisition	Capturing a digitized version of a hard copy or real-world image, using devices such as a scanner or video camera.
image editor	Program such as Adobe Photoshop, PixelPaint, or Fractal Design Painter, that are used to edit bit-mapped images.
imagesetter	A high-resolution PostScript printer that creates camera-ready pages on paper or film. *See PostScript.*
ink-jet	A printing technology in which dots of ink are sprayed on paper.
input	Incoming information. Input may be supplied directly to the computer by the user or to a program by either the user or a data file.
instruction cache	A type of high-speed memory used to store the commands that the microprocessor used most recently. A cache *hit* can eliminate the need to access slower RAM or the hard disk, increasing the effective speed of the system.
interlacing	A way of displaying a video image in two fields: odd-numbered lines first, then even-numbered lines, updating or refreshing each half of the image on the screen separately.
interpolation	A technique used when resizing or changing the resolution of an image, to calculate the value of pixels that must be created to produce the new size or resolution. Interpolation uses the tone and color of the pixels surrounding each new pixel to estimate the correct parameters.
Input/Output (I/O)	Used to describe the process whereby information flows to and from the microprocessor or computer through peripherals such as scanners, disk drives, modems, monitors, and printers.
invert	To change an image into its negative; black becomes white, white becomes black, dark gray becomes light gray, and so forth. Colors are also changed to the complementary color: green becomes magenta, blue turns to yellow, and red is changed to cyan.

jaggies

Staircasing of lines that are not perfectly horizontal or vertical. Jaggies are produced when the pixels used to portray a slanted line aren't small enough to be invisible because of the high contrast of the line and its surrounding pixels.

JPEG compression

Reducing the size of an image through algorithms specified by the Joint Photographic Experts Group. The image is divided into blocks, and all the pixels within the block are compared. Depending on the quality level chosen by the user, some of the pixel information is discarded as the file is compressed. For example, if all the pixels in a block are very close in value, they may be represented by a single number rather than by the individual values.

knockout

Area where the background is totally deleted, so another color can lie on top of it without the background overprinting or showing through.

landscape

The orientation of a page in which the longest dimension is horizontal, also called *wide orientation*.

lasso

A tool used to select irregularly shaped areas in a bit-mapped image.

layers

Separation of a drawing or image into levels, which can be edited or manipulated individually, yet combined to provide a single drawing or image.

lens flare

In photography, an effect produced by the reflection of light internally among elements of an optical lens. Bright light sources within or just outside the field of view cause lens flare. It can be reduced by the use of coatings on the lens elements or with the use of lens hoods, but photographers (and now digital image workers) have learned to use it as a creative element.

lighten

An image editing function that is equivalent to the photographic darkroom technique of *dodging*. Gray tones in a specific area of an image are gradually changed to lighter values.

line art

Usually, images that consist only of black and white.

line screen

The resolution or frequency of a halftone screen, expressed in lines per inch. Typical line screens are 53 to 150 lines per inch.

lines per inch (lpi)

The yardstick used to measure halftone resolution.

lithography	Another name for *offset printing*. A reproduction process in which sheets or continuous webs of material are printed by impressing them with images from ink applied to a rubber blanket on a rotating cylinder from a metal or plastic plate attached to another cylinder.
luminance	The brightness or intensity of an image. Determined by the amount of gray in a hue, luminance reflects the lightness or darkness of a color. *See saturation.*
LZW compression	A method of compacting TIFF files using the Lempel-Zev-Welch compression algorithm. It produces an average compression ratio of 2:1, but larger savings are produced with line art and continuous-tone images with large areas of similar tonal values.
Magic Wand	A tool that selects contiguous pixels that have the same brightness value or that fall within a selected range.
mapping	Assigning colors or grays in an image.
marquee	A selection tool used to mark rectangular areas.
mask	Covering part of an image so it won't be affected by other operations.
mechanical	Camera-ready copy with text and art already in position for photographing.
mezzotint	An engraving that is produced by scraping a roughened surface to produce the effect of gray tones. Image editing and processing software can produce this effect with a process called *error diffusion*, resulting in randomly sized and placed dots instead of the regular dots found in a halftone screen.
microprocessor	The computer-on-a-chip that is the brains of a personal computer.
midtones	Parts of an image with tones of an intermediate value, usually in the 25 to 75% range.
millisecond	One-thousandth of a second.
moiré	In scanning, an objectionable pattern caused by the interference of any two patterns, particularly halftone screens—often produced when a halftone is rescanned and a second screen is applied on top of the first.
monochrome	Having a single color.

multisession CD A Photo CD that can have images placed on it two or more times, as opposed to *single-session CDs*, which are written to only once.

National Television Standard Code (NTSC) The standard for video in the United States.

negative A representation of an image in which the tones are reversed—blacks are shown as white.

neutral color A color in which red, green, and blue are present in equal amounts, producing a gray.

noise Random pixels added to an image to increase apparent graininess.

offset printing *See lithography.*

opacity The opposite of *transparency*: the degree to which a layer obscures the view of the layer beneath it. *High opacity* means low transparency.

overlay A sheet laid on top of another to specify spot colors for printing. In programming, a portion of a program that is called into memory as needed, overlaying the previous redundant section of the program. Overlays allow writing programs that are much bigger than those that could fit into memory all at once.

palette 1. A set of tones or colors available to produce an image. 2. A row of icons representing tools that can be used.

Pantone Matching System A registered trade name for a system of color matching. If you tell your printer the PMS number of the color you want, that color can be reproduced exactly by mixing printing inks to a preset formula. Most programs contain values for the closest CMYK match to PMS colors if you wish to emulate them with process inks.

parallel Moving data several bits at a time, rather than one at a time. Usually, parallel operation involves sending all 8 bits of a byte along 8 separate data paths at one time. This is faster than serial movement. Most scanners use parallel connections to move image information.

Photo CD A special type of CD-ROM developed by the Eastman Kodak Company that can store high-quality photographic images in a special space-saving format, along with music and other

data. Photo CDs can be accessed by CD-ROM XA-compatible drives, using Kodak-supplied software or with compatible programs such as Photoshop.

PICT
A graphic image and file format used by the Macintosh and its clipboard. *PICT2* is an enhanced version, which can be used in both 8-bit and 24-bit formats.

pixel:
A picture element of a screen image. One dot in a collection of dots that make up an image.

plate
A thin, light-sensitive sheet, usually of metal or plastic, which is exposed and then processed to develop an image of the page. The plate is used on the printing press to transfer ink or dye to a surface, generally paper.

Plug-In
A module that can be accessed from within a program like Photoshop to provide special functions. Many plug-ins are image processing filters that offer special effects.

plugging
A defect on the final printed page in which areas between dots become filled, producing an area of color that is too dark.

port
A channel of the computer used for input or output with a peripheral.

portrait
The orientation of a page in which the longest dimension is vertical, also called *tall orientation*.

position stat
A copy of a halftone that can be placed on a mechanical to illustrate positioning and cropping of the image.

posterization
A photographic effect produced by reducing the number of gray tones in an image to a level at which the tones are shown as bands, as on a poster.

PostScript
Developed by Adobe Systems, PostScript is the dominant page description language for PCs. It provides a way of telling the printer or imagesetter how to generate a given page.

prepress
The stages of the reproduction process that precede printing, particularly those in which halftones, color separations, and the printing plates themselves are generated.

preview scan
A preliminary scan that can be used to define the exact area for the final scan. A low-resolution image of the full page or scanning area is shown, and a frame of some type is used to specify the area included in the final scan.

process camera A graphic arts camera used to make color separations, photograph original artwork to produce halftones and page negatives, and to perform other photographic enlarging, reducing, and duplicating tasks.

process colors Cyan, magenta, yellow, and black. The basic ink colors used to produce all the other colors in four-color printing.

proof A test copy of a printed sheet, which is used as a final check before a long duplication run begins.

quadtone An image printed using four inks.

quantization *See posterization.*

raster image An image defined as a set of pixels or dots in row and column format.

raster image processor (RIP) The hardware/software used to process text, graphics, and other page elements into a raster image for output on a printer.

rasterize The process of turning an outline-oriented image, such as a PostScript file or an Adobe Illustrator drawing, into a bit-mapped image.

read-only memory (ROM) Memory that can be read by the system but not changed. Read-only memory often contains system programs that help the computer carry out functions.

reduced instruction set computer (RISC) A computer system that includes an optimized instruction set designed to complete each instruction in one clock cycle and therefore operates faster. Such systems depend on the software for functions that formerly were handled by the microprocessor.

reflection copy Original artwork viewed and scanned by light reflected from its surface, rather than transmitted through it.

register Aligning images, usually different versions of the same page or sheet. Color separation negatives must be precisely registered to one another to ensure that colors overlap in the proper places.

register marks Small marks placed on a page to make it possible to align different versions of the page precisely.

resampling The process of changing the resolution of an image—adding pixels through interpolation or removing pixels to reduce resolution.

resolution	The number of pixels or dots per inch in an image, whether it is displayed on the screen or printed.
retouch	Editing an image to remove flaws or create a new effect.
RGB color correction	A color correction system based on adjusting the levels of red, green, and blue in an image.
RGB color model	A way of defining all possible colors as percentages of red, green, and blue.
right-reading image	An image, such as a film used to produce a printing plate, that reads left to right when viewed as it will be placed for exposure.
rubber stamp	A tool that copies or clones part of an image to another area.
saturation	Purity of color: an attribute of a color that describes the degree to which a pure color is diluted with white or gray. A color with low color saturation appears washed out. A highly saturated color is pure and vivid.
scale	Change the size of a piece of artwork.
scanner	A device that captures an image of a piece of artwork and converts it to a bit-mapped image that the computer can handle.
screen	The halftone dots used to convert a continuous-tone image to a black-and-white pattern that printers and printing presses can handle. Even expanses of tone can also be reproduced by using tint screens that consist of dots that are all the same size (measured in percentages, a 100% screen is completely black).
screen angle	The alignment of rows of halftone dots measured horizontally.
SCSI ID	The number from 0 to 7 assigned to each device on the SCSI bus. This assignment is made by either adjusting a jumper or DIP switch on the equipment, or sometimes, through software. No two devices can have the same ID number.
secondary color	A color produced by mixing two primary colors. For example, mixing red and green primary colors of light produces the secondary color magenta. Mixing the yellow and cyan primary colors of pigment produces blue as a secondary color.
selection	1. Marking various portions of an image or document to work on them separate from the rest of the image or document. 2. The area that has been marked, usually surrounded by a marquee or outline that is sometimes colorfully called *marching ants*.

sensor	Usually a charge-coupled device that captures analog image information either linearly (in many scanners) or as an array of pixels (in digital cameras and some slide scanners.)
separation	*See color separation.*
separations	Film transparencies, each representing one of the primary colors (cyan, magenta, and yellow) plus black, used to produce individual printing plates.
serial	Passing information 1 bit at a time in sequential order. Some scanners use *serial connections*.
shadows	The darkest part of an image, generally with values ranging from 75% to 100%.
sharpening	Increasing the apparent sharpness of an image by boosting the contrast between adjacent tones or colors.
single in-line memory module (SIMM)	Now being replaced by *dual in-line memory modules* in the latest PCI-bus Macintoshes.
Small Computer Systems Interface (SCSI)	An intelligent interface, used for most scanners and other devices, including hard disk drives.
smoothing	Blurring the boundaries between tones of an image to reduce a rough or jagged appearance.
smudge	A tool that smears part of an image, mixing surrounding tones together.
solarization	In photography, an effect produced by exposing film to light partially through the developing process. Some tones are reversed, generating an interesting effect.
spot	The dots that produce images on an imagesetter or other device.
spot color	Individual colors used on a page. Usually limited to one or two extra colors in addition to black accenting some part of a publication.
spot color overlay	A sheet that shows one of the colors used in a publication for a given page. A separate overlay is prepared for each color and all are combined to create the finished page.
strip	Assembling a finished page by taping or otherwise fastening pieces of film containing halftones, line art, and text together in a complete page negative or positive. The most common

format is as a negative, because dirt and other artifacts show up as pinholes which can be easily spotted or opaqued before the printing plates are made.

subtractive colors The primary colors of pigments. When two subtractive colors are added, the result is a darker color which further subtracts from the light reflected by the substrate surface.

tagged image file format (TIFF) Tagged Image File Format. A standard graphics file format that can be used to store grayscale and color images.

terminator A device that absorbs signals at the end of a bus, preventing electronic "bounce-back." A SCSI bus must have two terminators, one at the first device and one at the last device. Some devices are internally terminated. Others require an add-on device.

text file Usually an ASCII file created by selecting **Save Text Only** from within an application.

thermal wax transfer A printing technology in which dots of wax from a ribbon are applied to paper when heated by thousands of tiny elements in a printhead.

threshold A predefined level used by a scanner to determine whether a pixel will be represented as black or white.

thumbnail A miniature copy of a page or image, which provides some idea of what the original looks like without having to open the file or view the full-size image.

tint A color with white added to it. In graphic arts, *tint* refers to the percentage of one color added to another.

tolerance The range of color or tonal values that will be selected, with a tool like the Magic Wand, or filled with paint, when using a tool like the Paint Bucket.

toner A pigmented substance used in page printers (and office copiers) to produce an image on a page.

trapping The ability of an ink to transfer as well onto another layer of ink as to the bare paper itself. In halftoning, poor trapping will result in tonal changes in the final image. In desktop publishing, trapping has an additional meaning: printing some images of one color slightly larger so they overlap another color, avoiding unsightly white space if the two colors

are printed slightly out of register. Printers call this technique *spreading* and *choking*.

triad
Three colors located approximately equidistant from one another on the color wheel. Red, green, and blue make up a triad; cyan, magenta, and yellow make up another. However, any three colors arranged similarly around the wheel can make up a triad.

trim size
The final size of a printed publication.

tritone
An image printed with black ink plus two other colored inks.

undercolor removal
A technique that reduces the amount of cyan, magenta, and yellow in black and neutral shadows by replacing them with an equivalent amount of black. It can compensate for trapping problems in dark areas. *See gray component removal.*

unsharp masking
The process for increasing the contrast between adjacent pixels in an image, raising the apparent sharpness.

virtual memory
Hard disk space used when there is not enough RAM to carry out an operation.

wrong-reading image
An image that is backward relative to the original subject—a mirror image.

zoom
Enlarging part of an image so that it fills the screen, making it easier to work with that portion.